Exploring American Girlhood through 50 Historic Treasures

AASLH

Exploring America's Historic Treasures

About the Organization

The American Association for State and Local History (AASLH) is a national history membership association headquartered in Nashville, Tennessee, that provides leadership and support for its members who preserve and interpret state and local history in order to make the past more meaningful to all people. AASLH members are leaders in preserving, researching, and interpreting traces of the American past to connect the people, thoughts, and events of yesterday with the creative memories and abiding concerns of people, communities, and our nation today. In addition to sponsorship of this book series, AASLH publishes the *History News* magazine, a newsletter, technical leaflets and reports, and other materials; confers prizes and awards in recognition of outstanding achievement in the field; supports a broad education program and other activities designed to help members work more effectively; and advocates on behalf of the discipline of history. To join AASLH, go to www.aaslh.org or contact Membership Services, AASLH, 2021 21st Ave. South, Suite 320, Nashville, TN 37212.

About the Series

The American Association for State and Local History publishes the Exploring America's Historic Treasures series to bring to life topics and themes from American history through objects from museums and other history organizations. Produced with full-color photographs of historic objects, books in this series investigate the past through the interpretation of material culture.

Exploring American Girlhood through 50 Historic Treasures

ASHLEY E. REMER AND TIFFANY R. ISSELHARDT

ROWMAN & LITTLEFIELD
Lanham • Boulder • New York • London

Published by Rowman & Littlefield
An imprint of The Rowman & Littlefield Publishing Group, Inc.
4501 Forbes Boulevard, Suite 200, Lanham, Maryland 20706
www.rowman.com

6 Tinworth Street, London SE11 5AL, United Kingdom

British Library Cataloguing in Publication Information Available

Library of Congress Cataloging-in-Publication Data

Names: Remer, Ashley, author. | Isselhardt, Tiffany R., 1986- author.
Title: Exploring American girlhood through 50 historic treasures / Ashley E. Remer
and Tiffany R. Isselhardt.
Description: Lanham : Rowman & Littlefield, [2021] | Series: AASLH exploring
America's historic treasures | Includes bibliographical references and index. |
Summary: "This full-color book is a must-read for those who yearn for more
balanced representation in historic narratives, as well as an inspiration to young
people, showing them that everyone makes history. It includes color photographs
of all the treasured objects explored"— Provided by publisher.
Identifiers: LCCN 2020049957 (print) | LCCN 2020049958 (ebook) | ISBN
9781538120897 (cloth) | ISBN 9781538120903 (epub)
Subjects: LCSH: Girls—United States—History. | United States—Social life
and customs.
Classification: LCC HQ777 .R45 2021 (print) | LCC HQ777 (ebook) | DDC
305.230820973—dc23
LC record available at https://lccn.loc.gov/2020049957
LC ebook record available at https://lccn.loc.gov/2020049958

Contents

List of Illustrations ix

Preface: Why Girls? xiii

Timeline of Objects xv

Acknowledgments xix

Introduction: Finding Girls in American History 1

PART I: In Search of Home, 9500 BCE to 1590s CE 3

1 Xaasaa Na' (Upward Sun River), Alaska, c. 9500 BCE 5

2 Hāʻena State Park, Kauaʻi, Hawaiʻi, c. 1000 to 1400 CE 9

3 Mound 72, Cahokia Mounds State Historic Site, Collinsville,
 Illinois, c. 1050 CE 13

4 "The Display with Which a Queen-Elect Is Brought to the King," 1564 17

5 Virginia Dare Monument, Roanoke Colony, North Carolina, 1587 21

PART II: Her and Me—Otherness in the New World, 1600 CE to 1770 CE 25

6 Pocahontas Statue, Jamestown, Virginia, 1607 27

7 Samuel Parris Archaeological Site, Danvers, Massachusetts, 1692 31

8 Mary Wright's Sampler, ca. 1754 35

9 Mary Jemison Statue, Letchworth State Park, New York, 1758 39

10 Phillis Wheatley Statue, Boston, Massachusetts, 1760s 43

PART III: **Becoming "American," 1770s to 1840s** **47**

11 Anna Green Winslow's Diary, 1771 49

12 Sybil Ludington Statue, Carmel, New York, 1777 53

13 Sacajawea Statue, Salmon, Idaho, 1804 to 1806 57

14 Bill of Sale for a Girl Named Clary and Runaway Advertisement
 for Harriet Jacobs, 1806 to 1835 61

15 Pantaloons, 1833 65

16 Patty Reed's Doll, 1846 to 1847 69

PART IV: **Reckoning, 1850s to 1860s** **73**

17 Lime Rock Lighthouse, Newport, Rhode Island, 1858 75

18 Belle Boyd House, Martinsburg, West Virginia, 1861 79

19 *Reminiscences of My Life in Camp* by Susie King Taylor, 1864 83

20 "Vinnie Ream at Work," 1866 87

21 *Poems and Translations* by Emma Lazarus, 1866 91

PART V: **Hope, 1870s to 1910s** **95**

22 "Group in Bathing Costumes" by Alice E. Austen, 1885 97

23 Water Pump at Ivy Green, Tuscumbia, Alabama, 1887 101

24 Statue of Annie Moore, Ellis Island, New York, January 1, 1892 105

25 Portrait of Georgia Rooks Dwelle, 1904 109

PART VI: **Strife, 1870s to 1910s** **113**

26 Photograph of Princess Ka'iulani, 1881 115

27 "Indian Girls Dressed for a Ball Game," 1904 119

28 "Sadie Pfeifer" by Lewis Hine, November 30, 1908 123

29 Dormitory at Angel Island, California, 1910 127

PART VII: **Becoming "Modern" American Girls, 1910s to 1940s** **131**

30 Girl Scout Pledge Card, 1917 to 1918 133

31 Paper Doll of Clara Bow, 1920s 137

32 Cashay Sanitary Puffs, ca. 1934 141

33 *Stand Up and Cheer!* Dress Worn by Shirley Temple, 1934 145

34 "Jumping Rope on Sidewalk" by Edwin Rosskam, April 1941 149

PART VIII: **Voices, 1940s to 1950s** **153**

35 Elizabeth Kikuchi's Letter to Clara Breed, May 25, 1942 155

36 *Seventeen* Magazine, 1944 159

37 Patty-Jo Doll, 1945 to 1949 163

38 Monument to the *Westminster* Case Children, Westminster,
 California, 1945 to 1947 167

39 Transportation Token from Montgomery, Alabama, March 1955 171

40 Barbie Teen-Age Fashion Model, 1959 175

PART IX: **Revolutions, 1960s to 1970s** **179**

41 "Will You Still Love Me Tomorrow" by The Shirelles, 1960 181

42 Kachina Doll, 1964 185

43 *Are You There God? It's Me, Margaret* by Judy Blume, 1970 189

44 Mary Beth Tinker's Black Armband, 1965 to 1969 193

45 "Peggy Oki" by Pat Darrin, 1975 197

PART X: **Girl Power, 1980s to the Present** **201**

46 Selena Quintanilla Memorial, Corpus Christi, Texas, 1995 203

47 Dominique Dawes's Leotard, 1996 207

48 *Rookie Yearbook One*, 2011 211

49 GoldieBlox and the Spinning Machine, 2012 215

50 Letter by Anna Lee Rain Yellowhammer and Photograph
 of Mari Copeny, 2016 219

Afterword: The Future of American Girlhood 225

Notes 227

Selected Bibliography 251

Index 255

About the Authors 267

List of Illustrations

1.1 Excavations at the Upward Sun River Site in Alaska 5

2.1 Kēʻē Beach (aerial view), Kauaʻi, Hawaiʻi 9

3.1 Mound 72 at Cahokia Mounds State Historic Site,
Collinsville, Illinois 13

4.1 "The queen-elect is brought to the king"
by Jacques Le Moyne de Morgues 17

5.1 Virginia Dare Monument, Roanoke Colony,
North Carolina 21

6.1 Pocahontas Statue, Jamestown, Virginia 27

7.1 Excavation of Samuel Parris's rectory, Danvers,
Massachusetts 31

8.1 "Embroidered Picture" by Mary Wright 35

9.1 Statue of Mary Jemison, Letchworth State Park, New York 39

10.1 Statue of Phillis Wheatley, Boston,
Massachusetts 43

11.1 Frontispiece of *Diary of Anna Green Winslow:
A Boston School Girl of 1771* 49

12.1 Statue of Sybil Ludington, Carmel, New York 53

13.1 Sacajawea Monument, Salmon, Idaho 57

14.1 Bill of sale for a girl named Clary 61

14.2 Advertisement for the Capture of Harriet Jacobs 61

15.1 Pantaloons 65

16.1 Patty Reed's doll 69

17.1 "Lime Rock Island, off Newport, Rhode Island,"
 published in *Harper's Weekly* 75

18.1 Belle Boyd House, Martinsburg, West Virginia 79

19.1 Frontispiece for *Reminiscences of My Life in Camp
 with the 33d United States Colored Troops:
 Late 1st S. C. Volunteers* by Susie King Taylor 83

20.1 "Vinnie Ream at work" 87

21.1 Title page of *Poems and Translations* by Emma Lazarus 91

22.1 "Group in Bathing Costumes" by Alice E. Austen 97

23.1 Water pump at Ivy Green, Tuscumbia, Alabama 101

24.1 Statue of Annie Moore, Ellis Island, New York 105

25.1 Portrait of Georgia Rooks Dwelle 109

26.1 Princess Ka'iulani at home 115

27.1 "Indian girls dressed for a ball game" 119

28.1 "Sadie Pfeifer" by Lewis Hine 123

29.1 Angel Island dormitory, San Francisco, California 127

30.1 Girl Scout Pledge Card 133

31.1 Clara Bow paper doll 137

31.2 Yellow tennis dress for Clara Bow paper doll 137

32.1 Cashay Sanitary Puffs 141

33.1 *Stand Up and Cheer!* dress worn by Shirley Temple 145

34.1 "Jumping rope on sidewalk" by Edwin Rosskam 149

35.1 Letter to Clara Breed from Elizabeth Kikuchi,
 Arcadia, California 155

36.1 *Seventeen* magazine cover 159

37.1 Patty-Jo doll 163

38.1 Rendering for a monument to the *Westminster* case children, Westminster, California 167

39.1 Transportation token, Montgomery, Alabama 171

40.1 Barbie Teen-Age Fashion Model 175

41.1 "Will You Still Love Me Tomorrow" record single 181

42.1 Supai Girl kachina 185

43.1 Cover of *Are You There God? It's Me, Margaret* by Judy Blume 189

44.1 Mary Beth Tinker at the Newseum 193

45.1 Peggy Oki in 1975 197

46.1 Selena Quintanilla Memorial, Corpus Christi, Texas 203

47.1 Olympic gymnastics leotard, worn by Dominique Dawes 207

48.1 Cover of *Rookie Yearbook One* 211

49.1 GoldieBlox and the Spinning Machine 215

50.1 Letter to US Army Corps of Engineers by Anna Lee Rain Yellowhammer 219

50.2 Mari Copeny meets President Obama 222

Preface

Why Girls?

As children, we fell in love with museums. Yet something was always missing: the stories of young girls. "Where were the girls? What would our lives have been like? Did we just play with dolls and get married?" These were our earliest encounters with what is now a refrain: representation matters.

Girls are one of the most marginalized groups in history. Movements to diversify the American story do not fully represent the voices of women, let alone children. When females are included, the focus is on their achievements in adulthood, not girlhood experiences. Such inclusion also heavily relies on biography, rather than tangible objects and places where girls can experience their unique history. For example, in 1777, 16-year-old Sybil Ludington completed a 40-mile midnight ride to muster troops to fight against the encroaching British army. Her efforts enabled the militia to win the Battle of Ridgefield. Despite riding twice the distance of Paul Revere and having a statue erected in her honor, Sybil's story only recently returned to American memory.

Like Sybil, girls' stories are excluded from most history books. This is inexcusable, as one of the keys to achieving gender equality is ensuring representation. By seeing themselves in historical sites and artifacts, girls are empowered to become history-makers themselves, and society is shown that girls are as important as the rest of history's participants. *Exploring American Girlhood through 50 Historic Treasures* is our declaration for girls' inclusion, representation, and equal rights. Through it, we show girls took up important

roles in their families and communities while also profoundly shaping and progressing American history.

A girl-focused lens is not superficial. Girls are not just artists' subjects, anonymous bystanders, or women inappropriately termed "girls." Rather, ours is the first American history text focusing exclusively on "girls," defined as "females under the age of 21," which takes into account historical and modern definitions of "adulthood." While women's history tends to focus on "rebellious" or "unique" females, we demonstrate that all girls are major forces in society and their experiences are valid and worthy of further study. We also use tangible heritage–historic sites, landmarks, monuments, or artifacts integral to understanding American girls' history and culture. Finally, we recognize that "American" encompasses a diverse range of peoples, thus exploring treasures from the last Ice Age to the early 21st century and utilizing the BCE/CE notation system (rather than BC/AD due to its Christian basis). Our sections reflect themes that define American girlhood generally, with each chapter focusing on a specific historic site or artifact.

We hope *Exploring American Girlhood through 50 Historic Treasures* inspires girls to become leaders and changemakers, while providing teachers and interpreters a framework to make educational and interpretive content more inclusive of girls. Ultimately, in giving girls the representation they have long deserved, we hope to inspire a more intersectional American history that respects girls, promotes their equality, and reaffirms their rights.

Timeline of Objects

ca. 9500 BCE
Excavations at the Upward Sun
River Site in Alaska, page 5

ca. 1000–1400 CE
Kē'ē Beach (aerial view), page 9

ca. 1050 CE
Mound 72 at Cahokia Mounds
State Historic Site, page 13

1564
"The Display with Which a Queen-Elect
Is Brought to the King," page 17

1587
Virginia Dare Monument, page 21

1607
Pocahontas statue, page 27

1692
Excavation of Samuel Parris's
rectory, page 31

ca. 1754
"Embroidered Picture"
by Mary Wright, page 35

1758
Mary Jemison statue, page 39

1761–1774
Phillis Wheatley statue, page 43

1771
Book: *Diary of Anna Green Winslow:
A Boston School Girl of 1771*, page 49

1777
Sybil Ludington statue, page 53

1804–1806
Sacajawea statue, page 57

1806
Bill of sale for a girl name
Clary, page 61

1833
Pantaloons, page 65

1835
Advertisement for the capture
of Harriet Jacobs, page 61

1846–1847
Patty Reed's doll, page 69

1858
Lime Rock Lighthouse, page 75

1861
Belle Boyd House, page 79

1864
Book: *Reminiscences of My Life in
Camp* by Susie King Taylor, page 83

1866
Vinnie Ream at work, page 87

1866
Book: *Poems and Translations*
by Emma Lazarus, page 91

1881
Princess Ka'iulani at home, page 115

1885
"Group in Bathing Costumes"
by Alice E. Austen, page 97

1887
Water pump at Ivy Green, page 101

1892
Statue of Annie Moore, page 105

1904
Portrait of Georgia Rooks Dwelle,
page 109

1904
"Indian girls dressed for a ball game,"
page 119

1908
"Sadie Pfeifer" by Lewis Hine,
page 123

1910
Dormitory at Angel Island, page 127

1917–1918
Girl Scout Pledge Card, page 133

1920s
Clara Bow paper doll, page 137

1920s
Yellow tennis dress, page 137

ca. 1934
Cashay Sanitary Puffs, page 141

1934
Stand Up and Cheer! dress,
page 145

ca. 1941
"Jumping Rope on Sidewalk"
by Edwin Rosskam, page 149

1942–1945
Letter to Clara Breed from
Elizabeth Kikuchi, page 155

1944
Seventeen magazine, page 159

1945–1956
Patty-Jo doll, page 163

1945–1947
Rendering for a monument to the
Westminster case children, page 167

1955
Transportation token, page 171

1959
Barbie Teen-Age Fashion Model,
page 175

1960
Album: *Will You Still Love Me Tomorrow*
by The Shirelles, page 181

1964
Kachina doll, page 185

1970
Book: *Are You There God? It's Me, Margaret* by Judy Blume, page 189

1965–1969
Mary Beth Tinker's black armband, page 193

1975
"Peggy Oki" by Pat Darrin, page 197

1989–1995
Selena Quintanilla Memorial, page 203

1996
Dominique Dawes's leotard, page 207

2011
Rookie Yearbook One, page 211

2012
GoldieBlox and the Spinning Machine, page 215

2016
Letter by Anna Lee Rain Yellowhammer, page 219

2016
Mari Copeny meets President Obama, page 222

Acknowledgments

This book was driven by love for researching the past and frustration for the present America. It is a great privilege to be able to honor our younger selves with a book we wish had been available to inspire us and to build on our work with Girl Museum, which was founded to elevate girls' voices and stories. We are grateful for the opportunity to write it and share our passion for girlhood, history, and education.

All books are produced with team efforts, and we give eternal thanks to our editors, especially Kathleen Weidmann, for making us coherent; our researchers, Megan Cooper, Jennifer Rhoades, and Matthew D. Remer; and all those in libraries, archives, museums, and beyond who helped provide advice, content, and reflections on the many places and objects that reveal American girls' history. We also thank all those who have worked with us at Girl Museum, inspiring us to continue pursuing equal representation and rights for girls.

And special thanks to our partners, Ross and Michael, for their unwavering support in all we do.

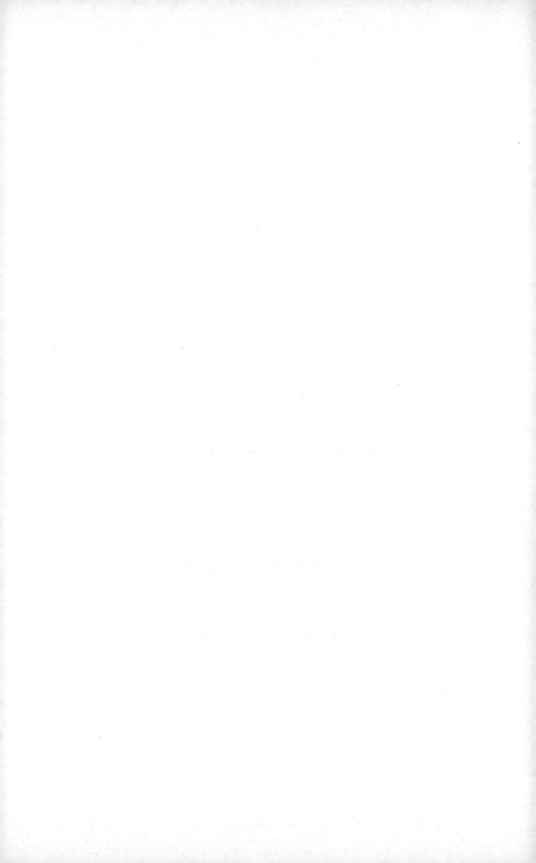

Introduction

Finding Girls in American History

In 2013, the Smithsonian Institution published *A History of America in 101 Objects*. Like many books using objects to tell broad histories, females and their contributions are generally overlooked. In this instance, only 11 objects—just over 10%—were explicitly related to females. In response, we produced a virtual exhibition at Girl Museum entitled *52 Objects in the History of Girlhood*. In 2018, when the American Association of State and Local History put out a call for books in a new series on objects and historic sites, it was the perfect opportunity to delve deeply into American history from a girl's perspective.

Making a list book, especially one to cover an entire country's history, is no easy task. It requires hard decisions on what people, moments, and objects are important. In making these decisions, two concepts were paramount. First, we wanted to address Jake Page's idea that "[h]istory is the story of one's people's past, to be sure, but also the story of one's personal identity."[1] How were girls' identities shaped by American history? Did they adhere to or subvert societal conventions? How did their actions lead us to today?

Second, Freeman Tilden suggested that interpretation should implore visitors to better understand themselves in order to find inspiration and meaning.[2] How can we do that if girls are rarely included at the majority of historic sites and museums? Girls are complex, multidimensional beings who encompass the range of good, bad, and in-between in the same way adults

do. Unfortunately, they are rarely portrayed that way. Interpretation favors them as innocent children or little demons, rather than active participants with agency in their own lives and in our country's formation. We choose to recognize girls as full and complicated participants in American history, from the Ice Age to the present day. Girls have always been capable of achieving greatness, and this book is just a slice of that capacity, meant to supplement American history curricula in order to inspire girls to find meaning and identity in our nation's history.

Yet, like all list books, our methods must be rigidly defined or risk becoming too broad. This book privileges the perspective of girls by focusing on the period of their youth rather than achievements in later life. We also attempted to be balanced in terms of time periods and ethnicities, identifying sites and objects that are easily accessible, yet representative of key moments in American history or changes in girl culture. American history is a patchwork of progressive and destructive stories, and our narrative recognizes this complexity by engaging with difficult histories and issues that are still relevant today, such as female oppression, objectification, and racism. We have tried to balance ethnic histories as well, extending our narrative to the very first people to enter the North American continent, while ensuring our sources were reliable and the stories reflect broader themes important to American history. As is symptomatic of white male-written, hero-driven narratives, the stories of girls, their objects, and related historic sites have been ignored or neglected. Many have no surviving tangible records related to their actions or life, and thus they must be saved for a volume that is not object-focused. All these histories contributed to the formation of identity for American girls, up to the present moment. And much work needs to be done at the primary source level, to locate and recover more American girl stories.

We hope this book inspires readers to visit their local museum or historic site and look for the girls, and to better incorporate girlhood into our teaching and research of American history and culture. Importantly, we want to motivate those of us working in interpretation to not only incorporate girls' histories, but to understand, appreciate, and protect those places and objects that remind us how girls have been—and always will be—major players in the American narrative.

Part I

IN SEARCH OF HOME, 9500 BCE TO 1590s CE

People seeking places to call "home" are the first stories of American history. Yet most textbooks start with a brief summary of Native America, quickly moving to European conquest. Such texts discount the long, complex history of Native America and Native views of American history. History is a series of stories, seen through biased eyes, reinterpreted with each telling. As Jake Page states, "Indians' history is a story as well, but story comes first—that is, the meaning of a story is its originating core. The facts follow the meaning."[1] Starting with the first searches for "home" in America during the Ice Age, our book follows this model, placing meaning at the core of each chapter.

American settlement began over 14,000 years ago. Around 9500 BCE, Paleo-Indians established settlements sizeable enough to leave a recognizable archaeological record.[2] One of the earliest found to date is Upward Sun River, where two young girls provide genetic evidence that revises our history. Over 10,000 years later, what is now Hā'ena State Park in Hawai'i tells a tale of sisterhood and female power through the rituals of hula, which was obscured by European male bias. This discrimination also underscores interpretation of the Native American city of Cahokia, glossing over its account of female authority, and a Timucuan Queen-Elect who is remembered more as a European princess than a Timucuan girl-bride. Finally, Roanoke—the first English colony in America—hints at the importance of girls in European settlement and how newborn Virginia Dare—and subsequently white American girls—

became valued over Native girls. Only by recognizing that "American girl" encompasses a variety of identities over the past 14,000 years can we begin to understand the complexity of girlhood and its influence on society today.

Xaasaa Na' (Upward Sun River), Alaska, c. 9500 BCE

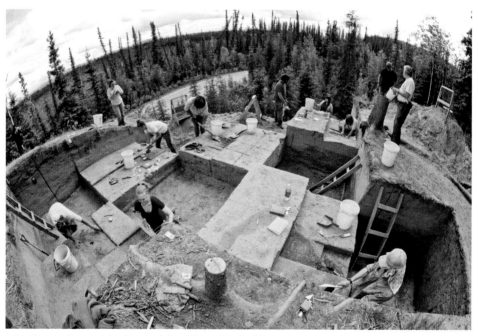

1.1. Excavations at the Upward Sun River Site in Alaska.
UNIVERSITY OF ALASKA FAIRBANKS

Where and when did occupation of the Americas begin? Many scholars have argued whether or not the first Americans entered via an ice-free corridor along the Pacific Coast, by boat across the oceans, or through land bridges created from what is now Northern Europe to New England. Clues to resolve the debate are found in archaeological sites, most pointing to the peopling of the Americas between 25,000 and 11,000 years ago. Among these clues are three individuals who died about 11,500 years ago: a 3-year-old child and two young girls at Upward Sun River along the Tanana River in central Alaska.

Upward Sun River was part of prehistoric Beringia, between the Arctic and Pacific oceans. Around 25,000 years ago, this region was covered with grasses and populated by megafauna like mammoth and bison. The seas were roughly 500 feet lower, exposing a land bridge for people to follow game animals from Asia into the Americas. When sea levels rose around 11,000 years ago, much of the archaeological record of these migrations was lost. Yet some sites, like Upward Sun River, remained above sea level. In 2006, archaeological work began and, four years later, "the oldest known human remains ever recovered from the Arctic/Subarctic of North America"[1] were discovered.

Buried under 10 meters of sand, clay, and silt, Upward Sun River was a residential summer camp with firepits and activity areas, including a semi-subterranean house and pit-hearth containing the remains of three children. Within the pit-hearth are four layers: (1) a layer of fill; (2) a layer with the cremated remains of a 3-year-old child and fauna; (3) layers of charcoal, burned fish, and small mammal bones; and (4) the burial of two female infants and associated grave goods. Radiocarbon dating indicates these burials happened around 11,500 years ago. They also indicate the 3-year-old and the infants were likely from the same family and possibly buried in the same year.[2]

The two female infants were named Xach'itee'aanenh T'eede Gaay (Sunrise Girl-Child) and Yelkaanenh T'eede Gaay (Dawn Twilight Girl-Child) by the Healy Lake Tribe. These girls are the earliest human remains found to date in northern North America.[3] Their remains were unburned, largely complete, and placed in anatomical positions, meaning they were purposely buried in the pit-hearth. Xach'itee'aanenh was only a few weeks or months at death, while Yelkaanenh was a late-term fetus.[4] Both infants were completely covered in ochre, indicative of being in shrouds, and were near "four antler rods and two projectile points placed parallel to each other" covered in red ochre.[5] The

antler rods were of particular interest to archaeologists because they were covered with decorations (X-incision designs) similar to prehistoric tools from Asia. In 2015, DNA analysis revealed the girls were close relatives, but had mothers who belonged to genetically distinct population groups.

After the girls were buried, the pit-hearth was used for cooking, evidenced by the presence of animal remains and tertiary flakes that were produced during tool maintenance. During one summer, a 3-year-old child—named Xaasaa Cheege Ts'eniin (Upward Sun River Mouth Child)—died and was cremated at the top of the hearth. Though only 20% of the skeleton remains, it holds vital clues to Paleo-Indian history. Fragments of the skull show no signs of trauma and a dental pattern consistent with Northeast Asians and Native Americans. Coloring on the bones showed that Xaasaa Cheege Ts'eniin had been placed on his/her back in the cremation fire, and no evidence of grave goods—except for two small ochre fragments—was found.[6] Shortly after the cremation, the pit-hearth was filled, and Upward Sun River was abandoned.

These burials offer the first evidence of complex mortuary practices and reuse of a residential feature over a previous burial.[7] The reuse of the site suggests three points. First, death was not relegated to distinct areas like cemeteries; it was part of everyday life. Second, the deaths of three children during summer, the time when resources should have been plentiful, suggests relatively high infant mortality. Finally, the girls' burials exhibit great care and devotion, despite long-held stereotypes of youth's unimportance. Upward Sun River demonstrates that Paleo-Indian cultures recognized the value of their children, mourned when they died, and did so as closely related family groups.

Beyond mortuary practices, the Upward Sun River infants provide evidence about the first Americans. Analysis of their DNA reveals the infants belonged to a population group previously unknown, the Ancient Beringians, who share a common ancestor with Native Americans. This suggests the first Americans were from East Asia and that they became two distinct genetic lineages *before* separately migrating to the Americas. The environmental and archaeological evidence also supports this theory, known as the Beringian Standstill Model. The first migrants were Native American ancestors, who evolved into two groups of Native Americans (Northern and Southern). They were followed by Ancient Beringians, who remained in the northern parts of North America. Eventually, the Northern Native Americans and Ancient Beringians merged into one group.

Combined with the Beringian Standstill Model, the burials reveal more complex cultural practices than archaeologists previously considered. These practices are similar to ones found in prehistoric Russia, suggesting the continuance of more ancient mortuary practices despite migration. The evidence also suggests girls during the Paleo-Indian period were granted respect in death, as demonstrated by the grave goods and ochre-covered impression of shrouds. This directly refutes centuries of bias toward prehistoric hunter-gatherer groups, which were assumed to be male dominated because modern societies are patriarchal. Most of the scientific community now considers prehistoric hunter-gatherer groups to possess social norms free from modern patriarchal bias, and the Upward Sun River infants provide additional support.

Xach'itee'aanenh, Yelkaanenh, and the cremation of Xaasaa Cheege Ts'eniin are treasures of America's prehistory, providing the first direct evidence of girls in North America and fostering a better understanding of how and by whom it was populated. By acknowledging their silenced voices, we begin the journey of rectifying girls' places in American history. Through refuting the patriarchal bias, we broaden our understanding not only of these girls, but of the many girls who came after and settled what would become "America."

Hāʻena State Park, Kauaʻi, Hawaiʻi, c. 1000 to 1400 CE

2.1. Kēʻē Beach (aerial view), taken on June 19, 2010.
JORDAN FISCHER VIA FLICKR

Just before 1000 CE, descendants of the Lapita[1] arrived and settled on the northern shores of what is now Kaua'i in Hawai'i. They arrived in family groups, carried across the Pacific in *wangka*, the first watercraft capable of crossing oceans, along with seeds, pigs, dogs, chickens, and other necessities. Over the next 700 years, they built a thriving culture, similar to yet distinct from the other Hawaiian Islands. Kaua'i became unique for its connection to girls and hula, which centered on what is now Hā'ena State Park and the legend of two sister goddesses.

As a culture transmitted through oral history, the story of Hawai'i is contained within the landscape itself—each feature has a historical narrative that maintains Hawaiian identity. Kaua'i has a unique narrative, because travel from the other Hawaiian Islands was difficult, enabling its inhabitants to maintain their autonomy from other rulers. Hā'ena's settlement began on the beaches of Ke'e, then moved into the valleys and cliffs of Nepali. Among the flora and fauna are reminders of this *heiau* (sacred site): "Lohi'au's house platform, actively tended cemeteries and burial sites, a former poi mill, and dozens of archaeological sites."[2] In 1959, Kekahuna noted the *heiau* included varying levels of pavements, short walls, and pits surrounding more prominent features like square idol sites, a 16-foot-long compartment facing a circular idol site, a refuse pit, and a stairway that led to temple areas strictly for hula instructors to pray to their patron goddess, Laka.[3] Above the cliffs of Nepali is Ka-ulu-a-Pa'oa Heiau, identified as the site of the most prominent hula seminary (*hālau hula*) of ancient Hawai'i, followed by the peak of Makana (meaning "gift"), which Kaua'i residents honor as the provider of all Hā'ena's abundance.

This landscape is central to the narrative of Hā'ena and its girls, which focuses on sister goddesses Pele and Hi'iaka and the creation of hula. The oral history of Pele and Hi'iaka and their family of demigods tells of their arrival from Tahiti, with Pele arriving on Kaua'i, then settling on the big island of Hawai'i. In her absence, the Hawaiian people settled Kaua'i, and eventually chief Lohi'au came into power at Hā'ena. This is where the sisters' story merges with Hawaiian girls, demonstrating how mythology and history are interwoven.

One day, Pele and her sisters bathed in the sea. Pele took a nap on the seashore, and while asleep, heard drumming and chanting. Her spirit-form followed the sound to Kaua'i, where she saw chief Lohi'au presiding over a

celebration. Pele became a beautiful woman and joined the celebration, and Lohi'au fell in love with her. After three days, Pele returned home and asked her sisters to bring Lohi'au to her. All refused except Hi'iaka. Afraid of her sister's power, Hi'iaka made Pele promise to watch over her beloved forests and her best friend, Nānāhuki. She then journeyed to Hā'ena, creating poems and songs about the land and her journey. Arriving at Kaua'i, she was told by the new chief, Pa'oa, that Lohi'au had died of a broken heart. His spirit was taken by a *mo'o* (lizard) woman into the cliffs. Hi'iaka turned the *mo'o* woman into a stone, defeating her. The stone is identifiable by its size and honeycombed surface, found at the cliff base northwest of the *heiau*. Hi'iaka restored Lohi'au's life through herbs and prayers and took him to Hawai'i. Arriving home, Hi'iaka found Pele had destroyed Hi'iaka's forest and killed Nānāhuki for taking too long. Enraged, Hi'iaka embraced Lohi'au, who fell in love with her. The sisters fought, eventually stopped by their brothers. Hi'iaka and Lohi'au returned to Kaua'i, where they married and spent the rest of their lives at the *heiau*.

Though mythical in nature, the tale has roots in the real world. Hi'iaka is believed to be a human with significant *mana* (spiritual power), having spent a natural life with Lohi'au. Additionally, chief Pa'oa—Lohi'au's friend and successor—is recognized as the founder of Ka-ulu-a-Pa'oa Heiau. There, Hi'iaka taught the hula she learned from Nānāhuki when they were girls. Hawaiians came from all the islands to seek training in the hula from the *kumu hula* (hula teacher) and partake in rituals to honor Hi'iaka and Laka (goddess of the hula and forests, sometimes thought to be Hi'iaka's spiritual form). Children were selected to be devoted to hula, living isolated for years in their *hālau* (hula school) under the strict teachings of the *kumu hula*. They learned that hula is a cultural tradition expressed through costumes, posture, gesture, and chants. Through hula, Hawaiians learn and transmit their history, genealogy, and cosmology. Upon graduation, a few students became *kumu hula* while the rest joined royal households or troupes who toured the islands. Hula connected all Hawaiians, bringing their shared history to life through ritual and entertainment.

Hula was first described for Europeans by David Samwell, a surgeon on James Cook's *Discovery* in early 1779. Samwell recorded, "In the afternoon they [Hawaiian women] all assembled upon deck and formed a dance; they strike their Hands on the pit of their Stomack smartly & jump up all together,

at the same time repeating the words of a song in responses."[4] Other European accounts are similar. Additionally, Hawaiian legends tell of girls and women performing the hula and being among the earliest practitioners of the art, crediting Hiʻiaka as the first hula dancer. Legends, combined with records from European explorers and missionaries, demonstrate the intelligence and importance of girls in ancient Hawaiʻi as they harnessed their own spiritual power and became keepers of cultural traditions. Where other societies respected elders, Native Hawaiians respected hula dancers.

Europeans thought hula was intriguing, but missionaries deemed it heathen and lascivious. By the early 19th century, hula was nearly forgotten. However, it experienced a resurgence in the 1880s under the reign of Kalakaua. Girls reclaimed their ancestral space as primary entertainers and storytellers during the chief's coronation.[5] Hula continued into the 20th century, but at a cost. Performance became mainly pantomime, with girls' power transformed by tourists into commercialized sexual attraction, featuring coconut bra–topped, grass-skirted, lei-bedecked dancers. This image evoked lush tropics and generated what L. K. Kaulapai called "the greatest lie in Hawaiian history."[6] The stereotypical hula girl—and the loss of power by true hula dancers—reflected the larger appropriation of Hawaiʻi by Europeans and, later, Americans.

The true names and purpose of Hāʻena were marginalized, remembered only by Native Hawaiians and the efforts of 19th-century Native Hawaiian scholars who recorded the great sagas of their past as the *moʻolelo o Hawaiʻi*. Dismissed by many scholars as myth, these texts confirm archaeological findings and paint a picture of ancestral Hawaiian girlhood. By neglecting to recognize, excavate, and recount the sites of Hāʻena and the hula, history disregards the most powerful manifestation of itself: the sites in which we live. Hula was an art form that kept Hawaiian culture and history alive, while reinforcing traditions that affirmed the power of girls and enabled them to be self-sufficient and respected. Through each performance, Hawaiian life and identity were reaffirmed, ensuring their continuance into the future.

3

Mound 72, Cahokia Mounds State Historic Site, Collinsville, Illinois, c. 1050 CE

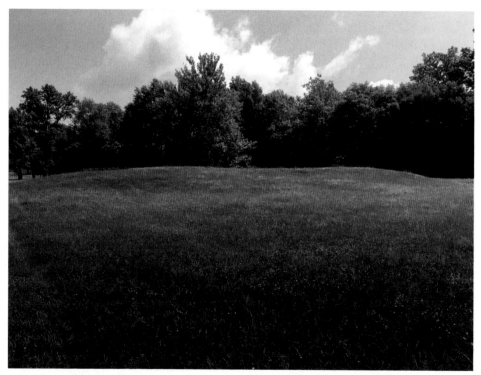

3.1. Mound 72 at Cahokia Mounds State Historic Site, Illinois, taken May 2018.
TIFFANY ISSELHARDT

Around 1050 CE, something extraordinary happened in what is now Collinsville, Illinois: a great city named Cahokia arose. It was the center of political, religious, and social life for the emergent Mississippian culture. At its height, Cahokia comprised more than 200 mounds, referencing the four sacred directions (north, south, east, and west) and was arranged around vast open plazas.[1] The greatest was Monks Mound, the largest Pre-Columbian earthwork in North America, towering 100 feet high with a base wider than the Great Pyramid of Giza in Egypt. Interspersed between the mounds were suburban-like neighborhoods, while farther out were family farmsteads. Only 80 mounds remain today, including the most mysterious of all: Mound 72.

Mound 72 is actually a series of three smaller mounds that were reshaped and covered to form one 7-foot-high, 140-foot-long ridgetop mound. It contains the burials of at least 272 people, many of whom were 15- to 25-year-old girls, killed as part of human sacrifice rituals. The area that pertains to our story is Mound72Sub2, which features burial pits for four groups. The first contains 21 people, four buried in bundles and 13 between the ages of 15 and 25 buried in a charnel structure (for storing human bodies). The second contains 22 bodies placed two deep in pits lined with sand and mats. The third contains 19 females, also buried two deep in pits, accompanied by over 36,000 shell beads, hundreds of arrow points, and several ceramic vessels. The final group contains 24 females arranged in two layers. The other burials in Mound 72 include the Beaded Burial of a man and woman covered by over 20,000 shell beads shaped like a bird; 7 males and females buried with mice, chunky stones, copper rolls, and arrow points; a burial of 57 bodies, mostly females ages 15 to 25; and a burial of 39 males and females ages 15 to 45 who were clubbed to death alongside 15 bodies of men, women, and children resting on litters placed in the pit.

Analysis suggests nearly all of these graves were human sacrifices taking place over two centuries, with one ridgetop burial mound for every generation living there.[2] This makes Mound 72's burials—the majority of which are teenage girls—central events in Cahokian life. Unlike other mounds, it is aligned with the summer solstice sunset and the winter solstice sunrise, on a northwest-southeast axis. Additionally, among the buildings that flanked the mounds, archaeologists found flint-clay figurines that depict "kneeling women" adorned with plants; hoes; feline-headed serpents; and baskets, which may represent medicine bundles. Most of the figurines' accoutrements

are associated with food production and fertility and are similar to a central character in later Mississippian mythology: Grandmother or Corn Mother. In myths and legends, Grandmother, as the patroness of vegetation and rejuvenation, taught people how to live well and resurrects the spirits of the dead. Later, her prominence extended across tribes thousands of miles apart and speaking very different languages.[3] After use, the statues were ritually broken near ceremonial buildings or burials linked to Monks Mound. This suggests that female deities were central in Cahokian mythology or ritual.

Additional archaeological evidence shows Cahokia might have been a matrilineal society where ritual feasting and unique crafts reaffirmed the importance of women's roles. Evidence of locally produced pots in the surrounding region suggests Cahokians invited neighboring groups to participate in rituals and gifted them plants, goods, and knowledge of crop production.[4] Through offerings, prayers, and performances, which might have included the female sacrifices and mound-building of Mound 72, Cahokian women spread their culture and maintained the status quo. The burials of Mound 72; flint-clay figurines; and evidence of ritual feasting, public performances, and agricultural dissemination through women reveal a society that valued females. Even the sacrifice of teenage girls shows females were central to Cahokia's success.

The girls could also be key to understanding Cahokia's downfall. Within 300 years of its establishment, Cahokia was abandoned. Scholars have proposed several reasons: resource depletion, overpopulation, and climate change. As Cahokian society struggled to survive, archaeological evidence of fortifications suggests that warfare was prevalent. As a result, Cahokians moved on. They stopped building mounds and sacrificing humans and left the city. They spread across the Mississippi River floodplain, though which tribes they became is unclear. Evidence suggests the Osage, Omaha, Quapaw, Ponca, and Kansa were once a unified tribe in the Mississippi-Ohio confluence area, perhaps as Cahokians, and then split to their later territories.[5] Unfortunately, no known narratives or oral histories explicitly link tribes to Cahokia. This leads some archaeologists to wonder whether life at Cahokia, and its subsequent decline, resulted in its people wishing to forget their heritage entirely. Did Cahokia's rulers push their power into the realm of oppression? "Maybe, by the twelfth century, people were seeking to escape Cahokia, and their desire to forget it—and create a more perfect, communal post-Cahokian society—

were all a part of starting over."[6] Whatever the reasons for its abandonment, evidence from archaeology, Native American cosmology, later Mississippian iconography, and oral histories suggest Cahokians became many of the Midwestern, Southern, and Plains tribes present at the time of European contact. They left Cahokia without the central role of sacrifice played by teenage girls, but with the Grandmother/Corn Mother, mound-building, and other elements that became vital to Mississippian ways of life.

Though long forgotten, the girls of Mound 72 are helping archaeologists understand the founding events of Mississippian culture and the role of females as agricultural producers, knowledge disseminators, and religious participants. The archaeological finds at Cahokia and oral histories from possible descendant tribes hint that what happened at Cahokia—including the sacrifice of teenage girls—was integral to coalescing and then dispersing Native peoples across the American South, Midwest, and Plains. Since girls were the primary Cahokian ambassadors and disseminators, they held high cultural status in life—and the burials of Mound 72 suggest this status continued in death. Through their actions and sacrifice, Cahokian girls shaped the Native cultures encountered by Europeans.

"The Display with Which a Queen-Elect Is Brought to the King," 1564

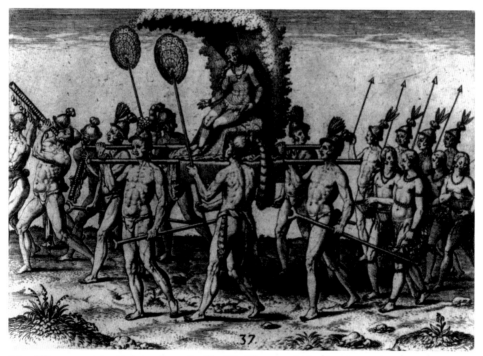

4.1. "The queen-elect is brought to the king" by Theodor de Bry (1528–1598), after a watercolor by Jacques Le Moyne de Morgues, published in 1591.

In 1564, the Queen-Elect was carried by her tribesmen on a decorated sedan chair, accompanied by musicians and handmaidens, to wed a king. It was a scene familiar in Europe, yet took place thousands of miles away. The Queen-Elect was a Timucua of what is now Florida. Sketched by Jacques Le Moyne de Morgues and published in Theodore de Bry's *Grand Voyages* (1591), she introduced Europeans to America. But did this engraving foster positive relations or contribute to the destruction of entire cultures?

Le Moyne was an artist hired by Huguenot[1] explorer Rene Goulaine de Laudonnière to document Florida's native flora and fauna with his expeditions based out of Fort Caroline. His drawings became "the earliest known European depictions of Native Americans in what is now known as the United States."[2] Yet the Huguenots were not the first Europeans to meet the Timucua. A decade earlier, Spanish explorer Hernando de Soto explored the region, seizing food and supplies while enslaving the Native people. Thus, the established Fort Caroline was disputed territory claimed by the Timucua, Spanish, and French. When the Huguenot explorers arrived in May 1562, the Timucua were both welcoming and cautious.[3] Two years later, Laudonnière arrived with 300 people, settling along the St. Johns River. Relations improved, and the colonists made alliances with various Timucua tribes.

From 1562 to 1564, Le Moyne documented Timucua culture. Two of his drawings depict Timucua girls. In Plate XXXVII, "The Display with Which a Queen-Elect is Brought to the King" (Figure 4.1), Le Moyne describes a wedding ceremony:

> When the king wishes to get married, he orders the most beautiful and the tallest girl from among the most noble families to be chosen. Then a seat is fixed on two stout poles and covered with the skin of some rare animals. Behind the seat a structure of branches is made so as to shade the head of the sitter. The queen-elect is put on this chair and four strong men take up the poles and carry them on their shoulders. They each carry a wooden fork on which to put the poles when they halt. On each side of the queen walk two men waving elegant fans, attached to long handles, to protect her from the ardors of the sun. Other men go before, blowing trumpets made of tree bark. [. . .] Then follow the most beautiful of the young girls, all decked out with necklaces and bracelets of pearls. Each carries a basket full of the choicest fruit. For the sake of decency they hang moss from their navel to their thighs. After them come the bodyguards.[4]

Another drawing by Le Moyne, Plate XXXVIII, describes the reception held in honor of the Queen-Elect, at which the king stated his reasons for marrying her and her handmaidens formed a circle and began to dance and sing.[5]

Jean Ribault also wrote accounts about Timucua customs, describing their women as "well favored and modest," preferring to leave relations between the tribe and the Huguenots to men. Laudonnière wrote that women "were as agile as the men . . . and strong swimmers, capable of crossing a large river while holding an infant out of the water with one hand, and equally adept at climbing the highest trees."[6] Their skin was tawny and they wore long, well-combed hair and shell adornments around their throats, arms, and ankles. Unfortunately, Huguenot sources focused more on women's bodies than their activities. Later, Spanish explorers noted the Timucua were matrilineal and a chief's heirs were typically the children of his eldest sister.[7]

In 1565, the Spanish founded St. Augustine and attacked Fort Caroline, taking control of it and, subsequently, Florida. Le Moyne and a few others were rescued and returned safely to Europe.[8] Most of his drawings were gone, so Le Moyne sketched his experiences from memory. After his death in 1588, his sketches were obtained by Theodor de Bry, a Flemish publisher. Theodore de Bry compiled the book *Americae* (1590), describing Native Americans as "not to be feared" and "a people poore, and for want of skill and judgment" that would "have the greater respect for pleasing and obeying."[9] These depictions do not match later descriptions of the Timucua, and many believe de Bry altered the images prior to publication. Since only one of Le Moyne's drawings has survived, and many were based on memory, they are highly questionable. The images published by de Bry are more important for understanding European attitudes toward America rather than the reality of Native societies.

Such portrayals had profound effects on relations between Europeans and Native Americans, especially for women and girls. Accounts by explorers, colonists, and modern scholars suggest the Timucua were matrilineal and had female chiefs who wielded the same power as male chiefs, presiding over councils of women.[10] Women also served as the tribes' agriculturalists, in charge of planting and tending crops. Europeans documented that, as soon as a girl could understand and remember what was being said, she would be taught about her role in society and "the customs, etiquette, social obligations, and folklore of her tribe."[11] To European eyes, this indicated Native women

were inferior because the men enjoyed more leisurely pursuits of hunting, fishing, feasting, and fighting while women worked the fields. This viewpoint led to the stereotype of "lazy" Native American men, with Europeans projecting their own opinions on the roles of hunting and fishing in Native culture. European accounts ignored the partnership required between men and women to survive and the value placed on the contributions of women.

After the Spanish took control of Florida, the Timucua were enslaved. The population fell from nearly 200,000 to less than 2,500 in the following century. The Timucua rebelled in 1656, but were defeated and forced to relocate to southern Florida. By 1706, the Timucua disappeared entirely. Prior to 1492, Native Americans like the Timucua had societies that developed unhindered for centuries. When Europeans arrived in the 16th century, a massive population decline among Native Americans began, with disease and death ravaging and recreating America.[12] The Timucua Queen-Elect and her people were among the first casualties on mainland America, their voices silenced by death or assimilation within 150 years of initial contact with Europeans. The reality of the Queen-Elect will never be known.

5

Virginia Dare Monument, Roanoke Colony, North Carolina, 1587

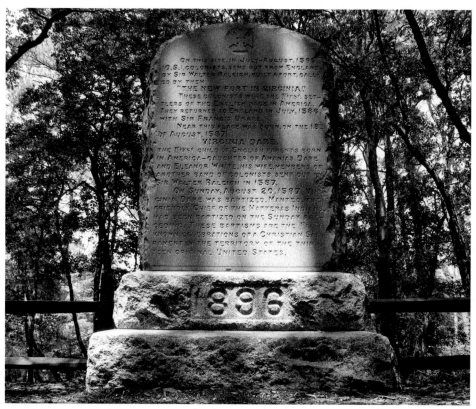

5.1. Virginia Dare Monument in Roanoke, North Carolina.
NATIONAL PARK SERVICE

In 1896, a monument to the Lost Colony of Roanoke was erected, commemorating European settlement—and girls—in the Americas. It hints at the iconic story of Virginia Dare, the first English child born in America, and her fellow colonists. We know little about the colonists and even less about Virginia. Her story began not with her parents' inclinations for a better life, but her grandfather's determination—despite his inexperience—to make his employer proud.

In 1585, Virginia's grandfather, John White, documented the flora and fauna of the Virginia coast. The expedition ended in disaster: the explorers angered local tribes by demanding supplies and murdering Chief Wingina of the Secotan tribe. The following year, White's party returned to England, leaving 15 men to guard a fort established on Roanoke Island. Using White's drawings (published in Theodor de Bry's *Americae*), Sir Walter Raleigh sought to establish a permanent colony in Virginia. John White was selected as leader, and he recruited 150 men, 14 families, and 17 single women for the new colony. The recruits included White's daughter, Eleanor, and her husband, Ananias Dare. Eleanor was one of two women who were pregnant when the colonists set sail in April 1587. The women's daily tasks of baking, brewing, churning butter, tending animals, manufacturing household goods, and collecting seeds and herbs were well suited to the needs of a new colony, providing domestic labor while the men focused on establishing the colony.[1]

Their voyage was difficult. White frequently disagreed with Captain Fernandez of their ship, the *Lion*, and many became sick from eating poisonous berries during a stop in the Bahamas. Arriving at Roanoke Island on July 22, the colonists encountered another shock—the 15 men left behind had been slain and all but a few houses were destroyed. Captain Fernandez ordered the colonists to Roanoke Island and anchored two miles offshore, threatening to leave rather than delivering them to their destination of Chesapeake Bay. On July 28, colonist George Howe was killed by the Secotan while hunting for crabs. In response, White launched a counterattack, but mistakenly attacked the friendly Croatoans. Though White attempted to make amends, relations with their only friendly neighbors were strained.

On August 18th, White wrote that Eleanor gave birth to a daughter, who was christened "Virginia" the following Sunday because she was the first Christian born in the colony (which at the time was part of Virginia).[2] Over the next week, the events leading to Virginia's disappearance unfolded. On

August 21, a storm devastated the colony. White paddled out to the *Lion* and begged Captain Fernandez to help get word to supply ships headed for Chesapeake Bay. Strangely, Fernandez agreed to take a messenger back to England, not Chesapeake. The colonists chose White. In White's writings, he makes no mention of distress at leaving his family or whom he put in charge of the colony. He did instruct the colonists to move 50 miles in-land, stating that, if they left Roanoke of their own will, to write only their destination on a tree, but if they left in distress, to carve a cross over their destination.[3] White reached England in November 1587, hoping for a quick return.

Unfortunately, England was at war with Spain and Queen Elizabeth I required all ships for its defense. White and Raleigh's attempts to secure supply ships for the colony were delayed until March 1590—a full two and a half years after White left. Further delayed when the captain spent four months privateering in the Caribbean, White returned to Roanoke on August 18, 1590, which would have been Virginia Dare's third birthday. The colonists were gone, and the colony appeared to have been abandoned for some time. Upon a tree, he found the letters "CRO," which looked hastily carved and half finished. He also noted that, in one of the fort's posts, the bark had been removed and the word "CROATOAN" was carved, without any cross.[4] Summer storms hindered their search and forced the ship's return to England. White never returned to the Americas.

Raleigh sent several expeditions in search of the colonists. Three failed and two landed in Chesapeake Bay, only to be attacked by local tribes. The sixth, led by Samuel Mace, returned to London in 1603 with urgent news, but Raleigh and his comrades were now in hiding or convicted of treason in the political turmoil following Queen Elizabeth's death. Mace's news was never recorded. Further attempts to locate the Roanoke colonists were made by the Jamestown colonists. In April 1607, Captain Christopher Newport was informed of a friendly tribe in the Chesapeake Bay, but arrived to find only cleared farmland and hostile Natives.[5] A month later, George Percy saw a 10-year-old blonde, light-skinned Native boy.[6] Additionally, John Smith was informed by Chief Powhatan that prophecies about a nation destined to destroy Powhatan's empire led to a massacre just days before the Jamestown colonists arrived. Powhatan's loot included a musket barrel, a bronze mortar, and pieces of iron that were English in origin.[7]

By the time Virginia Dare would have been 25 years old, the English stopped searching for her. And while Virginia's story as the "first born" is a popular American narrative, it overshadows other narratives of settlement. Nearly 600 years prior, the first European child born in America was Snorri Thorfinnsson of the Vinland colony, established by Vikings along Canada's eastern seaboard. And in 1567, the first Spanish child, Martin de Arguelles, was born in St. Augustine, Florida. Virginia's story also surpasses that of her own 24-year-old mother and other early female colonists. Further still, Virginia's popularity marginalizes the tens of thousands of Native girls who lived in America before her.

The conflicting evidence and theories about the Lost Colony take center stage in history books. With minimal facts, Virginia's legend has assumed a reverent place, commemorated and reenacted, rather than placed into the context of European settlement. Recent theories claim the colonists dismantled the fort, resettled farther north, and were killed or captured by the Powhatan. Virginia and her fellow colonists likely followed White's instructions to move farther inland, away from hostile tribes and closer to Chesapeake Bay. How far north they went, whether they survived and assimilated or their deaths came mere days before the arrival of the Jamestown settlers, remains a mystery. Thus, like the colony itself, Virginia Dare and the lives of the first colonial girls remain as mythical as they are historical.

Part II

HER AND ME— OTHERNESS IN THE NEW WORLD, 1600 CE TO 1770 CE

The "New World," as it was called, quickly became seen as a place of opportunity. For Europeans, exploration turned to settlement, with girls participating throughout this process. Yet most textbooks recite girls' stories with more emphasis on legend than fact. They leave out their everyday lives: going to school, settling the frontier, and overcoming barriers to participation in society. These textbooks also leave out the tragedies of settlement, including its effects on Native and African girls. In this section, we focus on the meaning behind five girls' experiences in colonial America, which center on girls attempting to find their place in society. They also reveal the distinct experiences of Native Americans, European settlers, and Africans brought to America as slaves.

"Her and Me" begins with Matoaka—popularly known as Pocahontas—whose legend centers on a lovestruck teenager, rather than her true power as a Beloved Woman integral to Jamestown's success. Over the next 100 years, the colonies became thriving settlements that remained in fear of the unknown. These fears coalesced in Salem, Massachusetts, where two girls turned a psychosomatic disorder into a quest for personal freedom. Further artifacts show girls' asserting their individualism through art, hardship, and literary achievement. The embroidery sampler of Mary Wright reveals adherence to societal norms while providing a means of self-expression. Around the same time, Mary Jemison's experiences as a settler and captive on the Pennsylvania

frontier reveal the hardships—and hard choices—that girls faced. Finally, Phillis Wheatley's poetry provides a rare direct view of Black girl culture, slavery, and abolitionism. Together, these girls demonstrate the contrasting—yet similar—lives that developed in America before the Revolutionary War and beg consideration of how 13 separate colonies evolved into one nation.

Pocahontas Statue, Jamestown, Virginia, 1607

6.1. Pocahontas Statue in Jamestown, Virginia.
CATHERINE (_CCK_) ON FLICKR, MARCH 11, 2009

Arms outstretched, Pocahontas's statue appears as a welcoming adult woman in Native-esque dress, moccasins, and beaded necklace. Yet the only accuracy is a feather in her hair symbolizing her role among the Powhatan, an alliance of tribes in Virginia and Maryland. When Pocahontas—originally named Matoaka—entered history, she was an 11-year-old and training as a Beloved Woman, a priestess who read natural signs (wind, tides, storms, plants, and animals) as the will of the gods. Her actions would change her people's future.

Around 1595, Matoaka was born in a Powhatan tribe overseen by Chief Wahunsenaca, called Chief Powhatan by the English. Their society was matrilineal and matrilocal, emphasizing spiritual power and prophecy as key to survival. Powhatan prophecies predicted two groups of foreigners would attempt to overthrow them before a third group succeeded. The Powhatan thwarted a 1570 Spanish Jesuit mission and the Roanoke Colony of 1585. They awaited the third invasion.

Matoaka's parentage is uncertain. Raised by her mother's clan, Matoaka was chosen to become a Beloved Woman at age 6 or 7. When Matoaka was 13, Captain John Smith was captured and brought before Wahunsenaca for judgment, facing execution or adoption into the tribe through a ceremony called *Nikomis*. The Powhatan gathered for the ceremony, including Beloved Women like Matoaka, who wore swans down feathers, deerskins, and wampum shells to signify their position. After Smith's fate was debated by the elders, Wahunsenaca commanded Smith's head be laid upon a flat stone. Standing above Smith were two priests, one with a clamshell club. Smith thought he was to be executed, but a cry arose from Matoaka as she ran forward and positioned herself over him. Within moments, the Powhatan wailed and danced. The interpretation of this moment could not have been more different between Smith, who thought he was spared by a besotted young girl, and the Powhatan, who had adopted Smith and Jamestown into their alliance.

Because Matoaka assumed responsibility for Jamestown, she frequently visited to encourage trade and ensure the colonists were well. Yet clashes were common, especially when Smith refused to trade weapons for food. After one skirmish, Matoaka negotiated a prisoner exchange, during which Smith "made it clear that the prisoners would be spared and released only as a gesture to her."[1] In 1609, Smith was injured by a gunpowder explosion and sent to England for treatment, never to return.

Matoaka ceased visiting Jamestown. The settlers assumed she was heartbroken; in reality, she had reached puberty. Matoaka underwent the *huskanasquaw* ritual to be recognized as an adult, her clothing and behavior changed, and she married Kocoum. In her absence, relations escalated into a tense standoff and contributed to the "Starving Time," a winter during which all but 60 colonists died. The next year, Samuel Argall arrived with supplies and revived Jamestown. By 1613, Argall believed Matoaka was Wahunsenaca's daughter and thought Wahunsenaca would pay any price if she were kidnapped.[2] He lured Matoaka into captivity, but the Powhatan refused to meet Argall's demands.

While in captivity, Matoaka lived with Reverend Alexander Whitaker, a religious leader who promoted tolerance. She met daily with Argall, Whitaker, and John Rolfe (the colony's secretary) and was instructed in English language, customs, and culture. She was also baptized and renamed "Rebecca." Her willingness to convert is debated: as a prisoner she had no choice, but as a Beloved Woman, she likely became Christian to see if it was beneficial for her people.[3] The English claimed Matoaka fell in love with John Rolfe, yet Mattaponi[4] history says Matoaka told her sister, Mattachanna, she had been raped and was pregnant.[5] This is likely, as within a year, 18-year-old Matoaka was kidnapped, converted to Christianity, married, and bore a son named Thomas. Matoaka's family visited often and shared methods of tobacco cultivation with Rolfe, leading to peace and the first successful tobacco exports for Jamestown.

On June 2, 1616, Matoaka, Rolfe, Thomas, and a Powhatan retinue sailed for England. The Virginia Company intended to market Matoaka as the first successful convert to Christianity while Rolfe hoped to increase demand for tobacco. In England, she was entertained by nobles who "said that she was altogether worthy of the time and money the Virginia Company . . . had lavished upon her."[6] She was seated next to the queen at the midwinter gala, while Rolfe was shunned for marrying above his station because Matoaka was considered a princess. The trip was a success, but Matoaka felt the strain. This led to what the English described as a repeated illness. Matoaka was sent to a country estate and recovered within a few weeks, so Rolfe arranged for their return to Virginia.

As they set sail, Matoaka died. English accounts claim it was an extension of her illness, while Mattaponi history states that after dining with

Rolfe and Argall, Matoaka became violently ill and told Mattachanna that she suspected poison.[7] Her burial was quick, and Rolfe left Thomas with his English relatives. The ship stopped in Bermuda and sold the Powhatan, except Mattachanna and her husband, into slavery. The period of peace brought by Matoaka's marriage dissolved into war by 1622.

As told by Europeans, this story neglects Matoaka's role in Jamestown's prosperity. Historians have perpetuated the idea of Matoaka as a helpmate, peripheral to the actions of men. From her appearance as a Beloved Woman during the *Nikomis* ceremony to her death, she is misinterpreted as a besotted young girl who used Wahunsenaca's affection to spare Smith's life. In his memoirs, Smith revealed his assumptions and contributed to lasting misunderstandings about the role of Native American females. Smith likely wrote about Matoaka to help bolster his standing as an explorer and conqueror.[8] By making her a lovesick convert, Smith's memoir asserted England's divine right to conquer. The characters became mythic symbols: Smith as rugged individualist who tamed the wilderness, Rolfe as industrious colonist who converted America, and Matoaka as beautiful Native who embraced and supported them. Additionally, his memoirs were published after 1622, when war broke out between the English and Powhatan, making it likely that Smith had reframed reality in order to appease current sentiment against the Powhatan and nostalgia for the peace that existed when Matoaka was alive.

This narrative ignores Matoaka's perspective. Chosen as a Beloved Woman, Matoaka selected Smith for adoption rather than execution.[9] She served as diplomat, ensuring Jamestown understood and practiced Powhatan ways. She acted as Argall, Whitaker, and Rolfe later acted for her: assimilator and teacher of a new way of life. Unfortunately, the colonists did not understand this and saw Matoaka as a child bearing gifts. This perpetuates the idea of European conquest as the natural order and colonization as the result of hardworking settlers, rather than cooperation and negotiation. It downgrades Matoaka to enamored girl, rather than spiritually powerful ally who ensured Jamestown's success. Much like her statue, what is told about Matoaka is what Europeans wanted seen: the welcoming woman who fell in love. Matoaka's truth remains silent.

Samuel Parris Archaeological Site, Danvers, Massachusetts, 1692

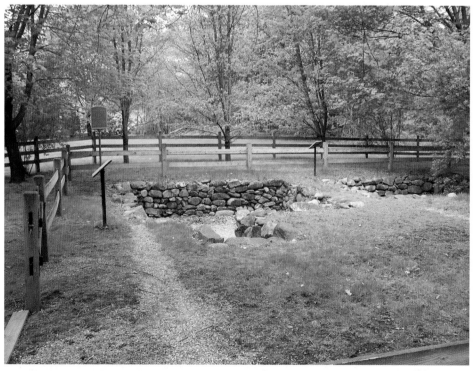

7.1. Current excavation status of the former rectory in Danvers, Massachusetts, May 2006.
MATTHIAS SCHÖNHOFER VIA WIKIMEDIA COMMONS

Founded in 1636, Salem Village in Massachusetts was a prosperous Puritan village near a thriving port. Yet it had its share of political factions, frequent civil disputes, and ongoing warfare with Native Americans. By 1692, the atmosphere was ripe for a power grab by one of the factions. During what became known as the Salem Witchcraft Trials, two girls took power and demonstrated how "witch persecutions had more to do with the accusers than with the accused."[1]

The historic marker for Reverend Samuel Parris's home barely hints at the chaos his 9-year-old daughter, Betty Parris, and 11-year-old niece, Abigail Williams, wrought on their village. In 1692, the two-story timber-frame house of four rooms—a hall and parlor downstairs, a bedroom and study upstairs—was a crowded and dark home for a family of six and two slaves.[2] Having failed to resolve Salem's factionalism, Reverend Parris's salary and firewood were withheld by the town, creating a cold and agitated house. Parris's sermons reflected this, claiming an evil menace had infected his opponents. Home was unbearable for Betty and Abigail.

On January 15, the girls experienced prickling sensations. Within days, their symptoms included bites and pinches by invisible agents, fits of barking and yelping, body spasms, uncontrollable spinning, and paralysis. Suspecting witchcraft, their neighbor, Mary Sibley, instructed the family's slaves—Tituba and John—to make a witch cake (a loaf of rye bread mixed with the girls' urine) and feed it to the family dog. "When the dog ate the witch cake, it was supposed to reveal the witch's identity. Indeed, the afflicted girls soon cried out that it was Tituba who was tormenting them."[3] That same night, their neighbors—12-year-old Ann Putnam Jr. and 17-year-old Elizabeth Hubbard—became afflicted.

As their symptoms worsened, local ministers concluded the girls were being attacked by Satan. Ann Jr. claimed she was pinched by the specter of Sarah Good, a poor woman known for her sharp tongue. Elizabeth claimed she was stalked by a wolf and the specter of Sarah Osburn, a widow who scandalously married her indentured servant. "To have a Native American slave, a distracted pauper, and a scandalous woman all charged with witchcraft meant they had rounded up the 'usual suspects.'"[4] On March 1, the crowded meetinghouse heard the girls confirm Sarah Good as their tormentor. She denied the charges, and the girls fell into fits on the floor, claiming Good's specter lunged at them. The scene repeated until Tituba took the stage, acknowledg-

ing Satan was at work and four adults had told her to hurt the children.[5] She accused Good and Osburn while revealing that Salem had nine witches. The witch hunt began.

Arrests and examinations continued as more girls became afflicted. Yet there were signs something else was amiss. Ann Jr. became the central accuser, especially when other afflicted girls could not remember or were struck dumb when questioned in court. In March, 20-year-old Mary Warren recovered when her master threatened to beat her; she later claimed the girls were faking fits. Yet the girls became celebrities, helping discern whether witchcraft ailed a child or caused cattle to freeze to death. A court was established on May 25, led by Salem's elite, who had no legal training and relied on spectral evidence.[6] On June 10, Bridget Bishop was the first convicted witch to be executed. A brief lull in afflictions seemingly proved that the executions were effective, and so the trials continued.

Despite concerns about dubious evidence and the trials' hurried pace, verdicts were doled out all summer. The witch hunt spread to other towns, creating a near economic standstill. Essential work like farming was neglected, and many were near ruin trying to support jailed relatives. In October, the governor dissolved the court. A month later, a Superior Court was created to try the remaining cases, and use of spectral evidence was banned. Though trials continued into May 1693, convictions ceased. Within nine months, 150 people had been accused, 19 executed, and Salem's economy ruined.

Most historians have not focused their study on the first girls to be afflicted. Abigail and Betty lived in an environment of fear. Puritans believed in predestination, that people were born sinners and God decided who to save before birth. Many girls agonized over predestination. In 1696, Samuel Sewall found his 15-year-old daughter sobbing over a line from the Gospel of John and writings from Cotton Mather that made her believe she would go to hell.[7] Compounding their religious fears was frequent warfare, which made New England a land of destroyed settlements, orphans, and leaders casting blame toward everyone but themselves. In Salem, more than 40 participants in the trials were refugees. The Puritans saw war as God's punishment for their sins.

Given these conditions, Abigail and Betty likely had conversion disorder, in which anxieties manifest as uncontrollable physical afflictions like those recorded. Yet the timing of their fits in court suggests they were conscious of their actions. Were the girls using conversion disorder to spark rebellion?

Puritan females were assigned strict gender roles, performing the same work from childhood into late adulthood. This required strict ideals of modesty, tireless housework, religious piety, and the absolute authority of men. There was no place in Puritan society for a different life. Rather than take responsibility for their desires, Abigail and Betty found attention by accusing "witches." With Reverend Parris constantly agitated, they surely faced discord at home. Was he taking out his anger in other ways? Did he—as had another husband who blamed witchcraft—cause the "black and blue marks" on his wife or daughters?[8]

Today, most historians acknowledge that some fakery took place. In 1720, a nearly identical case nearby involved an 11-year-old girl, her younger sister, a pact of secrecy, and a ladder to aid in the illusion of flight; the girls were declared a fraud.[9] Yet the biggest hint at fakery was given by Ann Jr., who at age 19 told Salem Village church that "'it was a great delusion of Satan that deceived me in that sad time' and made her instrumental, 'though ignorantly and unwittingly,' in the shedding of innocent blood."[10]

Salem is a case study of Puritan girlhood, where girls' lives were anything but stable. They were constantly fearful and struggling to find their place. This left them feeling like "others"—distinct for wanting control of their lives, yet damned for it. Yet Abigail's and Betty's actions helped shape America. Locally, they damaged and forever changed families, social structures, and economies. Regionally, witchcraft persecutions ceased and the Trials later became a metaphor for female persecution. Despite 300 years of analysis, we still do not fully understand those nine months in Salem Village, nor the girls who started it.

Mary Wright's Sampler, ca. 1754

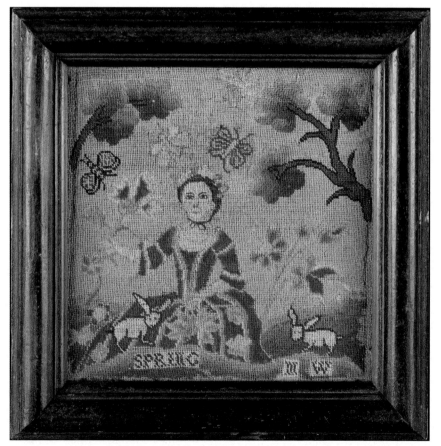

8.1. "Embroidered Picture" by Mary Wright (1740–1829), possibly Sarah Osborne's School, ca. 1754. Newport, Rhode Island.

Since the Medieval period, samplers were used as a reference tool to practice and remember stitches. By the 18th century, samplers were a distinctly female art form. Using homespun linen, girls embroidered patterns of figures and floral motifs in colored silks or cotton. In 1754, Mary Wright embroidered this sampler (Figure 8.1) while attending boarding school in Newport, Rhode Island. At first glance, it seems to be a simple embroidery of a spring day, including a girl, bunnies, and butterflies. However, samplers are much more complex and layered than they appear. This one holds clues to the growth of the American colonies, the value of women's work in the emerging middle class, and female self-expression.

Mary was born in Middletown, Connecticut, in 1740. The only child of a farmer and brickyard owner, she received an education typical of a rising middle-class girl.[1] Mary began to sew alongside her mother, practicing needlework and knitting integral to keeping a home. Girls needed to be able to sew clothing and household linens, as well as maintain them. She also attended a local school for reading and arithmetic. Girls' education was different from boys', with all of the learning geared toward marriage, children, and domestic duties. During this time, Mary completed a marking sampler, demonstrating her knowledge of basic embroidery, alphabet, and numbers. Once she completed local school, Mary's parents elected to send her to boarding school.

Boarding schools were typically run by single women who offered instruction in drawing, dancing, embroidery, manners, comportment, and French. Sarah Osborn's school in Newport, Rhode Island, was renowned for its emphasis on teaching Christian ethics to young ladies, which Mary's parents found preferable.[2] Mary completed this sampler featuring a shepherdess and the four seasons motifs popular at the time. It was a mark of her accomplishments and readiness to run a household, as well as her adherence to middle-class values.

During the 18th century, the colonies' population boomed, from 629,000 in 1700 to nearly 5,000,000 in 1800.[3] Growth was centered in major eastern seaports like Newport, where an emerging middle class was prosperous and ambitious to acquire fine houses and art. Among their ambitions was the desire for better educated children. For girls, this meant going beyond the basics of literacy and arithmetic to learn music, dancing, painting, needlework, reli-

gion, literature, grammar, and geography, all to attract a wealthy husband or become self-supporting. Many samplers showed this learning in text, typically biblical quotes, Christian sayings, genealogies, or maps.

Samplers also demonstrated a girl's mastery of skills integral to household management and personal adornment for middle-class families. These skills were valuable to the middle class. "When completed, the sampler would be hung on the wall by proud parents as a record of achievement. It was a sign of belonging in the sturdy, upper-middle class world."[4] Such displays also garnered respect and served as advertisements to possible suitors of a girl's abilities and piety. Mary went to Osborn's school with the hopes of becoming a desirable wife for a middle-class merchant.

In Mary's sampler, she demonstrated her literacy, knowledge of literature and music, in stitching Vivaldi's "Four Seasons" and quotes from Virgil, and self-identification with colonial life. It may also have signaled her availability for marriage. These skills were vital to a middle-class wife, who performed domestic duties, provided early education to her children, and might manage her husband's affairs in his absence. Mary's sampler signaled she was preparing for these responsibilities, and provided her parents with artwork promoting her beauty and accomplishments to suitors.

While samplers were a tool for education, they could also be distinctly personal forms of self-expression. "Few other objects tell us as much about their makers. We can imagine the hours and months that must have been spent in quiet dedication perfecting the techniques required."[5] Though categorized as craft, 18th-century samplers are a uniquely female art form. Mary's sampler showcases her self-identification with the norms of her time, but also her personal preferences. In depicting butterflies and rabbits, choosing the colors of thread, and placing herself within the picture, she provided insight into her personal tastes and how she might prefer to decorate her home. Looking at the collection of her later embroidered works held by the Winterthur Museum, including chair covers, pocketbooks, and pictures, as well as a "roundabout chair" held by Yale University Art Gallery, her preference for bright, springtime colors is evident.[6]

Mary created needlework for over 60 years of her life. Many of her pieces survive as sentimental objects passed down through her family and now held in museums. Mary's embroidered works were prized possessions, first by her

parents and herself, and later as a way for her descendants to remember her. In the absence of written records, samplers and later embroidery by girls are evidence that they lived, learned, and loved.

9

Mary Jemison Statue, Letchworth State Park, New York, 1758

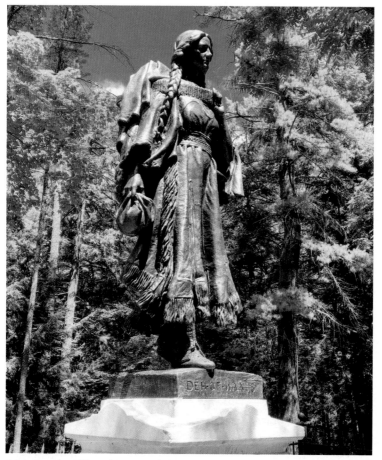

9.1. Statue of Mary Jemison in Letchworth State Park, at her grave site, 2018.
TIFFANY ISSELHARDT

In 1824, Mary Jemison's biography was published. The book made her fa-
mous, and in 1910, a statue was erected to mark her grave in Letchworth
State Park, New York. Though identifying as part of the Seneca tribe, Mary
was an Irish settler kidnapped by a raiding party at age 15. Repeatedly offered
her freedom, Mary chose to remain with the Seneca. Her story illustrates
the complex reality of Native captivity and social changes in 18th-century
America.

In 1743, Mary was born aboard the ship on which her parents were emi-
grating from Ireland. The family settled near Marsh Creek, Pennsylvania, a
frontier territory in the midst of the French and Indian War. Young Mary
played with her siblings and learned domestic duties in preparation for being
a wife and mother. On April 5, 1758, war arrived. As her father sharpened his
axe, mother prepared breakfast, and older brothers worked in the barn, they
heard gunshots. A Shawnee and French raiding party attacked, capturing ev-
eryone but Mary's eldest brothers. The captives were led through the woods,
soon joined by another raiding party and their captives. On the second day
of marching, the Shawnee replaced Mary's shoes and stockings with moc-
casins. Joined by a little boy, Mary was taken from her family and spent the
night under a small guard, separate from the rest of the party. The boy begged
her to run, but Mary chose to stay, rather than face the wilderness. The next
morning, the other Shawnees joined them—but the captives, including Mary's
family, were gone. Later, Mary witnessed the Shawnee scrape and dry scalps
over the fire. She recognized one as her mother's red hair and knew her family
was dead.[1]

They continued for another six days, hiding their tracks and sheltering
from a snowstorm. Arriving at Fort Duquesne, Mary was sold to two Seneca
women, who took her to She-nan-jee along the Ohio River. There, Mary was
cleaned, dressed in new clothes, and seated in the center of a wigwam. "I had
been in that situation but a few minutes, before all the Squaws in the town
came in to see me. I was soon surrounded by them, and they immediately set
up a most dismal howling, crying bitterly, and wringing their hands."[2] The
mourning turned to rejoicing as part of a ceremony to honor a dead brother
and welcome Mary in his place. She was named Dickewamis ("pretty girl")
and became a Seneca.[3]

Mary was treated as a sister. Her duties included looking after children,
light housework, and helping carry game. She was not allowed to speak Eng-

lish, especially to white captives. Mary described her Seneca sisters as "kind good natured women" who were "very tender and gentle towards me."[4] At age 17, she married Sheninjee, a Delaware who won her heart through his kindness, generosity, and friendship. They had two children, though neither survived to adulthood. To escape the ongoing French and Indian War, they decided to settle along the Genesee River in New York. During the journey, Sheninjee died. Mary was welcomed by her husband's family and spent a few years with them. During this time, the King of England offered bounties to those who rescued white captives. Despite numerous attempts, Mary evaded rescue and chose to remain with the Delaware. She later married a Seneca chief, Hiakatoo; they had six children. During the American Revolution, Hiakatoo served with the British, who offered the Seneca money and goods in exchange for military aid. In 1779, Mary's village was attacked by revolutionaries, and she escaped with her children to the Gardow flats of New York. Mary eventually bought over 17,000 acres, which she leased to white farmers. In 1817, Mary became a naturalized American citizen, which solidified her land claim. Her happy disposition and welcoming of white settlers led to her title "White Woman of the Genesee." She died September 19, 1833. Originally buried on her land, she was reburied at Letchworth State Park in 1874.

As one of the few white captives to tell her story directly to a biographer, Mary's life encapsulated many changes in America at the time—frontier life, captivity, and the emergence of the first American female literature. Between 1675 and 1763, over 1,600 New Englanders were kidnapped by Native Americans for ransom or to replace dead relatives. "Captivity was part of the customs that governed Indian warfare. Indians warred to gain control of people, not territory or plunder."[5] Children—especially young girls—brought cultural value, serving in customs like the Iroquois "mourning-war," where adoption of captives restored the community after war. Captured girls, like Mary, found their new lives different than before. Though still likely to be wives and mothers, Mary recounted that Native American women "had no master to oversee or drive us, so that we could work as leisurely as we pleased."[6]

Mary's captivity narrative was part of the first American literature dominated by women. "Although both men and women penned such narratives, those featuring female captives were the best sellers and achieved the greatest notoriety."[7] Her story offered an inside view of Seneca culture, challenging

male-dominated histories of the American frontier. She became a heroic figure: a small, weak girl transformed into a strong, accomplished woman, which spoke to colonial girls destined for monotonous domestic life. Additionally, it showcased a positive view of Native cultures, the changes contact with whites caused, and the reasons captives chose to stay with their adoptive families. "Throughout her story Jemison observes and compares Indian and white life. She tells Seaver [her biographer] that both liquor and the attempts to 'civilize and christianize' have hurt Indians."[8] Mary recounted how women's powers declined as a result of disease, warfare, and the ascendancy of the United States as a nation, and how she chose to stay because of her family, who would not have been accepted into white American society.

Other accounts of captured girls who stayed in Native American culture include Eunice Williams, Cynthia Ann Parker, and Frances Slocum. These stories are epics where females are at the center of American history. As captives, they witnessed the changes that the emerging United States brought to Native cultures. Their perspectives are invaluable to understanding life in early America.

10

Phillis Wheatley Statue, Boston, Massachusetts, 1760s

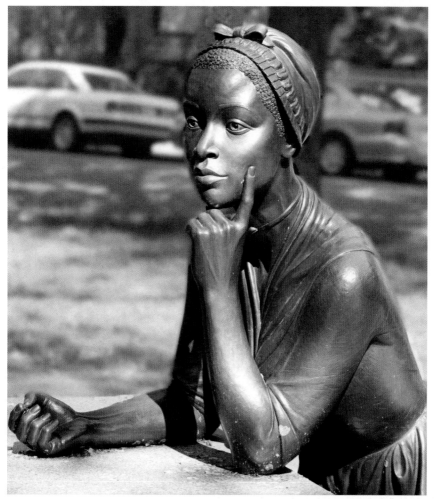

10.1. Statue of Phillis Wheatley at The Boston Women's Memorial, dedicated in 2003.
SHARON MOLLERUS VIA FLICKR

As a renowned pre–19th-century American poet, Phillis Wheatley's work led her to assume a public role for which Black girls had no precedent. Her poems provide a window into Black girls' culture and slavery and the emergence of abolitionism before and during the American Revolution. Her statue sits in Boston, Massachusetts, as a memorial to her achievements, which have been debated from her youth until today.

Phillis first appears in historical records as a captive aboard *The Phillis*, from which she derived her name. Taken from Senegal or Sierra Leone, Phillis was brought to the colonies as a slave. The ship's manifest describes her as "being 'of slender frame, and evidently suffering from a change of climate,' and as having 'no other covering than a quantity of dirty carpet about her.'"[1] Too weak for manual labor, Phillis was sold in 1761 to John and Susanna Wheatley of Boston to be Susanna's domestic servant and companion. Susanna soon realized Phillis was an ardent learner and tutored her alongside the Wheatley's children. Phillis learned English, Latin, history, geography, and the Bible. She was kept as a servant and forbidden to interact with the other slaves. Though scholars do not know why the Wheatleys educated Phillis, she soon displayed talent in writing poetry. These talents were encouraged and demonstrated to friends and family. Phillis also developed friendships with free Blacks, including Obour Tanner of Newport, to whom she often wrote letters evidencing her identification with Blacks.

At age 11, Phillis wrote her first poem about the deaths of a neighbor's children. Two years later, she published "On Messrs. Hussey and Coffin" in the Newport *Mercury*. However, "An Elegiac Poem, on the Death of the Celebrated Divine, and Eminent Servant of Jesus Christ, the Reverend and Learned George Whitefield" (1770) sparked national renown upon publication in Boston, Newport, and Philadelphia newspapers as well as recitation at Whitefield's funeral sermon. By age 17, Phillis completed 28 poems ready for publication, but American print houses refused to publish her book. The Wheatleys sent Phillis with their son to London where, in between tours of prominent landmarks and meeting famous figures, Phillis secured publication of her poems by Captain Hall. In 1773, *Poems on Various Subjects, Religious and Moral* was published on both sides of the Atlantic with a frontispiece of Phillis's portrait (Figure 10.1), making her the first Black person and one of the first women to publish a book in America.

Her fame eventually led to calls for her freedom, notably editorials in British publications, which the Wheatleys granted on March 3, 1774. Within the next four years, both John and Susanna died, leaving Phillis penniless because the Wheatleys likely claimed her royalties for themselves. She married John Peters, a free Black man. He held various jobs, but was later imprisoned for debts, leaving Phillis to work as a charwoman and scullery maid. She continued writing, but was rarely published. She died on December 5, 1784, "uncared for and alone," and her second volume of poetry disappeared.[2]

Phillis's works constitute the first direct source of information on Black girls in America. Scholars combine her poetry and letters with other evidence from childhood studies and social history to reveal these experiences. Phillis is the only well-documented Black girl during the Revolutionary Period, when about 10% of Boston's population was Black.[3] Her poetry and publications provide evidence that Blacks were noted by white chroniclers only when they surpassed racial stereotypes and proved adherence to white cultural standards of achievement.

These stereotypes remain in scrutiny of her poems, where scholars have posited that Phillis was unwilling to challenge slavery. Many claim she lacked race consciousness, making her a controversial figure in Black history. However, recent analysis suggests Phillis used subtle language to criticize slavery but remained race neutral in order to survive, continue to learn, and be published.[4] Using double meanings and metaphors, Phillis published direct statements on Blacks' experiences. Of her 46 poems, 18 are elegies expressing the theme of freedom through death, with death being a flight or voyage over water—a metaphor later prevalent in slave spirituals.[5] For example, in "Farewell to America," Wheatley describes a quest for relief that culminates in health arriving when she sights land, a metaphor for her arrival in England, where recent court cases had established slaves transported to England were free.[6] Through metaphor, Phillis focused on the theme of freedom and became "illustrative testimony that blacks could be both artistic and intellectual," providing abolitionists with proof to refute racism.[7]

Phillis's story is more than poetic achievement. She proves that Black girls managed to survive, both in life and the historical record. Their survival is extraordinary, given the dominance of slavery and racism. Though her profits were taken by the Wheatleys because they owned her, Phillis found fulfillment

through writing itself—forging relationships that subtly challenged her place in society. She was a Black girl persistently tugging on her chains, hinting that Black culture in the colonies was much more complex and freedom seeking than scholars assumed. In writing, Phillis secured her own freedom while advocating for the freedom of her people.

Part III
BECOMING "AMERICAN," 1770s TO 1840s

During the mid-18th century, a distinctly "American" identity evolved alongside calls for independence from Britain. This distinct identity stressed democratic partnership and participation and expanded colonial society to include all ages and sexes. Yet, after the American Revolution, society struggled to define race and gender roles as part of this new American identity and forced girls into marginalized positions.

Anna Green Winslow's diary is a primary source on girls' daily lives, demonstrating girls' agency in identifying with the new American character. Further still, the midnight ride of Sybil Ludington illustrates how girls' political participation was questioned, both during and after the American Revolution. Following the war, questions arose about who could be called American. Sacajawea is one Native American girl who experienced marginalization despite being integral to westward expansion. Her story is primarily known through white-produced narratives and conflicting oral histories. Other records left by whites, like bills of sale and runaway advertisements, reveal another marginalized group: enslaved Black girls. Supplemented by mid-19th century memoirs, enslaved girls' experiences reveal how some girls were forced to become American.

As the 19th century progressed, girls' roles were constricted and debated. New beliefs about health and leisure led to changes in fashion, such as pantalettes, which show the emphasis placed on keeping girls in the private,

domestic sphere. Yet girls' daily lives challenged this emphasis, especially for those who migrated to the West Coast, like Patty Reed of the Donner Party. Throughout, girls faced unique challenges that offered both more freedom and hardship than before. Their narratives provide conflicting experiences of agency and powerlessness as girls became—and struggled to define themselves as—Americans.

Anna Green Winslow's Diary, 1771

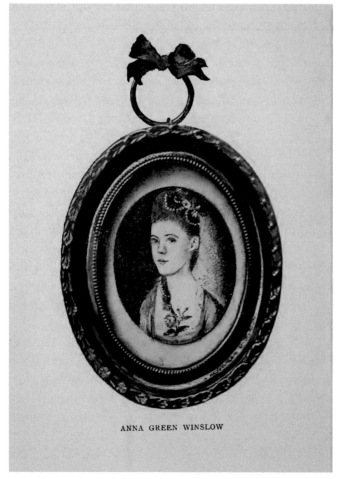

ANNA GREEN WINSLOW

11.1. Frontispiece of *Diary of Anna Green Winslow: A Boston School Girl of 1771*, edited by Alice Morse Earle, 1894.

On the eve of the American Revolution, Anna Green Winslow wrote letters to her mother nearly every day from November 18, 1771, to May 31, 1773. She copied the letters into a book to improve her penmanship, telling her mother about all aspects of upper-class life with her aunt, Sarah Deming, in Boston, Massachusetts. Despite the fact that her father was a British officer in Halifax, Nova Scotia, Anna's diary reflects a growing loyalty to the Americans. It also describes the ways in which she, a young girl, participated politically in the Revolution. Her diary is evidence that girls possessed—and expressed—agency in their lives, especially because the events leading up to the American Revolution forced every family to choose sides.

Anna's diary contains a wealth of information about girls and their lives in the late 18th century. She describes learning and performing household tasks, such as spinning flax, doing needlework, knitting, and making shirts. She also writes of social occasions like going to church and school, visiting with friends, dancing in Sudbury Street in the evenings, and attending public performances and exhibitions. Anna writes about her leisure pursuits, such as reading *Gulliver's Travels*, celebrating Thanksgiving with pies, and New Year's gift-giving. Throughout, Anna's concerns are similar to modern-day girls', evident in her wanting to fit in with her Boston friends and keep up a certain appearance. On November 30, 1771, she writes, "I hope aunt [won't] let me wear the black [hat] with the red Dominie—for the people will ask me what I have got to sell as I go along the street if I do, or, how the folk at New guinie do? Dear mamma, you [don't] know the [fashion] here—I beg to look like other folk." Repeatedly, Anna desires to be as fashionable as her friends.[1] She also remarks on the illness that would later claim her life, which often left her with bruised hands, boils on her hips and thighs, and sore eyes.

Yet Anna's diary illustrates more than a girl's daily life. As public sentiment was moving toward revolution, the Daughters of Liberty arose around 1766 as a way for women to identify with calls for independence from Britain. Their efforts included boycotting British goods, choosing instead to manufacture and wear their own cloth (known as "homespun"). Anna felt strongly about this, writing on February 21, 1772, "As I am (as we say) a daughter of liberty I [choose] to wear as much of our own manufactory as [possible]."[2] Though not noted in her diary, Anna may have attended spinning and weaving gatherings held by the Daughters of Liberty, often attended by young unmarried girls. Her personal beliefs likely also stemmed from her associations in Boston, one

of whom was her writing teacher, Samuel Holbrook, known for his affiliation with the Sons of Liberty. Like many Boston residents, Anna also recorded her observations of the Continental Army. In February 1772, Anna noted the encampment of the 29th Regiment just before the Boston Massacre, and she would infrequently watch the Regiment practice during visits to the common.

While Anna was witness to the beginnings of the Revolution, she continued to prioritize documenting her everyday life, until her diary ends on May 31, 1773. Her last entry relates time spent with her aunts and uncles, asking her mother about her newborn cousins, and remarking how her Aunt Sarah had no interest in Anna's diary. She concludes her diary by stating, "So much for this matter."[3]

For modern scholars, Anna's diary reveals girls' adherence to gender roles in Revolutionary America. Her choices—and those of the Daughters of Liberty—were always framed in the context of the household. Evidence from newspapers, such as the *Massachusetts Gazette*, details how the Daughters advocated for homespun, including a November 9, 1767, statement that read in part:

First then throw aside your high top knots of pride
Wear none but your own country linen.
Of economy boast. Let your pride be the most.
To show cloaths of your make and spinning.[4]

Additional writings, including women's diaries and newspaper columns, demonstrate that the primary form of the Daughters' participation was the boycotting of British goods—called "taxables." This dealt a substantial blow to British merchants, who depended on American buyers for profit, and reshaped Atlantic trade networks. As household decision-makers, women influenced the war and fostered patriotic pride with their purchasing. Anna wrote multiple times about her pride in wearing clothing of her own manufacture, showing such participation was common among young girls.

Anna's patriotism also reveals a subversion unexpected in Revolutionary America. In the late 18th century, society considered females to be incapable of making political choices distinct from their fathers' or husbands'. A girl was expected to defer to her father's wishes, even if she did not agree with him or lived far away, and to refrain from participating in political debate. As the

daughter of a British officer, Anna was expected to obey her father and support his political decisions. Anna's life in Boston was on the front lines of revolutionary sentiment, and she likely discussed such matters with her friends, especially after witnessing the encampments of soldiers. Her diary reflects a deliberate choice to reject her father's authority and side with the Americans through boycotting British goods. Her choice challenged the notion that girls could not be politically independent of their fathers or husbands. Other women also challenged this notion, raising the question of whether females could be political persons. The American Revolution became a time that witnessed, as Lucy Knox wrote in April 1777, "Brother against Brother—and the parent against the child."[5] Anna's diary demonstrates that this conflict, at societal and family levels, was not limited to males.

Since its first publication in 1894, Anna's diary has never gone out of print. She would likely never have imagined that her letters, dutifully copied into diaries to improve her penmanship, would provide a window into girls' lives on the eve of the American Revolution. Whether bemoaning a snowstorm that prevented her attendance at school or remarking on the soldiers encamped just outside Boston, Anna's words remain an in-depth look at her everyday life while giving us a glimpse of how girls politically participated in a revolution that birthed a nation.

12

Sybil Ludington Statue, Carmel, New York, 1777

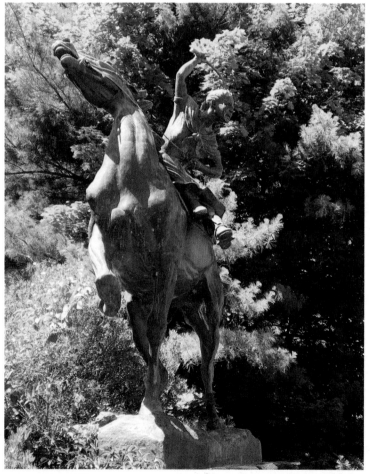

12.1. Statue of Sybil Ludington by Anna Hyatt Huntington, located on Gleneida Avenue in Carmel, New York, 2018.

TIFFANY ISSELHARDT

On April 26, 1777, 16-year-old Sybil Ludington was at her New York home with her father, Colonel Henry Ludington; her mother, Abigail; and her younger siblings. It was like any other day. The females were preparing supper, the boys were feeding the horses, and some were playing. At the same time, nearly 30 miles away, over 2,000 British troops were marching for Danbury, Connecticut, on a mission to destroy the Continental Army's supplies. Locals sent messengers to alert the surrounding towns and call up the militia to defend Danbury. Sybil's quiet night was about to turn into an adventure.

At 9:00 p.m., an exhausted messenger arrived and alerted Colonel Ludington to the impending disaster. Needing to remain at home to direct troops, Colonel Ludington asked Sybil to help muster the militia to their home by daybreak. Since the militia comprised primarily farmers, they were planting their spring crops on farms throughout the countryside. Sybil spent all night riding 40 miles of rugged roads from her home in Fredericksburg (now Kent) to Carmel, Mahopac, Kent Cliffs, and Stormville. At each town, she shouted, "The British are burning Danbury!" and the village bells rang the call to arms.[1] She rode along the shores of what is now Lake Carmel and Lake Gleneida, banging on doors with a stick to awaken those who could not hear the village bells.

Within hours, Sybil's actions were known by the enemy. By 1:00 a.m., General Tryon of the British army in Danbury knew of the militia gathering to face his army. The British continued to destroy the town and supplies, including over 7,000 barrels of food, tents, and shoes reserved for the army, 19 houses, a church, a blacksmith shop, and a meetinghouse.[2] During the troops' retreat back to ships anchored on the Saugatuck River, they met Colonel Ludington's militia, and the Battle of Ridgefield ensued. The British loss was twice that of the militia, thanks to the hundreds of farmers who heeded Sybil's call to arms. As for Sybil, she returned home the morning of April 27, bidding the militia goodbye and going to sleep. Very little is known about her life afterward. Records show that, after the war, she married a veteran and operated a tavern in Catskill, New York.

Today, roadside signs and a statue mark the supposed route taken by Sybil. Yet these signs tell only part of her story. Sybil was not the first to make a midnight ride: Paul Revere completed his 20-mile ride from Somerville to Arlington, Massachusetts—along with two oft-forgotten riders, William Dawes and Samuel Prescott—in 1775. Revere was captured, and his ride was

later made famous by the poet Henry Wadsworth Longfellow. Yet Sybil outdid Revere: she rode twice the distance by herself, completing her mission and evading capture.

So why is Sybil not in the history books? Historians have failed to accept that Sybil's ride was real, citing the lack of reliable evidence. There are no public records mentioning her ride, and she never claimed a military pension for her service. This is because her service lasted only one night and was not formally commissioned. It is unlikely that she tried claiming a pension because many female petitioners were denied. For example, in 1797, Deborah Gannett's petition was denied, despite three years of service and being wounded under the alias Robert Shurtless.[3] Additionally, Sybil's story did not appear publicly in print until 1880, and the family history written by Colonel Ludington's descendants was privately published in 1907. The facts of Sybil's life have so far been found only in local legend and records, newspapers, diaries, and correspondence about her father. These sources are filled with personal anecdotes rather than well-researched facts. As the 1907 account states, "One who even now rides from Carmel to Cold Spring will find rugged and dangerous roads, with lonely stretches. Imagination can only picture what it was a century and a quarter ago, on a dark night, with reckless bands of 'Cowboys' and 'Skinners' abroad in the land."[4]

Reliance on hard facts is conventional of historians, but it favors the experiences of men like Paul Revere, who were formally commissioned and documented. Yet even Revere's story reads more as legend than fact, made popular by Longfellow's poem. Despite affirmation from the Daughters of the American Revolution, demonstrated by construction of the 1961 statue pictured in Figure 12.1, historians continue to debate whether Sybil's ride was real. This reveals much about how history is local legend and the efforts of Americans to define themselves through local heroics. Sybil's story is an affirmation of New York's participation in the war, including the militia's role in winning the Battle of Ridgefield. It also affirms the place of oral history and local legend, proving such narratives as valid and worthy of study. "The story of the lone, teenage girl riding for freedom, it seems, is simply too good not to be believed."[5] There are plenty of stories of men's heroic deeds recorded in poetry and legend that are not called into question because we tend to believe them, rather than looking for hard evidence.

Through these local memories, Sybil is a testament to the place of girls in the American Revolution as actors and heroines. She demonstrates that girls participated outside their households as protectors of their communities. At times, girls took up arms to aid their fathers, brothers, and husbands. They demonstrated courage and fortitude that society did not expect, helping to further American efforts for independence. These girls were ordinary people who performed extraordinary acts, even when gender and youth sought to limit them. Through their stories, the American Revolution becomes more diverse and pluralistic by including those whom society dictated could not participate in the fight for independence. As a local legend, 16-year-old Sybil's story provides a window into the lives of girls during the Revolution and a reminder that history is remembered in multiple—yet still valid—ways.

Sacajawea Statue, Salmon, Idaho, 1804 to 1806

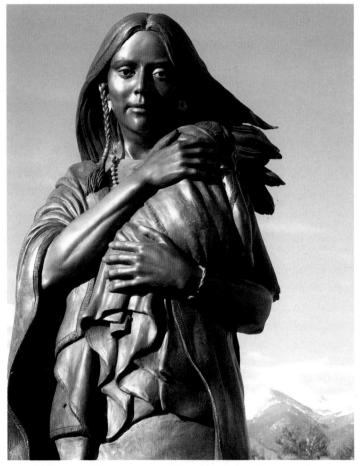

13.1. Sacajawea Monument, n.d. The Monument is located near the site of her tribe, the Lemhi people, who lived in the Salmon River Country. Sacajawea passed through this country during her travels with Lewis and Clark.
SACAJAWEA CENTER, SALMON, IDAHO

In 1788, a girl was born in the Lemhi Shoshone tribe of the Rocky Mountains. At the age of 12, she was kidnapped by the Hidatsa while hunting buffalo along the Three Forks River. The Hidatsa lived in what is now Missouri, where their frequent contact with French explorers and fur trappers led their villages to become important centers for trade. The girl, Sacajawea, spent the next few years learning French and diplomatic skills necessary for intertribal politics and trade. At some point, she became the second wife of Toussaint Charbonneau, a French-Canadian explorer. In November 1804, at the age of 16 and several months pregnant, Sacajawea and her husband joined the Corps of Discovery—led by Meriwether Lewis and William Clark—for a journey that would change America. Lewis and Clark would have failed without Sacajawea.

The Corps of Discovery was charged by President Thomas Jefferson to chart the rivers leading to the Pacific Ocean in hopes of finding the most direct passage west. They were also to assert American authority over the Louisiana Purchase, a swath of lands recently purchased from the French. Lewis and Clark hired Charbonneau as one of their interpreters, given his familiarity with the Hidatsa language, and Charbonneau brought Sacajawea, whose Shoshone background was integral to securing horses to cross the Rocky Mountains. While the journals of Lewis and Clark are prolific, they contain only periodic mentions of Sacajawea, most of which are pragmatic, such as mention of the birth of her first child in February 1805, whom she would take on the journey.

These sporadic mentions are evidence of Sacajawea's importance to the Corps' mission and thought-provoking relations with white explorers. On June 16, 1805, she fell extremely ill. Lewis mentions his concerns over losing her due to her value as an interpreter and guide in Shoshone territory, while Clark administered many remedies in an effort to save her. Later, when the Corps met with the Shoshone, Clark and Lewis were moved by Sacajawea's tearful reunion with her brother, who was the tribe's chief. While staying with the Shoshone, Lewis and Clark documented the domestic life of Shoshone women, such as mending moccasins and boiling tallow from elk bones. Yet their observations of Sacajawea and Shoshone women lacked respect for women's tasks, recording them as mere facts rather than their importance to survival.

This changes on August 25, 1805, when Sacajawea was integral to alerting Lewis and Clark to impending doom. After discovering that Shoshone men dispatched to help the expedition intend to leave them stranded in the mountains, Sacajawea alerted the party and prevented the Corps from being stranded without horses as winter approached. Following this, their tone toward Sacajawea changes. In October, Clark described her as vital to "our friendly relations" with Native Americans.[1] Sacajawea's growing agency is further evidenced on January 6, 1806, when she successfully convinced Clark to allow her to accompany them in seeing a beached whale at Tillamook Head, having finally reached the Pacific Coast.

Despite this power, Lewis and Clark never recognized Sacajawea as an official member of the Corps. Even though being an interpreter was an important job throughout the West, she was not paid for her assistance. Mentions of Sacajawea frame her as Charbonneau's wife, and journals of other Corps members refer to her as "savage" even as they state she was knowledgeable, reliable, resourceful, and compassionate. While Lewis and Clark appreciated her, they attributed her civilized traits only to her individual self rather than characteristic of Native American women. "Other Native women mentioned in the journals are described as miserably exploited, overworked, unattractive, and lacking in dignity and virtue."[2] This makes Sacajawea an interesting figure. Of all the women mentioned in the Corps' journals, she is the only one ever admired by white men.

Despite her legendary status, all that is known of Sacajawea comes from the Corps' observations. Even today, the Shoshone and Hidatsa debate her true origins, each claiming her name as their own. This comes from confusion surrounding her death. While John Luttig, a clerk at Fort Manuel, wrote of her death from fever on December 20, 1812, a different account written in 1907 by Professor Grace Raymond Hebard claims Sacajawea lived to old age and died at Wind River Reservation in 1884. These inconsistencies have led to numerous monuments erected to honor her travels and death.

Yet this mystery is not integral to our understanding of Sacajawea. Regardless of her parentage, tribal affiliation, or death, she is the primary depiction of western Native American girls during the early 19th century. These depictions are conflicting, resulting in a "savage" woman subordinate to her husband yet essential to the mission's success. The only attempt by Lewis and Clark to

meet with a tribe without her help ended in disaster. Without a Native inter-preter, they were unable to translate their mission and foster positive relations. Sacajawea's success in interpreting, encouraging trade, and obtaining food and horses was a fundamental and recognized part of her role as a Native Ameri-can woman. As a Shoshone and Hidatsa female, Sacajawea was raised with the skills necessary to survive the seasonal journeys: hunting buffalo, finding food through her knowledge of edible plants and roots, and the finesse to facilitate trading between tribes and the French. The journals also subtly hint at her skill as a mother during the Corps' journey: "The fact that nowhere in the journals is there a complaint about an inconsolable infant testifies to her talent and instinct as a mother."[3] Sacajawea was raised to survive the western lands.

History recalls Lewis and Clark as pioneers of the West, aided by a young Native American woman. Yet Lewis and Clark were not pioneers since the French had a long-established presence and relations with Native Americans, evidenced by Sacajawea's marriage. Additionally, the aid Sacajawea provided was not just helpful—it was fundamental to their success. Her knowledge of the land and ability to foster trade helped the Corps survive the harsh climate, and sometimes hostile tribes, of the West and forge an American path to the Pacific Ocean. This aid was given willingly, but also in fulfillment of her role as a Native American female rather than a believer in the cause. Like other women of her tribes, Sacajawea served as interpreter and guide, forging al-liances that changed the American West while continuing tribal traditions. Though portraying her as an anomaly among the overworked and exploited women they encountered, Lewis and Clark used Sacajawea's knowledge and resources to begin the process leading to forced removal of the tribes and a mythology of the American West that depicted Sacajawea and her people as savages. Whoever she was, Sacajawea was an unknowing participant in the destruction of her home, but an essential participant to creating the America known today.

14

Bill of Sale for a Girl Named Clary and Runaway Advertisement for Harriet Jacobs, 1806 to 1835

14.1. Bill of sale for a girl named Clary purchased by Robert Jardine for 50 pounds, January 15, 1806, ink on paper.

UNIDENTIFIED AUTHOR. COLLECTION OF THE SMITHSONIAN NATIONAL MUSEUM OF AFRICAN AMERICAN HISTORY AND CULTURE.

$100 REWARD

WILL be given for the apprehension and delivery of my Servant Girl HARRIET. She is a light mulatto, 21 years of age, about 5 feet 4 inches high, of a thick and corpulent habit, having on her head a thick covering of black hair that curls naturally, but which can be easily combed straight. She speaks easily and fluently, and has an agreeable carriage and address. Being a good seamstress, she has been accustomed to dress well, has a variety of very fine clothes, made in the prevailing fashion, and will probably appear, if abroad, tricked out in gay and fashionable finery. As this girl absconded from the plantation of my son without any known cause or provocation, it is probable she designs to transport herself to the North.

The above reward, with all reasonable charges, will be given for apprehending her, or securing her in any prison or jail within the U. States.

All persons are hereby forewarned against harboring or entertaining her, or being in any way instrumental in her escape, under the most rigorous penalties of the law.

JAMES NORCOM.

Edenton, N. C. June 30

14.2. Advertisement for the Capture of Harriet Jacobs, June 30, 1835, from the Norfolk (Va.) *American Beacon* newspaper.

STATE ARCHIVES OF NORTH CAROLINA OF THE NORTH CAROLINA DEPARTMENT OF NATURAL AND CULTURAL RESOURCES

Starting in 1513, nearly 10 million Africans were transported to the Western Hemisphere as slaves. Roughly 400,000 were brought to the United States, mostly as plantation labor to grow cash crops on a massive scale. Children were among those brought or born into the system, inheriting their mothers' slave status. As slavery became a highly profitable business, the records of bondage became more copious: the number of bills of sale for slaves and advertisements for wanted runaways are evidence of how casually Black girls were categorized as property. With only a few firsthand accounts available, these records are the primary source of information about Black girls in slavery.

In 1806, Robert S. Jardine purchased a slave girl named Clary for 50 pounds, the equivalent of $222 in 1806 and $4,693 in 2019. The bill of sale (Figure 14.1) describes Clary only as a "negro Girl Slave," providing no information about where she came from or her actual age. According to definitions of "girl" from the 15th to 19th centuries, she was likely a young unmarried female whose age mattered less than her ability to be bought and sold. The bill also hints at Clary's origins because she was sold in Virginia by Susanah, Richard, and Edmund Burk. Unfortunately, no confirmed records of the Burk family exist, and information about Clary's new owner, Robert S. Jardine, indicates he likely died in Madison County, Virginia, in 1815.[1] In Virginia, slave girls occupied a broad range of positions, typically on plantations, and were rarely educated.

Records from other enslaved Black girls help expand Clary's story. One of the most well-known records is the autobiography of Harriet Jacobs, *Incidents in the Life of a Slave Girl*, which recalls her youth on the plantation of Dr. James Norcom in North Carolina. While most textbooks use her autobiography, other records about Harriet exist, including an advertisement posted by Norcom after Harriet ran away at age 21 (Figure 14.2).

Runaway advertisements contained more information about slave girls than bills of sale. Advertisements included physical descriptors—age, height, hair, dress—and elements of slaves' personalities. This information helps piece together enslaved girls' lives. In Harriet's case, she is described as a "light mulatto" (meaning light-skinned) servant with black curly hair who ran away "without any known cause or provocation." Norcom likely used "servant" and avoided mentioning any cause to make her bondage seem more acceptable and release him of fault. In contrast, Harriet's autobiography states Norcom sexually harassed her, and she hoped to free her children from him. She hid

in her grandmother's crawl space for seven years, then escaped by boat. In the advertisement, Harriet is said to speak English "easily and fluently," which indicates she was born into slavery rather than having made the journey from Africa (confirmed by her autobiography). Norcom indicated her value by describing her as a "good seamstress" who could dress in fine clothes. He also suggested her destination was the free northern states. This was common practice by slave owners, who wanted to recover their property as quickly as possible.

Bills of sale and runaway advertisements, along with similar records, help us piece together girlhood in slavery. They indicate that childhood was full of hardship and that a girl's sex mattered less than her status as Black and slave. Skin color, not biological sex, was a defining feature for these girls; even after escape, the shade of their skin, their skills, and their personalities were more valuable than gender in finding and returning them to bondage. Other slave memories confirm this devaluation of sex, demonstrating that girl slaves "were not socialized at an early age to assume culturally defined feminine roles."[2] They worked alongside boys in domestic chores and, in later childhood, as field hands.

Yet upon reaching puberty, being female became more important. By age 15, Harriet entered "prematurely knowing girlhood," a stage which Black female slaves defined as the transition into adult sexual roles. A girl's value transitioned from labor to breeding. By having children, she increased her master's workforce and consequently his estate's value and labor output. Wanting girl slaves to bear children as soon as they were able, slave masters "practiced a passive, though insidious, kind of breeding" in which girls were forced into sexual relationships with other slaves or their masters.[3] Harriet recalled that at age 15, her master began whispering foul words in her ear, which made her aware of her new sexualized role. Masters also encouraged pregnancy by reducing a pregnant girl's workload and giving her rewards like dresses, silver dollars, and freedom after bearing a certain number of children.

Regardless of these benefits, slaves were forced to breed incessantly and, even if they gained freedom, would not be able to free their children. This led many to run away, temporarily or permanently. At times, such action was even encouraged by their families. Lucy Delaney of Missouri was encouraged by her mother at every opportunity to run away and recalled that by 12 years old she was "forever on the alert for a chance to escape."[4] Accounts from runaway

enslaved girls hint at the skills they possessed to survive both plantation and runaway life: physical endurance, rebelliousness, resilience, wit, cunning, patience, and a network of kin and friends who helped her. All of these point to their inner strengths and ability to gather resources from their communities to survive, demonstrating that slave communities had cultures independent of their masters.

These realities about Black girlhood in slavery are known to us through bills of sale, runaway advertisements, and the personal narratives of slaves. While textbooks emphasize Black girls' victimization under slavery, focusing on labor and sexual exploitation, these records provide a more in-depth narrative of resilience, resistance, and community. By posting public advertisements, slave owners "unwittingly provided windows into the lives of the men, women and children who were desperately trying to free themselves from bondage and forge their own destinies."[5] While Clary's story is one of being sold as a girl and the value of girls' labor, Harriet's runaway advertisement tells of the skills that girl slaves developed to survive and seek their freedom. Both reveal how slave owners considered Black girls as property, incapable of exerting agency or desiring to escape from bondage. When combined with autobiographies, the narrative of slavery becomes more nuanced, demonstrating a culture of contrasts between society and self that helped them survive and escape bondage.

Pantaloons, 1833

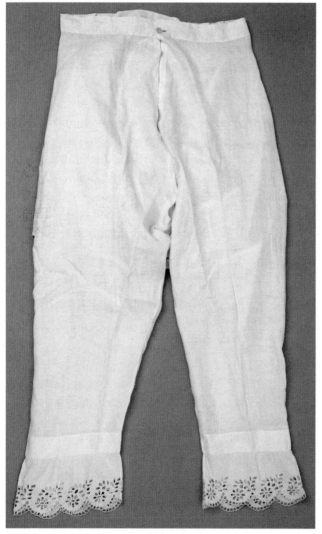

15.1. Pantalettes made of linen and cotton, ca. 1830, American.

THE METROPOLITAN MUSEUM OF ART

As the 19th century progressed, female gender roles changed from partnership with parents and husbands to confinement in the private domestic realm and total subservience to men. Yet one avenue for public participation remained, encouraging girls and fostering debate on their positions in society: fashion. As part of the expanding American economy, the middle and upper-classes saw an increase in leisure time and recreational activities. As girls' free time expanded to include physical activities, such as jumping rope, demand significantly increased for fashion that was modest yet accommodating. Figure 15.1 showcases the new leisure wear, including its most disputed component, a bifurcated garment variously called pantalettes, pantaloons, or trousers.

Until the 19th century, American girls had adapted many styles of men's clothing, but had never worn any kind of split garment. From birth to age 6, both boys and girls wore loose gowns that allowed them to play. Around 6 years old, the genders diverged. Boys began wearing miniature adult male wear while girls were confined to dresses. The various undergarments a girl wore helped shape her body to societal standards and were extremely cumbersome. Long skirts collected debris from the streets, could weigh up to 25 pounds, and easily tripped a girl as she walked upstairs. A girl's clothing was literally hazardous.

Since the 1760s, philosophers like Jean-Jacques Rousseau and John Locke had advocated for a return to nature, calling for outdoor play and freedom from tightly binding clothing for older children. Additionally, several women published articles in women's magazines that advocated for outdoor physical activity. Sarah Hale's "How to Begin" article in *Godey's* stated, "Until girls are fourteen or fifteen years old, they should be allowed to play in the open air at least six hours every day, when the season and weather will permit. They should be allowed to run, leap, throw the ball, and play at battledore, as they please."[1] This philosophy was bolstered by physicians' commenting on the general unhealthiness of American women, who often became sick or died in childbirth. Additionally, articles in women's magazines advocated for gentle exercise and the abandonment of constricting clothing. Inspiration for these exercises came from new immigrants to America. German gymnastics, which became known as calisthenics, was performed as part of girls' school curriculums. Other appropriate activities included croquet and roller or ice skating.

Yet girls' dresses were not appropriate for sport, causing exposure when skirts lifted up as they played. For girls to participate in leisure activities, they and their mothers wanted garments that allowed ease of movement while maintaining modesty. Pantaloons, and later trousers, were created and adopted by various groups to meet this need.

Many men and women were outraged at the new style. In response, early forms of girls' pantaloons mimicked two acceptable forms of pants: oriental costumes and children's wear. Increased trade and fascination with Eastern countries spurred the adoption of "oriental" dress—such as Turkish women's turbans and trousers—as appropriate costumes for masquerades. Feminists and Oneida Perfectionists, early pioneers of bifurcated garments, adopted Turkish trousers as a safe model. However, some called into question its appropriateness given that Turkish trousers were typically worn in harems. Women then turned to children's clothing as an argument for pantaloons. During the 1840s, pantalettes had been adopted by girls in Europe and England. These were loose, flapping garments tied with strings below the knee to cover the lower half of the leg.[2] Unfortunately, pantalettes were difficult to keep in place, leading to their attachment to knee-length underdrawers and turning them into loose-fitting pants. To keep these garments feminine, girls added embroidered and ruffled frills at the hem.

Feminized pantaloons helped girls participate in leisure activities while retaining the gendered fashion distinctions of the 19th century. Though girls' activities changed, expectations around their gender did not. Dress reformers claimed this mitigated any concerns about women asserting dominance in the public sphere or challenging male superiority. Unfortunately, critics were still not pleased. Adoption of pantaloons by female reform groups, notably those calling for women's suffrage, outraged commentators and spurred arguments that "by wearing pants—of any kind—women appropriated male dress, and, by association, male privilege and power."[3] This limited the adoption of bifurcated garments to the realm of underwear, not freeing girls from the more restrictive corsets and skirts that hindered their activities and threatened their health.

Despite revolutions in fashion, girls remained confined to the private sphere. Pantaloons gave girls their first experiences of physical freedom, allowing them to run, jump, and play whenever they chose. This had a lasting

effect on American sports as pantaloons—and later trousers—became the gymnastic uniform for schools into the mid-20th century. A simple change in clothing enabled girls to participate in one public sphere, sports, which would later help break barriers to their participation in other arenas of public life.

Patty Reed's Doll, 1846 to 1847

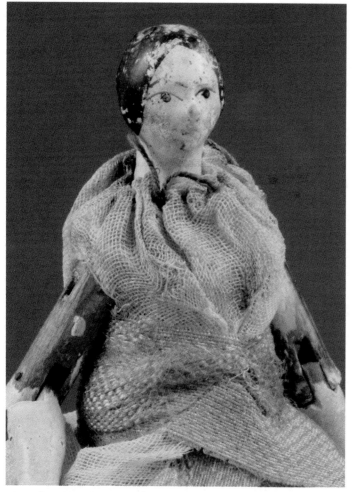

16.1. Patty Reed's doll, 2019.
COURTESY OF CALIFORNIA STATE PARKS

From 1841 to 1865, nearly 40,000 children moved with their families to the Western United States. Many of their diaries and letters have survived, including those of 8-year-old Patty Reed and her older half sister, Virginia, who were part of the Donner Party. Patty and Virginia were children of farmers from Springfield, Illinois, who headed west in hopes of settling in California's rich agricultural lands. Population growth limited available land in the Eastern states, and California promised to keep extended families near one another, with children being given plots of family land as they reached adulthood. California was also a healthier climate, away from the growing industry of the East. When Patty set out with her family in April 1846, she took a small wooden doll (Figure 16.1), which became her comfort and confidante during the worst winter of her life.

Patty's family included her father, James; mother, Margaret; Virginia; younger brothers, James and Thomas; and her Grandma Keyes. They were joined in Springfield by the families of George and Jacob Donner and later by others from Missouri and Kansas. The Reeds brought oxen, saddle horses, ponies, cattle, and three wagons. One wagon was large with spring seats, compartments, and a bed for Grandma Keyes. The other two wagons were loaded with supplies to last through their first winter in California: food, seeds, farm tools, watercolors and oil paints, school supplies, work baskets, medicines, lint and bandages for dressing wounds, canvas sacks of clothing, assorted knickknacks for trading with Native Americans, and books. Like many Americans, the Reed family valued education. "By the time their families were heading West, school attendance had become compulsory in the eastern and midwestern states."[1] Despite walking or riding every day, the girls continued their lessons.

Patty spent her days in the wagon with Grandma Keyes, chatting and listening to her mother read aloud. Virginia recalled that Patty would "almost forget that she was really crossing the plains."[2] Unlike Patty, Virginia had daily chores, such as milking the cows, churning butter, and gathering buffalo chips. Between chores, the children played and rode their ponies. At night, they gathered around campfires chatting, singing, and dancing. Yet all was not well. On May 29, Grandma Keyes died in Kansas and was buried on the trail. Then, in July, Virginia's pony died of exhaustion from the ceaseless travel.

After stopping at Fort Bridget in late July, the party split at a fork in the road—one the established road to California and the other known as the new

"Hasting's Cutoff"—and the Reeds, Donners, and other families (later known collectively as the "Donner Party") chose to take the new cutoff. As Virginia recalled, "There was absolutely no road, not even a trail. The canyon wound around among the hills. Heavy underbrush had to be cut away and used for making a road bed." They also crossed a desert that Hastings claimed was 40 miles wide, but in reality, was 80. During their crossing, they used flattened bullets or lumps of sugar moistened with peppermint oil to distract them from thirst. The Reeds lost all of their oxen and cattle in the desert, forcing them to abandon two wagons and most of their possessions. The children were told to leave all their toys behind, but Patty snuck her wooden doll into her dress.

By October, the party left the desert, but sorrow followed them. Patty's father, James Reed, killed another man in self-defense and was banished from the party. Soon after, they abandoned their last wagon since it was too heavy to cross the mountains, continuing on with only two horses and what they could carry. Winter set in early. At night, Patty dreaded the snow, taking shelter next to campfires under trees, covered only by blankets. Finding the pass blocked by snow, the party decided to winter in cabins at what is now Donner Lake. Running out of food, the party killed and ate all the cattle and dogs. There was little to pass the time. As Virginia recalled, "We used to sit and talk together and some times almost forget oneselfs for a while. We had a few books, I read them over and over." When the meat ran out, they cooked ox hide into a glue-like paste to eat. On Christmas, Patty experienced a brief reprieve when her mother gave them dried apples, beans, and bacon that she had hidden for the occasion. Several failed attempts were made to cross the pass, including one by Virginia and her mother. As the weeks wore on, the families reached starvation and many died.

Meanwhile, James reached Sutter's Fort in California, where he helped organize rescue parties. The first rescue reached Donner Lake on February 19. As Virginia recalled, "But with the joy sorrow was strangely blended. There were tears in other eyes than those of children; strong men sat down and wept. For the dead were lying about on the snow, some even unburied, since the living had not had strength to bury their dead." The Reeds were the first to set out for Sutter's Fort, but Patty and Tommy were too weak to climb the pass. They stayed with the Breen family and were provided one ounce of smoked beef and a spoonful of flour twice a day.

When James learned two of his children remained, he accompanied the second rescue party and "found his two children alive at the Breens' cabin. Patty was sitting on the top of the snow-covered roof. She saw her father in the distance and rushed to meet him, but she stumbled and fell in his arms, weakened from hunger."[3] As the second party set out for Sutter's Fort, a snow-storm occurred; young Isaac Donner died while sleeping next to Patty. Despite her weakness, Patty insisted on walking until she collapsed, after which she was wrapped in a blanket and carried by James. Upon reaching the fort, Patty's family discovered the tiny doll hidden in her bosom. During her recovery, Patty talked to her doll of her new happiness at reaching the fort.

Of the 83 people snowed in at Donner Lake, only 18 reached California. The Reed family was the only one to arrive intact. News of their journey spread across the country as survivors told their stories to journalists. The Donner Party's fame spurred changes to the process of moving West. Notices were sent to forts along the route alerting them to upcoming wagon trains, trading posts and relief parties were set up along the routes ready to provide assistance, and innovations in wagon design and recommended supplies helped ensure faster travel times.

After the initial wave of press, Patty and her family settled in California. Patty married at age 18, gave birth to eight children, and helped C. F. McGlashan publish the first historical account of their experiences. Today, Patty's doll remains "a silent witness of one of the greatest tragedies to befall an emigrant party on the way to California."[4] She is a symbol of all the girls who walked westward, many of whom carried small dolls that became their treasured possessions and confidantes.

Part IV

RECKONING, 1850s TO 1860s

The time before and during the Civil War sought to end slavery in the United States. With the election of President Abraham Lincoln, the South felt it had no choice but to form a new country where they could maintain slavery, which was central to their economy. The North wanted to keep the Union together, but as a country of free people. Four years of battle ensued from 1861 to 1865. This section tells the stories of five girls who lived during this harrowing time. They came from different backgrounds and experienced varying degrees of contact with the war. Some resided near the front lines, while others lived far removed from any of the war's inconveniences.

Living in Newport, Rhode Island, Ida Lewis's daily life wasn't much affected by the war, but she encountered her own perilous adventures and rescues that made her famous. In Virginia, Belle Boyd used her upbringing as a Southern Belle to charm Union and Confederate soldiers alike, passing on important information to advocate for her cause. Also part of the war effort, Susie Baker was born a slave in Georgia, but was educated and became a nurse, later publishing her wartime experiences, the only Black girl to do so. In Washington, DC, sculptor Vinnie Ream was the first—and youngest—female artist to receive a federal art commission. Finally, in New York City, Emma Lazarus published her first book of poetry at 14 years old and went on to write one of the most famous poems in American history. Each

girl showed bravery in her own circumstances. Their contributions illustrate a reckoning of self in a time of social and political upheaval, centered on whether "freedom," as promised by the American Revolution, should extend to all Americans.

17

Lime Rock Lighthouse, Newport, Rhode Island, 1858

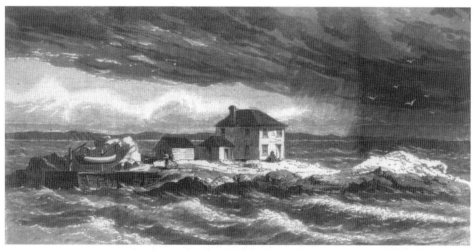

17.1. "Lime Rock Island, off Newport, Rhode Island," published in *Harper's Weekly*, July 31, 1869.

Throughout history, men have dominated the ocean. Seldom are women, let alone girls, considered strong or capable enough for seafaring. Ida Lewis challenged this notion. Living and working next to the sea her whole life, Ida became a master of her domain. She rescued dozens of people, and even a few animals, from drowning in the waters around her lighthouse home on Lime Rock Island. Through her courageous actions, the lighthouse keeper's daughter became a powerful symbol of girls' bravery in the 19th century.

Idawalley "Ida" Zoradia Lewis was born on February 25, 1842, in Newport, Rhode Island. Her father, Hosea, was the keeper of the Lime Rock Lighthouse, built in 1853, just 300 yards into Newport Harbor (Figure 17.1). Lighthouses were managed by the federal government because they were vital for safe navigation around the coasts, helping keep ships safe and responding to distress calls. Because lighthouses were often in remote or difficult to reach locations, the keeper's whole family typically lived on-site. However, the Lime Rock Lighthouse was built on a rocky outcrop in the rough waters of Narragansett Bay. So the Lewis family lived in Newport and Hosea rowed out to the lighthouse every day.

Ida loved going with her father to the lighthouse. Because it was a family effort, keepers usually trained an eldest child to help manage the lighthouse. Impressed by his daughter's strength, interest, and capacity, Hosea taught 11-year-old Ida all the jobs in the lighthouse. For efficiency, a dwelling was soon built on the island, and the family moved there. However, this meant Ida had to row herself and her siblings to and from school during the week. While not ideal, she grew stronger and more confident in a rowboat. Her father worried about them, especially when a storm blew, but they never had a single incident and the children always made it home safely.[1] Ida also helped to keep the oil replenished and cleaned the prisms and windows. This made her days long and full of work, but it also made her tough and skilled.

Four months after moving onto the island, Hosea suffered a paralytic stroke and could no longer walk up the stairs. Ida was told she had to quit school and work full-time at the lighthouse. At 15 years old, her new duties were to maintain the light through the night, polish and clean the lighthouse, fix anything that broke, order fuel, clear snow and ice, keep log books and weather notes, and watch for ships in distress. She continued to row her siblings to school and perform other domestic duties to help her mother. According to an article from *Harper's Weekly* in 1869, Ida's reputation as the strongest rower and the

best swimmer in town was widely known.[2] Despite this, it was still unusual for a girl or woman to manage a rowboat.

On September 4, 1858, Ida's resolve and watchful eye were put to the first real test. Local teenagers had taken a small sailboat, called the *Hug-'Em-Snug*, out for a picnic on some rocky outcrops. They were returning home when the wind dropped, so they let down the sail to let the current take them into shore. As the sailboat passed the lighthouse, Ida heard the boys laughing. However, night was falling and the temperature dropping quickly. Despite the cold and rapid waters, one of the boys decided to climb up to the top of the mast, causing the boat to rock and take on water. The boat capsized, and the boys shouted for help. Ida sprang into action, rowing out in her skiff and hauling the boys into her boat for safety. Hosea watched the scene with his telescope, and once safe inside, Ida's mother revived the boys with warm blankets. At 16 years old, Ida rescued four teenagers much bigger than herself.[3]

Yet this isn't the rescue that made Ida famous. Everyone involved decided to keep the incident a secret. While the boys were grateful, they were part of the Newport elite, which gave them a sense of entitlement as well as fear over the loss of their reputations if their families and the wider town knew they had been rescued by a working-class girl. Many didn't tell their families what happened until many years later, when Ida became a respected public figure. Ida felt it was just part of her duties and she did not need acknowledgment for doing her job. Life went on as usual.

In 1869, Ida saved four soldiers from their foundering boat. Because of this dramatic rescue of military men, the story became big news and Ida became famous. That summer, she received 9,000 visitors to the lighthouse, including President Ulysses S. Grant. In her lifetime, it is estimated Ida saved between 23 and 40 people, though she never recorded her rescues. She continued as lighthouse keeper into adulthood, performing her last rescue at age 63. In 1881, Ida received the highest medal awarded by the U.S. Life Saving Service.

Ida constantly defied expectations. Because she stood around 5 feet tall and weighed 100 pounds, many were baffled at how anyone that size—especially a girl—could be strong enough to lift grown, waterlogged men from the sea into a small boat. Through her abilities and courage, Ida challenged gender roles, while at the same time upholding them. Proud of her job, she saw it as a duty that she honored and loved. Being a girl didn't matter to her, although it did to others. On one hand, she was both a keeper and a rescuer, and on the other,

she dedicated herself to domestic duties and feminine dress, making sure to not appear too masculine so as to maintain social norms and public appeal.

Ida Lewis spent her girlhood in the lighthouse, and it set the stage for the rest of her life's work. She showed bravery and heroism that would continue until her death. Ida's passion for the sea, strength, and fearlessness defied the gender norms of the time and gave girls a heroine to look up to. Although it is now a yacht club, Lime Rock Lighthouse still stands as a testament to Ida's fortitude and the contributions of American girl heroines.

Belle Boyd House, Martinsburg, West Virginia, 1861

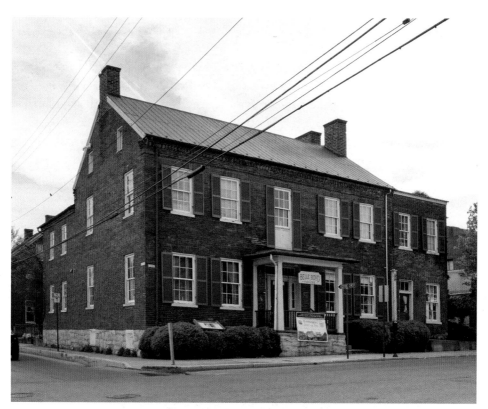

18.1. Belle Boyd House, once home to Confederate spy Belle Boyd during the Union occupation of Martinsburg, West Virginia, during the American Civil War.

In the years leading up to the Civil War, challenges to gender expectations were prevalent. Once the fighting began, these expectations changed forever as girls aided their families and country through fighting, nursing, and even spying. One of the most famous Civil War spies was a teenage girl from Virginia named Belle Boyd. She became one of the most infamous females in the war through her clever, formidable personality and education as a wealthy Southern girl.

Belle lived in the center of Martinsburg, in what was then Virginia. Her father, Benjamin Reed Boyd, was a successful merchant. He had the family's Greek Revival mansion built in 1853, when Belle was 9 years old (Figure 18.1). Like many wealthy girls of Virginia, Belle was well educated. At 12 years old, she was sent to Mount Washington Female College in Baltimore, designed to polish girls into Southern Christian women. Belle finished school at 16 and came out into society in Washington, DC, but returned to Martinsburg just before the fighting began.

Martinsburg was a flashpoint of military activity with a constant flow of soldiers from Union and Confederate camps, with the city's allegiance changing dozens of times. Belle and her family were firmly Confederate, and her father joined the 2nd Virginia Infantry Regiment. When he left, Belle and her mother took over management of the family and business. Life in Martinsburg was unsafe. As Belle described, "Our male relatives being with the army, we ladies were obliged to go armed in order to protect ourselves as best we might from insult and outrage."[1]

When the Union army first occupied Martinsburg in July 1861, it commandeered or destroyed homes and implemented a system of passes to manage people moving about town. During July 4th celebrations, Union soldiers drank heavily, vandalized homes, and harassed locals known to support the Confederates. Drunk soldiers came to Belle's house, swore at her and her mother, and threatened them and their home. Belle claimed her blood boiled over at their insults, so she shot one of the soldiers at point blank range, killing him.[2] While she was arrested, neither Belle nor her mother seemed bothered by what she had done. The deed solidified Belle's resolve. A Union army inquiry found that her actions were justified as self-defense. This exoneration convinced Belle that she was righteous in her actions.

Belle was also not a shy Southern girl. She was high spirited, brave, and willing to act. Her charm and ability to make conversation, combined with

her wealth, became great assets. Despite her unwavering devotion to the South, Belle had some ambivalence about slavery. Though against the law, Belle taught her Black maid, Eliza Hopewell Corsey, to read and write. Belle recorded, "Slavery was an imperfect form of society whose final extinction had not yet arrived."[3] Belle's attitude toward slavery and her trust of Eliza led her to enlist Eliza's help in subverting the Union.

Now heavily monitored by Union guards, Belle used this proximity to coax information on troop movements prior to the First Battle of Manassas. Belle sent Eliza on courier missions since slaves went relatively unnoticed by the Union army. Together, they participated in numerous espionage missions to inform Confederate troops about Union plans. One day after Martinsburg was recaptured by the South, Belle was out riding with her cousin and a Confederate soldier. Her horse was spooked and took off into the woods behind enemy lines. Belle convinced the Union soldiers to let her go, and they escorted her back to the Confederate side, where she had them arrested. Belle did not reveal her identity until she was back on secure ground. Stories of this incident circulated, and Belle became notorious.

Even after it was known who she was and what she had done, soldiers rarely hesitated to share information with her. No one suspected a girl could be a threat, so they assumed she was not capable of understanding the importance of their information. As a result, she could move through the town with relative ease. Additionally, Belle was very fashionable, and dresses of the time allowed for many hiding places to carry letters and all manner of contraband, including weapons, alcohol, and medical supplies.[4]

Belle was reported for spying more than 30 times, arrested at least six times, and imprisoned three times. Due to her unrepentance and continued efforts, she could have been shot as a traitor. Her whiteness, youth, and affluence were buffers against this consequence, and the Union couldn't risk creating a martyr to rally the South. Even as a prisoner, Belle continued her work, flaunting her Southern pride. She sang "Dixie," posted Confederate flags in her cell window, and passed notes using a clever system of communication that involved using a bow and arrow to shoot a rubber ball through her window with messages sewn inside. Belle was released in December 1863 because she contracted typhoid fever.[5]

After her time in prison, Belle was too conspicuous to carry on her work in the South. She volunteered to sail to England to transport Confederate papers

to sympathizers abroad. Her ship was stopped on May 10, 1864, and Belle was captured. In the meantime, she managed to turn one of the Union naval officers, Samuel W. Hardinge, to her side. He helped Belle escape, first to Canada and then London. They married on August 25, 1864. Hardinge, however, was now a traitor and returned to the United States to answer charges that he had aided and abetted an enemy spy. He died in prison, leaving Belle a 20-year-old pregnant widow in London. Ever resourceful, Belle decided to publish her memoirs to earn a living. She used sensational storytelling and slight embellishments to make the tales even more exciting. When the war was over, Belle returned to the United States, where she performed her life in dramatic readings. However, she was now more reflective on the war, and her performances stressed the importance of the unity between the North and South, winning her a following from veterans on both sides.[6]

As a wealthy, white, Southern girl, expectations about Belle's future were disrupted during the war. Like many girls, her society and home life were stretched to accommodate wartime needs of survival. Yet Belle took this further, using her society-bred skills to work as a spy. Her short career was full of thrills and drama, and her social status—which provided her with an education and standing—allowed her to get away with these crimes. While her privilege empowered and saved her, it did not keep her from public scorn from both sides. The Civil War had changed Belle Boyd forever, just as she had changed it.

Reminiscences of My Life in Camp by Susie King Taylor, 1864

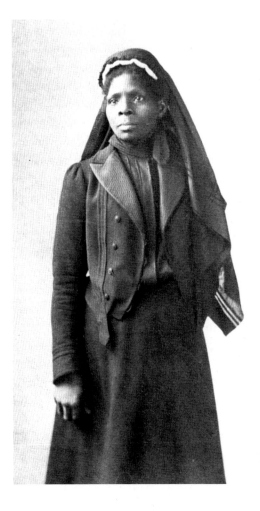

19.1. Frontispiece for *Reminiscences of My Life in Camp with the 33d United States Colored Troops: Late 1st S. C. Volunteers.* [Photograph of Susie King Taylor, unknown date.]

Girls born into slavery had unimaginably hard lives. Constant work and little to no education kept their bodies and minds bound. Yet against the law and under the guise of civilizing, many owners taught slaves how to read for Christian education. One girl who used this opportunity to her advantage was Susannah "Susie" Baker (later Susie King Taylor). Despite being born a slave, she wrote and published *Reminiscences of My Life in Camp* (Figure 19.1), focusing on her time working in a Union army camp while she was a teenager. There is no comparable historic text from or about female slaves' experiences during the Civil War.

Susie was born on August 6, 1848, in Liberty County near Savannah, Georgia. She and her family belonged to Valentine Grest and worked on his plantation. The Grests had no children, and Frederica, the young mistress of the house, paid special attention to Susie, teaching her to read and write.[1] This gave Susie an early start, while her grandmother, Dolly Reed, helped further her education. Dolly had been emancipated by the Grests and was living in Savannah and running a boardinghouse under their guardianship. Despite being free, Dolly still had to get permission to live on her own as well as travel from Valentine Grest. She visited her family on the plantation four times a year, trading and selling goods along the way.[2] When Susie was 7 years old, she and her younger brother moved to Savannah to live with Dolly.

It was against the law in Georgia for any Black person to be educated, free or slave, yet in Savannah there were four known Black women teachers.[3] Dolly sent Susie and her brother to a bucket school, which were secret schools for teaching slave children to read and write under the guise of teaching domestic trades. The school was run by Mary Woodhouse, a friend and free Black woman, who taught around 30 students in her home. Susie attended this secret school for about two years. Susie then studied under Mrs. Mary Beasley, who in May 1860 told Dolly that she had taught Susie everything she knew. Shortly afterward, the children were sent back to the Grest plantation after Dolly was arrested for breaking curfew while attending a church sermon.[4]

At the beginning of April 1862, nearby Fort Pulaski was captured by Union troops. Susie's family left for the Sea Islands off of the southern Georgia coast, under the protection of the Union army. Officer Captain Whitmore heard Susie speaking and asked if she could read. When she confirmed that she could, he didn't believe her. To prove her skills, she performed some basic

written tasks, much to his surprise. Susie explained that she had spent time in the city and had opportunities to learn. After two weeks, Susie's family moved St. Simon's Island with about 600 other refugee slaves, mostly women and children.

As a young teenager, Susie witnessed the end of slavery and the transformation of the South. But even though they were now free and under the protection of the Union army, it didn't mean they were safe. Former slaves were called "contraband," a term used for dangerous property.[5] The war was still going on around them, and Confederate spies were never far away. Many formerly enslaved men enlisted in the army, but women were unable to officially join, instead becoming unpaid labor for both the Union and their families. Because these first Black troops were not paid by the government for 18 months, families had to take care of themselves. Black women in the camps were typically described as cooks and laundresses, even though their primary responsibility was nursing. When it became known she was literate, Susie was asked to set up a school for the children. She agreed and also taught soldiers in the evenings after their daily duties of cleaning weapons and minding animals.

Susie wrote few details about her personal or emotional life. While at St. Simon's Island, she met Edward King, a noncommissioned sergeant, and they were married. Susie was only 14 years old. Whether for love, protection, or both, she tells us nothing of her motivations for this marriage. Because of her teaching and nursing, Susie was well known and liked among the soldiers, or "our boys" as she called them.[6] Her fearlessness was noted by many. When a mild form of smallpox broke out in the camp, she took care of the most severely affected with no concern for herself since she had been vaccinated.

In 1866, when the war ended, Susie and Edward returned to Savannah. Despite all her work, Susie received no pay for her years of service to the Union army. No longer a soldier, Edward became a carpenter, but struggled to find work because of postwar racism. To help support them, Susie quickly organized a school for freed children. Edward died later that year, leaving Susie on her own with their newborn son. She organized two more schools, supported by charging a small tuition. However, many Northern missionaries and teachers were arriving to teach the newly freed Black population, and Susie lost her students to a tuition-free school when it opened up in town. After trying to open other schools, she took jobs in domestic service for

wealthy white families. This meant Susie's mother looked after her child, a reality for many Black women. Even though the war was over, Susie continued her efforts to support the soldiers. Her beliefs in the rights of Black people to live without violence and receive education and preserving the memories of both the people who fought in war and the values for which the war was fought carried through the rest of her life.[7]

Susie used her education to teach and to heal while maintaining her social roles as wife and camp laborer—all before the age of 21. In her *Reminiscences*, Susie wrote, "There are many people who do not know what some of the colored women did during the war. . . . These things should be kept in history before the people."[8] Her story commemorates the incredible hardships enslaved and free Blacks faced during the Civil War, a narrative often hidden in textbooks. The strength of her character, sense of duty, and beliefs carried her through slavery, war, and into the hardships of freedom. Susie's life demonstrates how the country was built, in both war and peace, on the backs of Black girls and women whom we are just beginning to discover and appreciate.

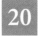

"Vinnie Ream at Work," 1866

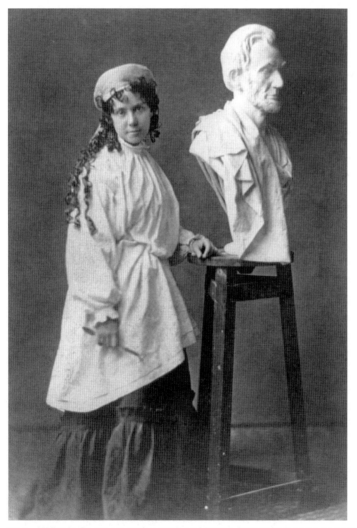

20.1. "Vinnie Ream at work upon her Lincoln bust which rests upon the stand she used in the White House while President Lincoln posed for her."

On January 25, 1871, a bigger than life-sized statue of assassinated President Abraham Lincoln was unveiled in the Statuary Hall of the Capitol Building in Washington, DC. He is shown wearing the clothes he died in, with his eyes downcast at the great Emancipation Proclamation held in his right hand. The sculpture was received with pride and sadness by those who attended the ceremony, but the controversy that preceded it was centered around the female artist, Vinnie Ream, who was 18 years old when it was commissioned. Her gender and youth were the main contentions surrounding her selection. There were a few prominent female sculptors at this time, but none were as young as Vinnie.

Lavinia Ellen "Vinnie" Ream was born in Madison, Wisconsin, in 1847. Her father, Robert Ream, was a civil servant, working as an engineer and surveyor for the Wisconsin Territory. As a surveyor, Robert kept the family on the move. They lived in several Northern and Southern states. In Missouri, at 10 years old, Vinnie attended the academy at Christian College (later Columbia College), which had just begun admitting female students. After a year, the family moved back to Washington, DC, when her father became a semi-invalid due to rheumatism.[1]

In DC, Vinnie volunteered for Civil War relief efforts and charity concerts. In 1864, with the passage of the Deficiency Act, the federal government opened up employment to women, so Vinnie found a job to help support the family by working in the Dead Letter Office of the Post Office. Through her work, she became reacquainted with Senator James Rollins of Missouri, whom she had first met when he visited her college in Columbia. She was a creative girl from early on, excelling in the arts. She created poetry, music, paintings, and sculptures. Her talents and beauty gave her an advantage that was seen as both an asset and a liability. Senator Rollins opened many doors for Vinnie. He introduced her to the well-known artist Clark Mills, from whom Rollins had commissioned a sculpture. Mills was taken with Vinnie and her talent and agreed for her to become a student assistant. Through Rollins and the powerful well-connected men she met at Mills's studio, Vinnie was encouraged to follow her aspiration to make a sculpture of President Lincoln.[2]

There are conflicting accounts about how Vinnie came to make her sculpture bust of Lincoln. According to Vinnie, she met Lincoln through her frequent visits to the White House. The president agreed to sit for her during 30-minute sessions over the five months before he was assassinated. Outside

of studio sessions, he allowed Vinnie to be in the room during his work hours in order to make her sketches. Detractors say this did not happen and that she simply sculpted him from memory and by viewing his death mask made by Clark Mills. First Lady Mary Todd Lincoln denied Vinnie's account because Mary had never heard of her. Mary was later against Vinnie's receiving the full statue commission, viewing her as an upstart and a public woman, which was an insult at the time.[3] Stepping out of her expected gender role and into the public sphere, especially into the art world, was a gross transgression for a young girl according to many traditionalists. It was seen as unseemly for her to promote herself and her talents. Regardless of public opinion, Vinnie completed a bust of Lincoln that many felt was extremely naturalistic and captured his appearance, demeanor, and sadness of spirit.

After his assassination, the government commissioned a full-size statue of Lincoln. Vinnie wanted the job, and she was determined to get it. Through clever marketing, Vinnie sold photographs of herself standing with her bust of Lincoln (Figure 20.1) to Congress and the public. Her youth, gender, and relative inexperience played both for and against her. Her supporters saw a raw talent from the Midwest, where Lincoln was born, unaffected by European artistic influences and art school airs, who was capable and had already made an acclaimed likeness of him. Those opposing her selection said she was too young, had no training or real experience, and that a female could not be successful in the task. In 1866, Vinnie surpassed 19 established artists, including her mentor Mills, to win the $10,000 commission.[4]

After securing the job, Vinnie was paid half after completing the plaster cast, and the rest after congressional approval for the final marble piece. This meant that for the first two years, while she worked on the plaster, Vinnie did so without pay. With her family relying on her and all of her expenses coming out of her pocket, she had to make a living while she was making the cast. Vinnie opened up the rent-free studio she occupied to viewers and tourists, using their visits to promote her work through photographs and studio tours. Her public persona was celebrated and criticized. Vinnie's bold personality was out of line in both the political world of Washington, DC, and the art world.[5]

However, the Secretary of the Department of the Interior, who had commissioned the statue, was pleased with her final plaster cast and approved both the design and payment. Using the money, Vinnie went to Rome to have the sculpture carved out of Carrera marble. At 20 years old, she was welcomed

by other artists, including Harriet Hosmer. Most sculptors—both male and female—relied on skilled Italian craftsmen to render their casts in marble, but Vinnie was particularly disparaged at home for this practice. She supervised the work and made sure it was faithful to her original. Despite its being a typical art practice, her detractors continued to apply double standards and criticize her methods.[6]

Vinnie was 24 years old when the statue was completed. It was unveiled at a ceremony where many who knew and loved Lincoln stood alongside those who hoped to see Vinnie's failure. The piece was mostly well received. Today, the somber yet dignified Lincoln, as seen and created by a teenage girl, stands in the Capitol rotunda. Vinnie continued making sculptures until she married, when her husband declared that part of her life was over. Even Vinnie, the strong-willed marketing master of both herself and her art, could not escape the fate of many females in the 19th century. While Vinnie did several other sculptures of note over her lifetime, she would always be known as "the girl who sculpted Lincoln."[7]

21

Poems and Translations by Emma Lazarus, 1866

21.1. Title page of Emma Lazarus's book, *Poems and Translations* (1867).

In the North, especially in the big cities, the impact of the Civil War was inconsistent. There were families and communities wholly impacted and others who barely noticed. In New York City, a girl named Emma Lazarus had the financial means and sheltered upbringing that enabled her to write poetry in the midst of a country fighting for its existence. Time and money spent on education gave her skills in both writing and translating languages. Combined with her talents, this propelled her to break ground as an American female poet, eventually writing one of America's most famous poems.

Born in 1849, Emma grew up in New York City in a well-established Sephardic Jewish family that had been in the United States for 100 years. Grace Seixas Nathan, her great-grandmother, was also a poet from New York. Emma's mother, Esther, married her father, Moses Lazarus, and had seven children, six girls and one boy. Emma was the fourth born into this family of comfortable wealth. Moses had a lucrative sugar business, which despite their affluent, urban lifestyle in the Northeast, was expressly tied to slavery. Others in their family volunteered and gave money toward the Union efforts, but there are no records of financial or time contributions by either of her parents.[1]

During the 19th century, many Jewish people in America began to relax or subvert their religious lives into more secular ones. They retained their Jewish identities privately, but publicly became neutral or even Christianized. Emma's parents kept the main Jewish holiday traditions, but they did not live by strict observance to Jewish law as many in their extended family did. Instead, Moses provided his children with a broad secular education. They had private tutors in their home, with Emma studying mythology, European literature, American poetry, music, Greek and Latin classics, and the languages of French, German, and Italian. However, she did not receive a Jewish education. Being a Jewish-American girl was difficult, with many finding it easier to leave their Jewishness behind. Emma had Christian friends and saw herself as being a member of both of these worlds, and proudly so, yet she would struggle to reconcile them her whole life, both personally and professionally.[2]

Emma was well read and adept with words and languages, teaching herself French by translation. She likely began composing poetry around age 11. Her writing was highly romantic, full of gods and heroines. Her father recognized his young daughter's talent and encouraged her work. In 1866, Emma's first book, *Poems and Translations Written Between the Ages of Fourteen and Sev-*

enteen (Figure 21.1), was published for "private circulation" by her father.[3] This collection includes 30 original poems and 45 translations of French and German authors. Although predominantly somber in tone, Emma wrote short rhyming verse, as well as two long-form narrative poems in free verse, "Bertha" and "Elfrida"—at 1,582 lines. This length is an achievement for a writer of any age or gender.

Many of Emma's poems are evocative of the faraway places she would have visited in her imagination through reading books and daydreaming. While her personal experience was primarily confined to New York and Newport, Rhode Island, she was able to evoke a depth and thoughtfulness beyond her years. During a Newport summer in 1867, Emma visited the Touro Synagogue, a significant site for her ancestors that had been closed in the early 1800s. Having reopened at midcentury, Emma's visit was almost exactly 15 years after poet Henry Wadsworth Longfellow visited; both were inspired to write about the place. In "The Jewish Cemetery at Newport," Longfellow wrote about the Jews' ability to survive persecution, despite their traditions keeping them an Old World, or even dead, nation. It was published in *Monthly Magazine* in July 1854. The synagogue Emma saw was very different. She responded to Longfellow with her own more hopeful piece, "In the Jewish Synagogue at Newport," her first poem to speak about struggles of modern American life and Jewish traditions.

Within a year of her private poetry debut, an established publisher, Hurd and Houghton, released a second, larger edition of *Poems and Translations*. A *New York Times* reviewer declared the poems "remarkable from the fact stated upon reading the title-page of the volume, that they are written by a girl—we beg pardon, by a young lady under seventeen, and during the three years preceding her arrival at that age."[4] Both a credit and a disservice to dwell on her age, the fact remains that she created lasting art that showed the mostly adult male readership that girls are capable of depth and literary merit.

In 1868, Emma met Ralph Waldo Emerson, famed poet and philosopher. Despite his being 65 years old and her being 19 years old, Emerson became a trusted mentor. He gave her feedback, from praise to criticism, and she gave him her youthful exuberance and an intellectual intimacy that he desired. Emma had a mission: she wanted to be a part of America's literary world and saw Emerson as the key. Emma went on to publish several more poems and another anthology, *Admetus and Other Poems* (1871), which launched her

into the literary world on her own merits. Despite a falling out and eventual reconciliation, she dedicated the book, "To my friend, Ralph Waldo Emerson." Critics at home and abroad saw her as a young poet, a woman poet, and an American poet.[5]

Emma achieved a great deal in her relatively short life, dying at the age of 38. Not only did she continue her career as a poet, but she also became a political activist and advocate for new immigrants, especially women and girls, and their conditions in New York City. However, it was only after death that she gained worldwide notoriety and had her place secured in American literary and social history. It was a short poem, which no one at the time of writing took much notice of, that became her best-known work. Until recently, that poem, *The New Colossus*, sat on the base of the pedestal at the feet of the Statue of Liberty, welcoming all those who seek to come to American shores.[6] A year after her death, Emma's cousin Sarah Lyons began the Emma Lazarus Club for Working Girls, which taught English and other skills to recent immigrants to help them get a foothold in their new home. Emma's ambitions as a poet and lifelong efforts for social justice enabled her legacy to be one of acceptance, uplifting girls and women out of poverty and dependence to being able to survive and make their own way in the world.

Part V
HOPE, 1870s TO 1910s

The years following the Civil War challenged the United States to become whole, perhaps for the first time. New laws tried to bolster a reconciled Union and support the freedoms won for millions during the war. With the South rebuilding its society and infrastructure and the industrial North booming, this was a time of both great hope and strife. Population movements, shifts in industry, and a huge increase in immigration put heavy demands on systems that were just becoming established. This was the boom time for the concept of the American Dream, which included freedom, success and prosperity as a reward for hard work, upward mobility, and inalienable rights. Given increased opportunities for education and employment, girls were a part of this movement. It offered hope for some, but for others the American Dream was full of strife.

With an upheaval of norms and gender expectations, the years from 1870 to 1910 reveal stories of girls who brought America hope of coming closer to the dream of freedom and opportunity it had for itself. On Staten Island, Alice E. Austen was a curious and creative girl who became America's youngest female documentary photographer. In Alabama, Helen Keller overcame the limitations of her physical self to become the most well-known deaf and blind person in the world. At Ellis Island, the doors opened to overseas immigration, and the first to be welcomed was a teenager from

Ireland, Annie Moore. In Atlanta, Georgia Rooks Dwelle was the daughter of slaves and the youngest woman to receive a medical degree in the South. All these girls faced adversity and overcame physical and social barriers to achieve their goals, fulfilling to varying degrees the hope promised by the American Dream.

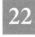

22

"Group in Bathing Costumes" by Alice E. Austen, 1885

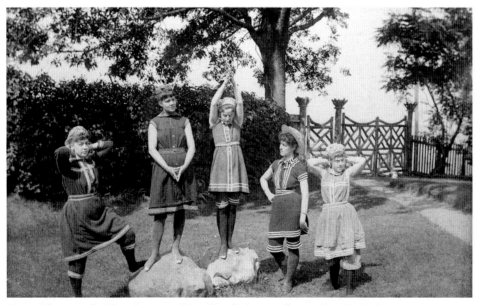

22.1. "Group in Bathing Costumes" by Alice E. Austen, September 17, 1885.
COLLECTION OF HISTORIC RICHMOND TOWN, STATEN ISLAND HISTORICAL SOCIETY

Life could have been very different for a girl whose father abandoned their family before she was even born, but Alice Austen was both fortunate and talented. Born Elizabeth Alice Munn in 1866, she lived in her grandparents' home once her mother left her married life and name behind. Alice was given her mother's maiden name of Austen, a brave act that set the precedent for the rest of her uncommon life. Coming from a well-off family on Staten Island, New York, Alice Austen had the means that allowed a gifted and unique girl to become one of America's earliest social and documentary photographers.

The home Alice grew up in was known as Clear Comfort. In 1844, her grandfather, John Haggerty Austen, wanted to move out of Manhattan. Having lost two infant sons to disease, John wanted a place where his family could live in open green spaces and breathe clean air. Staten Island, known as Richmond at the time, was ideal in both proximity to the city and its distance. It was a beautiful island, with many large mansions, that was on its way to becoming a vacation spot for wealthy Manhattanites. Originally built in 1690, John did extensive restoration and renovations of Clear Comfort's house and grounds. The property had an expansive view of New York Harbor, the Statue of Liberty, and Ellis Island. Alice watched boats as they made their way back and forth through the harbor, which were some of the first moving objects she captured with her camera.[1]

As the only child growing up in a house of six attentive adults, Alice was indulged and encouraged. With all those family members around, there were enough opinions and interests for Alice to have a well-rounded home education. Her uncle Oswald, who spent most of his time traveling the world as commander of a clipper ship, brought home a dry-plate camera when Alice was 10 years old. Watching her uncle explore in detail how the camera worked, Alice was able to learn alongside him. She was fastidious in absorbing everything she could about this incredible new technology.

When Oswald left home again, he told Alice she could experiment with his camera while he was away. This was exactly the opportunity she needed. Her uncle Peter, who taught chemistry at Rutgers, helped Alice with the chemicals and process used to make the prints. They built her a darkroom in the upstairs at Clear Comfort. This enabled her to play and practice for as many hours as she desired. The entire family supported her interest as it became more than a hobby. Alice was fascinated by the mechanics and chemistry, so a dry-plate camera—which required many steps to produce a photograph—was an ideal

project for her. Since there was no running water in the house, Alice had to pump it from their well, running back and forth to her studio to wash the plates.[2] She was an active and athletic girl, which helped her ability to carry the heavy camera equipment.

Most of Alice's early work comprises domestic shots of herself, her family, servants, friends, and Clear Comfort. Alice left no aspect unattended. When she created her photographs, she considered the subject, lighting, and composition. She kept precise notes about her work as well. On the envelopes where she stored her negatives, Alice recorded the brand names of the plates and lenses she had used, the exposure time, the aperture and focal distance, light conditions, subject, and the exact time at which she had taken the photograph. By reviewing her notes and examining her negatives and prints, she learned from her mistakes and refined which elements she preferred. This demonstrates both her perfectionist and professional approach to her work. Using a pneumatic cable to release the camera's shutter remotely, Alice was able to photograph herself within compositions. These images provide records of her changing self, her friendships, and the upper-middle-class fashions and leisure pursuits of the day. Alice was an artist who looked at the world in a unique way, which informed her unconventional and provocative work.

The photograph in Figure 22 is emblematic of Alice's abilities and lifestyle. By 18, she had mastered her camera. She had a close group of girlfriends, the four of whom were called "The Darned Club" by some Staten Island boys, and they posed together for many of her most well-known images. Alice Austen (at far left) poses in a bathing costume with her friends Trude Eccleston, Julia Marsh, and two unidentified girls on the grounds of Clear Comfort. Being exceptional, and able to afford the freedom to be so, gave Alice confidence and opportunities.

When Alice was a late teen, she traveled via horse-drawn carriage to other locations on Staten Island, including the beach, bringing her 50 pounds of photographic equipment. She had multiple cameras, a tripod, a magnesium flash attachment, and all of the glass plates, some measuring 8 by 10 inches.[3] From the dirt roads of Staten Island to the newly made grounds of the first tennis club in the country, Alice took her camera. By the time she was 18, she was one of the first female photographers to work outside of a studio and to become quite accomplished.

Alice was able to pursue many diverse interests. She loved gardening and landscaping and won awards for her work at Clear Comfort. She was very athletic, playing tennis and riding bicycles, for which she published her first images in a book advocating for women to ride.[4] Always keen on mechanics and adventure, she was also the first woman on Staten Island to drive a car.

Her curiosity and freedom allowed Alice to have a full girlhood to pursue her interests. She created around 8,000 photographs in her lifetime, with around 3,500 surviving today. Yet because she was not paid for her work, she considered herself an amateur. Alice, along with her partner Gertrude Tate, lived off of the Austen family inheritance until it was lost during the 1929 stock market crash. As a result, she sold off her belongings and ended up in the Staten Island poorhouse. In 1950, her photographs, which she had given to the Staten Island Historical Society (SIHS), were discovered. It was only in her last year of life that her work was recognized and she was supported by the SIHS to move into a nursing home. She died in 1952.

Because of Alice and her historical significance, Clear Comfort (now known as the Alice Austen House) was designated a National Historic Landmark in 1993 and was restored, guided by Alice's many documentary photos. Alice's talent and skills to use her camera helped document her daily life, providing one of the first archives of turn-of-the-century girlhood.

23

Water Pump at Ivy Green, Tuscumbia, Alabama, 1887

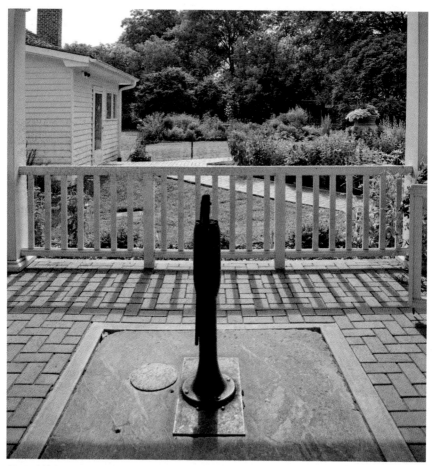

23.1. Water pump, on the grounds and interiors of Ivy Green, the house where Helen Keller grew up, Tuscumbia, Alabama.

One of the most famous girls of the late 19th century is Helen Keller. She was born at Ivy Green, a plantation house on 640 acres in Tuscumbia, Alabama. Built in 1820, the plantation was run by Arthur H. Keller, a former captain in the Confederate army, lawyer, and newspaper publisher. In 1877, he married his second wife, Kate Adams, a much younger, well-educated, independent woman. At 24 years old, Kate gave birth to Helen Austen Keller on June 27, 1880. Helen was a bright, healthy baby. She had even started speaking a few words before falling ill at 19 months old. The family doctor called it a brain fever.[1] As Helen began to recover, Kate quickly realized the illness had left Helen without sight or hearing.

As she grew, Helen became unmanageable, increasingly frustrated as her desire to communicate became stronger. Daily fits of kicking and screaming or uncontrollable giggling made many think she was going mad. When Helen was 5 years old, her sister, Mildred, was born. Not wanting to share her mother, Helen pushed over Mildred's crib, but luckily the baby was unharmed.[2] While her family desperately loved Helen, she was now a danger. Most children in this situation were sent to institutions, but the Kellers did everything to keep Helen at home. After many doctor visits, all concurred there was nothing that could be done to improve her condition.

Helen's childhood was lonely, having only one playmate she could communicate with: Martha, the daughter of their cook. They talked to each other in a kind of sign language with over 60 signs. While they got along, having fun and making mischief, Helen was very bossy. Helen later recalled, "It pleased me to domineer over her, and she generally submitted to my tyranny rather than risk a hand-to-hand encounter. I was strong, active, indifferent to consequences."[3] Read in the context of Helen's disabilities, it is easy to see how this was a demonstration of her strong will. However, in the context of her whiteness in post–Civil War Alabama, her comments show a sense of entitlement and superiority that is problematic.

When Helen was 6 years old, "the need of some means of communication became so urgent that these outbursts occurred daily, sometimes hourly."[4] The family visited Dr. Alexander Graham Bell, most noted for inventing the telephone, who was then working with deaf children in Washington, DC. He suggested they contact the Perkins Institute for the Blind in Boston. Less than a year later, a 20-year-old teacher appeared at the door. Annie Sullivan was partially blind herself, having had successful surgeries to restore some of

her sight after a childhood illness. Annie had gone through Perkins, where she learned the manual alphabet—and extreme patience—before graduating as valedictorian of her class. On March 3, 1887, just a month before her 21st birthday, Annie met Helen.

They began work the next day. The first few weeks of their time together was fraught. No time was wasted in Annie completely immersing herself in Helen's world, and she freely admitted to using physical force to get through to her pupil. The family had normalized Helen's tyrannical behavior such that they enabled her tantrums. At their first breakfast, they battled over Helen's behavior for hours, resulting in a broken front tooth for Annie.

Afterward, Annie asked to remove Helen from outside influences while she tried to teach her. They moved into a cottage on the property. At first, Annie taught Helen the way she had learned at Perkins, but quickly realized Helen would not be led. So Annie modified her teaching to focus on what Helen was interested in. Spelling D-O-L-L into her hand, she hoped for the connection, but Helen didn't feel it. Then, on April 5, 1887, Annie was trying to explain the difference between M-U-G and W-A-T-E-R to Helen while standing at the water pump (Figure 23.1). Annie pumped water over Helen's hand while signing. Helen suddenly realized what it meant. After this epiphany, Helen transformed into a pleasant, patient, and eager little girl. Helen acquired 20 more words on that first day alone. Within six months, Helen learned 575 words, Braille, and multiplication tables to five. Annie was a perfect teacher for Helen because she was equally stubborn and determined.

When it became clear more resources and a better learning environment were needed, the girls went to Boston for Helen to attend Perkins. Her time there was complicated. Director Michael Anagnos portrayed Helen's attendance as a triumph for the school, embellishing and publishing Annie's progress letters in the school's annual reports. Annie was reluctant to share in this, maintaining that Helen was still a young girl and not to be treated as a show pony. While this request was largely ignored, Helen's voracious appetite for learning extended to other areas of her life. She loved music, learning how to feel rather than hear it. She could even knit and crochet, but preferred reading. Helen also enjoyed exercise, learning how to swim and row.[5]

After Perkins, Helen wanted to attend Radcliffe College. After passing her exams and convincing the college president that she could keep up with the rest of the students, Helen enrolled in 1900. Annie also received a Radcliffe

education since she attended every class and translated the lectures into Helen's hand. When she graduated cum laude in 1904, Helen was fluent in three types of Braille, Latin, Greek, French, and German.

At Radcliffe, Dr. Charles Copeland encouraged Helen to write and find her personal voice. Her first published work was five installments in *The Ladies Home Journal*, for which she was paid $3,000. Following the column's success, Helen wrote her memoir, *The Story of My Life*, when she was 23 years old. The book offered insights into how she learned about her world. The projected values of Annie and her family are evident in her memories and descriptions of her life. Before Helen had names for the things in her life, all were equal. For example, she did not have the concept that some people were white and some were black or that some were servants and others masters.[6] But in the book, she describes people this way, so they were concepts she was taught.

Helen's girlhood achievements set the stage for a life in the public eye, of which Annie remained part until her death in 1936. Yet Helen's celebrity complicated her story. As Broadway plays and movies celebrated her life, the public largely overlooked how Helen's world was dictated to her, conveying the prejudices of society and those around her. Despite this, Helen's is a story of hope, overcoming physical limitations to become a voice for the deafblind community. No one expected what Helen achieved, and it was through Annie that Helen's great intellect and humanity were released into the world. Today, Helen's life and achievements remain a testament to these challenges at Ivy Green, which was placed on the National Register of Historic Places in 1954.

24

Statue of Annie Moore, Ellis Island, New York, January 1, 1892

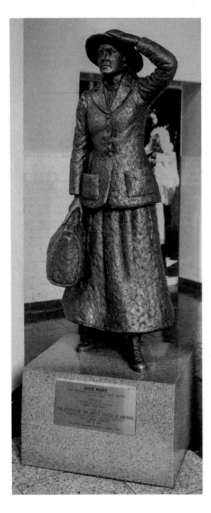

24.1. Statue of Annie Moore at Ellis Island, 2018.

NPS STATUE OF LIBERTY NM/ K. DALEY

Ellis Island sits just beyond the Statue of Liberty as ships enter New York Harbor. It is the most famous quarantine and immigrant processing center in the United States. From the time it opened in 1892 to its closing in 1954, around 12 million people started their new lives in America from this point of entry. As the first port of call for ships bringing immigrants from across the Atlantic, it served as both administrative and medical checkpoint. Around 33% of the current US population is descended from those brave and often desperate people who made their way through those large chambers.[1] Today, there is a statue of a girl in the Great Hall, her head held up as if looking for someone, with a suitcase in one hand and the other arm raised to hold her hat. This is Annie Moore, a teenage girl and the first immigrant to pass through Ellis Island into America.

The 19th century charts a shift from small boats of people making their way to the United States to large-scale immigration of millions from countries around the world. During this time, immigration was managed by individual states, rather than the federal government. Before Ellis Island was opened, immigrants arriving to New York came through the Castle Garden (now known as Fort Clinton) in Battery Park, Manhattan. This was the first processing center opened in 1855 to deal with the influx of Irish people fleeing the Great Famine. Castle Garden was still operating in 1888 when Annie's parents and older siblings arrived, several years before they sent for the rest of their children.[2]

Annie's parents were Matthew and Julia, who had come to America looking for work. There were great hardships in their past, including heavy drinking, mental illness, and premarital pregnancy. Yet coming to America was the dream of starting anew for many Irish people since the days of the Irish Famine. The Moore's lived at 32 Monroe Street, in the area known as Five Points, in Manhattan.[3] This was a densely packed area, with no running water or sewage and waste removal. Known for its bad air, Five Points was squalid, rife with disease and destitution. It is unlikely Annie would have known what sort of place in which they were going to live; children were told America was a wonderful place, and reuniting the family would have overridden any concerns about these realities.

Annie and her brothers, Anthony and Phillip, left from County Cork, Ireland, on the USS *Nevada* to reunite with their parents on December 20, 1891. They were among many children who traveled without adults to America during this time. Their parents were waiting for them, whereas many were

orphans and traveled as stowaways on the ships. The Moore children sailed for 12 days with 148 other passengers. Timing the sail just right, they arrived in New York on New Year's Eve, being processed the following morning on New Year's Day 1892. There are conflicting details about the children's ages. It is likely their parents lied about the children's ages to secure cheaper fares. This was a fairly common practice. The ship's manifest recorded Annie as 13 at departure. Several news reports claimed she turned 15 on the day of their arrival. The truth is that Annie was 17 years old when she arrived, and her birthday was actually in May.[4]

The particulars of the morning when Annie and her brothers walked into the Great Hall for processing were recorded in various ways. Some reported that several German men were ahead of them but that an Irish longshoreman shouted "Ladies first!," and her brothers pushed Annie to the front.[5] It is also possible that Annie was chosen to go first: a young, hopeful, Northern European, English-speaking immigrant made for a better story in the newspapers. Or perhaps she just walked faster than other people who may not have been able to read English or understand the signage and were more heavily laden with bags and small children.

What is not in dispute is that Annie was the first person in line and was brought to the registry desk of Mr. Charles M. Hendley, who requested the privilege of registering the first immigrant. He welcomed the teenager and asked, "What is your name, my girl?" Annie was registered and given a $10 gold piece (worth about $280 today) by the island's superintendent. Annie was quoted by the *New York Times* that she would "never part with it, but [would] always keep it as a pleasant memento of the occasion." Then, she and her brothers went into the station's waiting room, where their parents were expecting them.

After Annie and her brothers met with their parents, her story becomes largely one of conflicting accounts and assumptions. It is even argued that she never said she would keep her $10 gold coin as a memento. This would have been the largest sum of money Annie had ever seen, and the likelihood of her father letting her keep it is almost nonexistent. Ten dollars was about a week's worth of wages and a month's rent at the time. It has been suggested that the money was used by her father, either for a welcome party at the home or as celebratory drinking money for himself. These assumptions are based in both realities and stereotypes of Irish immigrants at the time.

Annie settled in the Lower East Side of Manhattan. As with much of her story, there has been much confusion. Recent historical analysis has confirmed that she never left her family's neighborhood for the rest of her life. She married Joseph Augustus Schayer, the son of German Catholic immigrants, in late 1895 at St. James Church.[6] Joseph worked at the Fulton Fish Market and for a bakery. Annie had at least 11 children, with only five surviving past childhood.

While Annie lived the rest of her life in four square blocks of Manhattan, the hopes and dreams of many young immigrants were inspired by the girl who was the first off the boat. In 1992, the Irish American Cultural Institute wanted to memorialize the legacy of Irish immigration to America. Irish sculptor Jeanne Rhynhart was commissioned to commemorate Annie's journey as the subject of two statues, the one in Figure 24.1 for Ellis Island and another portraying Annie with her brothers in Cobh Heritage Centre in County Cork, where they departed.[7] These statues stand for hope and bravery of individuals as well as the sociocultural impact of child immigration from all over the world to the United States in the early 20th century.

Portrait of Georgia Rooks Dwelle, 1904

25.1. Portrait, Georgia Rooks Dwelle, n.d.
COURTESY OF THE SPELMAN COLLEGE ARCHIVES

Opportunities for most girls in the South were limited through social and economic restrictions. However, the newly enacted Jim Crow laws severely hindered Black Americans trying to recover and move forward from the recent past. These laws were passed across the Southern states enshrining segregation and disenfranchisement of Black people. Yet still, for children of slaves who were born free, there was a sense of possibility not felt before the Civil War. There were some pathways that girls could pursue if they were resourceful and had their family's support. Education for Blacks was now legal and more widely available. One girl who was able to pursue an education with parental encouragement was Georgia Rooks Dwelle.

Born on February 27, 1884, Georgia grew up in Augusta, Georgia. Her parents were George and Eliza Dwelle. George was born to a slave mother and a white father. He was sold twice before he was able to buy both his and his mother's freedom. As an early teen, he learned to read and write at an illegal school run by two Englishmen. With a strength that came from taking control during his upbringing and his education, George became a minister and traveled primarily around the southwest of the state, helping to build churches, teach Sunday school, and uplift his people. George immensely valued education and was one of the first trustees of the traditionally Black colleges, Morehouse and Spelman. Eliza was his second wife, and Georgia was the only girl in the family, with four brothers: George, John, Thomas, and Edwin. All five of the Dwelle children received a college education.[1]

Throughout the country, health care for Blacks was dire at best, especially for females. There were few providers with qualifications and not many white doctors or nurses who would care for Black patients. Some who did were less than ethical in their treatment. Growing up in a house dedicated to the church and missionary work, Georgia inherited her father's desire to help improve people's lives. She attended the Walker Baptist Institute, an independent Baptist school that opened in Augusta in 1888. After leaving Walker, she entered Spelman Seminary (known today as Spelman College). Opening in 1881 as the Atlanta Baptist Female Seminary, Spelman is the oldest private historically Black university for women. At just 17 years old, Georgia graduated with an AB degree and is recorded as the first Spelman graduate to attend medical school. She studied at Meharry Medical College in Nashville, Tennessee, the first medical school for Blacks to open in the South.

Georgia's premedical education at Spelman didn't entirely prepare her for the rigors of medical school. When she arrived at Meharry, she had to supplement her studies with extra tutoring and courses at neighboring Walden University. Despite this setback, Georgia achieved an MD with honors in 1904, at the age of 20. The struggle for Blacks to obtain medical degrees was difficult, and even more so for females. Once the few who did graduate became doctors, it was very hard to establish practices. In the South, Black lives were regulated by Jim Crow laws, mandating racial segregation from medical schools to health care centers. Though the American Medical Association, established in 1847, did not officially discriminate, it was up to local chapters to manage membership. Especially in the South, white doctors were not interested in letting Black doctors, especially women, belong to the medical establishment and openly practice. Eventually, in 1895 in Atlanta, Black doctors, dentists, and pharmacists founded their own national body, the National Medical Association (NMA). The NMA provided "mutual cooperation and helpfulness" to the men and women of African descent engaged in these professions.[2]

When Georgia finished medical school, she returned home to Augusta and took the State Medical Board exam. Her exceptional aptitude served her well because she attained almost perfect scores, proving she was worthy of her license in a time when everyone was questioning her abilities. The *Women's Journal* mentioned her high scores, saying that it was "an indication of what is possible for a woman to do."[3]

Georgia moved to Atlanta in 1906, following in the footsteps of Eliza Ann Grier, a former slave who became the first Black woman to practice medicine in Atlanta. Like her predecessor, Georgia wanted to learn about the conditions of people living in the Black slums.[4] Atlanta was a booming city, having been rebuilt and repopulated since being razed during the Civil War. About 35% of the population was Black, many of whom had moved from the farms into the city. However, they were primarily unskilled and lived in overcrowded areas in the lowland parts of town. There was no sanitation; thus, it was rife with disease and crime.[5]

Georgia's discovery of how many people were living in extreme poverty and how appalling the conditions were convinced her to take immediate action. She rented a room, set up a couple of beds, and started a practice that would become the Dwelle Infirmary. Georgia specialized in gynecology and obstet-

rics. It was the first lying in hospital for new mothers that included a pediatric clinic, as well as the first venereal disease clinic in Georgia. In 1920, the Dwelle Infirmary officially became an obstetrical hospital, the first of its kind in the city. Georgia delivered 3,000 babies and reportedly never lost a patient.[6]

The portrait photograph of Georgia in Figure 25.1, which is held in the Spelman Archives, is an enigma. There is no date attached, and the location of the original is unknown. The digital image can be found on the internet without any attributions. Because it is held at Spelman, it is possible that it was taken when she was either in attendance or recently graduated, which would make her a late teenager. Despite her importance in both state and Black history, this dearth of information speaks to the need for research on Georgia as an important figure and health care practitioner. In addition to her medical association memberships, Georgia was a member of her Baptist Church, the National Association of Colored Women, and the Young Women's Christian Association (YWCA). Throughout her life, Georgia was concerned for Black women and children above all else. She continued what began as her father's legacy of serving humanity and became a champion of Black women's health.

Georgia's achievements have largely gone unknown and uncelebrated. Most medical history books leave her out completely. Her early girlhood and what inspired her passion for health care is a mystery—one worth solving. The forces that coalesced to give Georgia the courage and skills to make her way in such a difficult field, during a time of extreme racism and sexism, are worth discovering.

Part VI
STRIFE, 1870s TO 1910s

While some girls found America full of hope, others found the American Dream an unfulfilled wish full of strife. Across the country, forces such as immigration, poverty, entrenched racism, and imperial expansion re-created America's social landscape. The resulting social and political shifts made lasting impressions on the national psyche, even for girls, that are still felt today. Socioeconomic disparities widened after the Civil War, making life harder for many girls. While the last quarter of the century brought positive changes for some, others did not have childhoods in the way we think of them today. Rather, some were working for wages to help their families survive, while others faced endemic racism and sexism that tried to undermine their efforts to achieve success.

In Hawai'i, Princess Ka'iulani was the last of the Hawaiian royal line before the islands were annexed by the expanding United States. On the mainland, the government was discouraging the continuance of Native American culture through Americanizing education and displaying them as a dying race. Yet through a new sport called "basketball," the Fort Shaw Indian School Girls' team showed the world that Native Americans weren't going to quietly disappear. Meanwhile, the expanding textile industry employed thousands of children across the Northeast and South, including the young spinner, Sadie Pfeifer, whose photograph spurred changes in child labor across America.

And as immigration to the United States increased dramatically from all over the world, girls were being brought from China through Angel Island, which wasn't meant to welcome as much as keep them out.

Photograph of Princess Ka'iulani, 1881

26.1. Princess Ka'iulani at her home, 'Āinahau, at age six.

HAWAII STATE ARCHIVES. PHOTOGRAPHER UNKNOWN.

Recalling the importance of hula and girls in Hawai'i, a girl born in 1875 in Honolulu would see the end of an independent Hawai'i. The politics of late 19th-century Hawai'i were wrapped up in the growing influence of the business community and the sugar men, who wanted the land for themselves and were mostly descendants of or recently immigrated white Americans. Their greed and sense of entitlement grew as the century ended. This played out in the final years of the century with the death of King Kalākaua, the ascension of Queen Lili'uokalani, and finally the annexation of the islands by the United States, signaling the end of the monarchy in Hawai'i.

Princess Victoria Ka'iulani Cleghorn was the only daughter of Miriam, one of the four royal siblings in line for the Hawaiian throne. Her father was Scottish immigrant Archibald Cleghorn, who lived in Hawai'i for most of his life, held many offices, and supported the Hawaiian monarchy. Due to disease and general ill health, many members of the Hawaiian royal family were infertile.[1] There were no heirs until Ka'iulani was born. She was the answer to the prayers and hopes of both the royal family and the Hawaiian people.

Compared to her people, Ka'iulani grew up in luxury. King Kalākaua's lifestyle was so lavish that he had their Iolani Palace fitted with electric lights even before the White House had electricity. Ka'iulani was 11 years old when she flicked the switch, literally illuminating her country.[2] From the outside, it seemed Ka'iulani had a charmed life; however, there was great sadness and tragedy as well, including a traumatizing prophecy from her dying mother. At 6 years old (Figure 26.1), both Ka'iulani's godmother and governess died; both were like family. Just five years later, her mother died of an unknown illness. On her deathbed, Miriam predicted Ka'iulani's life would be sad and lonely, that she would never marry nor ascend to the throne. Despite this dire warning, Ka'iulani went ahead and planned for the life she intended, to serve her country as its queen.[3]

When Ka'iulani was 13 years old, writer Robert Louis Stevenson visited Hawai'i from his Polynesian island home in Samoa. Stevenson became friends with many members of the royal family, especially Ka'iulani's father Archibald, who, like Stevenson, was from Edinburgh, Scotland. Stevenson told Ka'iulani stories about Scotland, including ancient tales about Celtic queens. He also wrote her a poem, naming her "the island maid, the island rose, light of heart and bright of face, the daughter of a double race."[4]

Later that year, Kaʻiulani was sent to boarding school in England for an education befitting her eventual position as queen. Accompanied by her half sister, Anne, the girls had great adventures in England. Kaʻiulani learned about her Scottish roots as well, even learning the Scots' Gaelic language. She expected to meet with Queen Victoria, as her aunt Liliʻuokalani had done at the queen's jubilee in 1887, but because Hawaiʻi's status was in decline, an invitation never came. Through letters, Kaʻiulani kept in constant contact with Liliʻuokalani and was informed of most of the news from home.

During the final decade of the 19th century, Hawaiʻi was in constant upheaval. King Kalākaua died in January 1891, and his sister, Liliʻuokalani, became queen. She named Kaʻiulani as her heir. However, the economic and political situation had turned toward annexation. In January 1893, looking to escape high sugar tariffs, a cadre of businessmen, led by Samuel Dole, took control and forced Liliʻuokalani from her throne with the support of US Marines. Following this, 17-year-old Kaʻiulani visited the United States as an ambassador for her people. Many in the press were describing Hawaiians at the time as "savage,"[5] part of a propaganda campaign to persuade the American public that annexation was necessary for the Hawaiians' own good and not a brazen act of American imperialism. Kaʻiulani was not a savage. She was invited to the White House and made a strong impression on President Grover Cleveland and First Lady Frances.

President Cleveland was moved by her case that Hawaiʻi was being treated badly. To investigate, he sent James H. Blount, the former chair of the House Committee on Foreign Affairs, to find out what was happening on the ground. Blount's report was critical of the coup and recommended that Liliʻuokalani be restored to the throne. However, the government's chance to do the right thing was fleeting. The next president, William McKinley, who took office in January 1898, was pro annexation. Once the Spanish-American War began in April that year, the fate of Hawaiʻi was sealed. When the US began fighting in the Philippines, it needed a place in the Pacific for a base of operations. Despite McKinley's assassination, the annexation of the Hawaiian Islands was completed on August 12, 1898.

Kaʻiulani belonged to many worlds. She was the last in a line of Hawaiian royalty, with one foot in her remote island nation and the other, due to education in England, in Victorian society. She lived in a time approaching the

Belle Époque, where traditional norms were merging with a forward-looking viewpoint of the 20th century. Despite the excesses of her royal upbringing, her love of peacocks and croquet, Ka'iulani was a talented girl who learned languages, arts, and music.[6] She was afforded the time to do these things because of her station and wealth, but also because she was a girl. Being a girl was her strength and helped her cause.

When she was informed that Lili'uokalani had been removed from the throne, Ka'iulani was heartbroken for her country, but also for herself. Everything she had been brought up to be and do was taken from her. Ka'iulani was devastated when she returned to Hawai'i at 18 years old. On the day of annexation, when the Hawaiian flag was lowered, she and Lili'uokalani stood together in what they called a "day of mourning."[7] Sovereignty was lost, but the women continued to fight for the rights of Hawaiians to be able to vote because the only hope for their self-determination was through democracy.

Sadly, Ka'iulani's efforts of making a better life for her people were cut short. At the start of 1899, she became ill after riding her horse in a storm. She died a couple months later on March 6, at 23 years old. At the time, her death marked the end of hope for Hawaiians. The American government made it clear they were not going to relinquish the land they had taken and the control they asserted. Hawai'i was seen as too strategic to give back to its people. Ka'iulani is still remembered today at Iolani Palace and other landmarks that bear her name.

"Indian Girls Dressed for a Ball Game," 1904

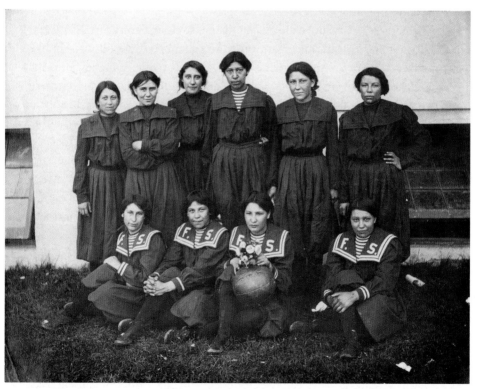

27.1. "Indian Girls dressed for a ball game, U.S. Government Indian Exhibit." (Fort Shaw Indian School Basketball Team) 1904 World's Fair.

In many ways, Native Americans were struggling to survive at the turn of the century. Through continuous efforts of the government, missionaries, and industries, an agenda of assimilation was mandated throughout the country, making traditions harder to maintain. Native schools were established to impose white culture through the paternalistic guiding hands of education. In 1891, a compulsory attendance law was issued; children were taken from their families to be "civilized" through a regime of Euro-American style boarding schools.[1] However, despite efforts to eradicate their cultures, Native Americans persevered, creating their own pathways within a system that did not want them to succeed. In 1904, a group of Native American girls became famous for doing something not at all expected of them—they became successful basketball players. The championship girls' basketball team of Fort Shaw Indian School made the public reflect on their assumptions about girls and Native potential.

The Fort Shaw Indian School began in an abandoned army fort near Great Falls, Montana, in 1892. Like many other assimilation schools, it was run like a military academy, with discipline of the students being of highest priority. Young people from many tribes across Montana, Idaho, and Wyoming were put together into dorms, with no regard for their backgrounds, historical grievances, or cultural conflicts. Native Americans were seen as a monolithic group, so this was an extension of the de-individualizing process. Their old clothes were burned and replaced with military-style uniforms. The curriculum included academic subjects but was not intended for achievement. Instead, the schools sought to make the girls into model housewives and domestic servants and the boys into farmers or manual laborers. As a result, most students didn't want to be there at all.[2]

Physical activity was a part of their daily routines, and especially popular was a new sport called basketball. Invented in 1891 by James Naismith at the International YMCA Training School in Springfield, Massachusetts, the game quickly spread across the country. It was introduced to the Fort Shaw girls by Josephine Langley (Blackfoot), who played when she was at the Carlisle Indian Industrial School in Carlisle, Pennsylvania. Playing by the same rules as the boys, the Fort Shaw girls' team very quickly became the best in the state. The girls were top athletes and well-rounded students. While all of them were from different tribes, they did have much in common; they were multilingual, and most were daughters of white fathers and Native mothers. The full team

shown here in St. Louis (Figure 27.1) is (standing from the left) Rose LaRose (Shoshone-Bannock), Flora Lucero (Chippewa), Katie Snell (Assiniboine), Minnie Burton (Shoshone), Genevieve Healy (Gros Ventre), and Sarah Mitchell (Assiniboine) and (seated, from left) Emma Sansaver (Chippewa-Cree), Genie Butch (Assiniboine), Belle Johnson (Piegan), and Nettie Wirth (Assiniboine).

As a result of their success in the state, the team was invited to the 1904 World's Fair in St. Louis to compete against any team that would play them. The Department of the Interior had several reasons for supporting this; they wanted to demonstrate that they had the Natives under control; they were compliant and could be taught skills to become acceptable members of society.[3] While the students may have been unaware of this exploitive purpose, they certainly understood why they were there upon arrival. The girls were housed in the Model Indian School, which was the focus of the Indian exhibition at the World's Fair, a place designed to reinforce the country's racist view of Native Americans.

Indigenous people from all over the globe were brought to the World's Fair, including tribes from the Philippines, pygmies from the Congo, and Ainu from Japan, all made to live in full view of the public for their entertainment and possible edification. Around 200 Native Americans from 14 tribes lived there for the summer of 1904 in traditional long houses, tipis, huts, and earth lodges.[4] The students from Fort Shaw and other schools were brought to St. Louis in early June and lived there through the hot summer until it became too cold, leaving in early November. Students demonstrated both traditional crafts and the new skills they were learning, thus illustrating the teachability of young Native Americans. Over three million people came through the World's Fair, and Indian Hill was one of the most popular exhibitions.

Under the guise of a learning experience and due to high demand, the students performed for visitors almost every day. The performances were big productions with a brass band and full costume; the girls wore buckskin and beaded dresses while they sang and danced. They played mandolins, did recitations and pantomimes to Longfellow poems, and performed many basketball demonstrations.[5] Often, they had to do press interviews. While wearing their traditional outfits, they were asked to take pictures with visitors. Being a team of Native American girls was meant to be a curiosity, and it was to most who saw them. But that didn't take away from the girls making the most of

their time there. They explored some of the fair and spent time with their fel-
low students, learning about the cultures of other tribes.

To prove their talents, several games were arranged for all-star girls' teams.
Every time, even with injuries, the girls of Fort Shaw prevailed by a wide mar-
gin. The core of their strength was their individual skills and speed, as well as
their cohesive teamwork. This led to their being praised as "natural athletes."
Thus, their achievements inadvertently made the twisted case for pseudo-
scientific assumptions about Native peoples. The media acknowledged their
wins, but were always careful to codify their praise in terms of their being
"dusky maidens."[6] The public was reminded at every turn that they were only
there due to the grace and auspices of the white culture that allowed it.

Despite winning all of their games, bringing home a trophy, and maintain-
ing a rigorous performance schedule, all while living in a dorm not meant to
withstand the cold of autumn and early winter in St. Louis, the girls were not
able to break through the dominant discourse of Native inferiority that perme-
ated American society and media. The Fort Shaw Girls' basketball team were
inspirational not only to their peers, but to girls all over the world. They were
more than hometown heroes, especially once the state of Montana claimed
them as state champions. The legacy and achievements of these talented girls
must be seen beyond the context of their position, as they were successful in
a situation where they were intended to be only showpieces.

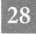

28

"Sadie Pfeifer" by Lewis Hine, November 30, 1908

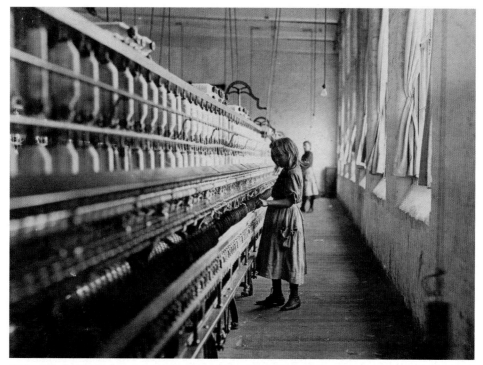

28.1. "Sadie Pfeifer" by Lewis Hine, November 30, 1908. Location: Lancaster, South Carolina.
LIBRARY OF CONGRESS, PRINTS & PHOTOGRAPHS DIVISION

Childhood wasn't fun and games for the roughly two million children who were working in the United States around the turn of the 20th century. In post–Civil War America, children across the agricultural South and industrial Northeast were employed in farms and factories. Many companies moved their businesses from the North to the South to take advantage of the multitudes of available workers, lower wages, and unenforced or nonexistent labor laws. Scenes of girls like Sadie Pfeifer (Figure 28.1) working for a living were all too common.

The majority of people who worked in these new Southern factories were from poor, white, uneducated families. Especially common for cotton and textile production, entire families moved to what became known as "mill towns," places that were set up with all of the essentials of a small village so workers would not have to travel for necessities. All residents were encouraged by the companies to participate in these new communities by becoming workers or those who served the workers (such as shop owners), yet racial segregation was maintained because bigoted attitudes from before the Civil War continued.[1] The companies' paternalism was duplicitous, both benevolent and exploitative, creating a dependent and loyal workforce and encouraging racist norms. Parents were urged to bring their toddlers to the factories, where they could be trained to do simple tasks that utilized their small hands, despite the obvious dangers.

Factory conditions ranged from decent to adequate to outright dangerous. There were no consistent laws governing factory workplace requirements or child labor. As a result, children worked 14-hour days, six days a week, with few breaks in mostly unhealthy environments. Many in the government profited from manufacturing and turned a blind eye to these conditions, claiming it was a harsh reality of achieving the American Dream. Others saw it for what it was: greed and exploitation. Reacting to growing public concern, the Department of Commerce and Labor commissioned a report to assess the condition of women and child workers in 1907. It found thousands of children working both legally and illegally (based on their ages in the specific states), in poor conditions, and some without any pay.[2]

Reformers made great efforts to raise awareness of these circumstances and promote regulations that would stop such practices. The National Child Labor Committee (NCLC) was formed in 1904 to promote the enactment of child labor laws. By 1908, photographer Lewis Hine was hired by the NCLC

to document children in their work life, gathering their images and stories. He spent three years traveling, disguising himself as a Bible salesman or an industrial photographer to be able to record factories, mines, mills, canneries, and fields where children were laboring.[3] The photographs were used to create pamphlets, posters, lectures, magazine articles, and other media to help campaign for child labor laws.

At the Lancaster Mill in South Carolina, Hine photographed Sadie Pfeifer, who became emblematic of the dire state of child labor in America. Girls as young as 7 years old were employed as spinners and seamstresses. Spinners would tend to large machines spinning many spools of thread. This job was reserved specifically for girls because owners felt girls paid more attention than boys. While the girls were rarely allowed to leave the factory, they had a short break when spools were replaced by the doffers, who were usually boys. On their feet for 12 hours a day, breathing dust and lint from the spinning threads, these children were unwell, often injured, and sacrificed any kind of childhood or education in order to earn a living for their families. Hine noted the conditions in the South Carolina mills, and mill towns were worse than those in North Carolina. To avoid breaking what few laws existed, the "helper system" was informally used to employ children who were grossly underage, off the books. It was presumed their wages were added onto a family member's earnings, but there would be little recourse if employers chose to overlook this addition.[4]

Sadie, whose real name was Sarah according to the 1900 census, had been working in the mill for six months. She was likely born on March 31, 1899, making her roughly 9 years old when Hine photographed her. Sadie was the youngest of eight children. Her family lived in the mill town of Gills Creek, near the Lancaster Mills. She did not attend school beyond second grade, when she left to work. She appears so small against the backdrop of the large spinning machines. It was important for Hine to show how diminutive and helpless children were in their situations. Due to the constant work, there was no opportunity to play or be outside, which is echoed on the sunlight that streams in behind her. The visual composition of Hine's photographs was designed to maximize the emotional effect on viewers.

Working children were thought of as little adults, who if not properly occupied, would become indigent and possibly criminal. This way of thinking also justified their employment. Besides needing all members of the family

to earn an income, education was not seen as beneficial to a child trapped in poverty. This was different for factory girls in the Northeast. They often lived in dormitories away from their families and were subject to even more dangers of work life. It was generally thought by factory owners that if girls were not under their complete care, working during the day and locked away safely at night, that they would become victims of moral decay. Using a paternalistic attitude to stoke fears as a justification, these companies made girls their "charges," and many would die under their watch. Neither system was designed for the benefit of the girls, but for maximum profit and maintenance of a suppressive social order.

Sadie's story did not end at that factory. She was married at 17 years old to Arthur Bush, who was 23 years old. They both continued to work in textile mills. After he served in World War I, the couple settled in Rock Hill, where they were employed at a cotton factory.[5] Sadie likely spent her entire working life inside of an unclean, loud factory. After multiple failed attempts to regulate the employment of children, the Fair Labor Standards Act was made into law in 1938, establishing for the first time a federal minimum wage, minimum age, and hours of work. These laws came too late for many girls like Sadie and continued to have many loopholes that were exploited by greedy employers, but they did save the lives of thousands of children who otherwise would have spent their entire lives inside the walls of the factories that helped build America.

Dormitory at Angel Island, California, 1910

29.1. Re-creation of the dormitory in which Asian women were housed at Angel Island Immigration Station.

XAVIER GOINS, ANGEL ISLAND IMMIGRATION STATION

Immigration into the United States occurred on all borders, including the East and West coasts. While millions passed by the Statue of Liberty and through the halls of Ellis Island, hundreds of thousands entered California via Angel Island. Sitting in San Francisco Harbor, Angel Island has a very different story to tell, not one of welcoming but of detention and deportation. While people came from all over the world, the majority of immigrants coming to Angel Island were Chinese and were subject to various racist government policies.

In order to process the increased immigrant numbers and to help execute xenophobic laws designed to discourage or prevent Chinese immigration, a processing facility was established on Angel Island, which operated from 1891 to 1925. Passengers arriving to Ellis Island in New York City or in first and second class to San Francisco spent only a few hours in quarantine. In comparison, quarantine of third class (steerage) passengers at Angel Island could last days, months, or even years on the island, with many eventually being deported.[1]

Typically, Chinese immigrants from the midcentury were single or married men who came to America with the intention of making money in the goldfields or building the railroads, then returning home after a few years. However, this rarely worked out in practice. Some did earn enough to send for their families, but most did not. Merchants were some of the only people who would have been able to afford the expense. Most of the women who came over without their families were intended for prostitution as trafficking girls to America from China was a lucrative business.[2] However, with the 1875 Page Act, essentially all East Asian women were barred from entry. This was largely to prevent Chinese prostitutes from being brought over by traffickers. Then, the Chinese Exclusion Acts of 1882 prevented all but a few privileged classes of Chinese from even entering the United States.

Human trafficking had existed in China for centuries. There was a system seen by some Chinese as beneficial to girls, but to others for what it was—socially acceptable slavery. Poor families would sell their young daughters to wealthy families or a middleman, who would then sell them on to be maids or concubines. This was called the *mui-tsai* system. The word itself means "little sister," but "little" is meant pejoratively. According to some, they were bonded servants, but in real terms that meant little more than a slave who was "adopted" into the family as a sister to soften the perception within the

family itself and to the public. It was described as a mutually beneficial act of charity.[3]

The poor family received a cash payment, and the girl typically became a servant, slave, or young bride for an older male. What the girls thought or wanted was not a consideration. The practice was justified by saying that the buyers would feed her, give her nice clothes, and potentially marry her off when she was old enough. However, this was not the outcome for most girls; instead, they were worked to exhaustion or death and often physically and sexually abused. This system continued when the Chinese immigrated to America, and many such girls entered through Angel Island. In America, the girls would arrive and be auctioned off, some as young as 6 years old. Traders selling older girls to established brothels could make thousands of dollars.[4]

The journey from China was a long one, at least 12 days with many stops along the way. Immigrant processing at Angel Island was crude and intended to make people want to leave. Women and children were separated from men when they got off the ship and were immediately sent for medical examinations. These were particularly humiliating for Asians, who had no precedent in their medical traditions of taking off their clothes for a doctor, especially a foreign one. They were then subjected to invasive examinations to determine whether the individuals had any communicable disease or parasites. Once inspected, they were housed in dormitories (Figure 29.1). These facilities were almost always overcrowded and unsanitary, with few working toilets. Families were separated and detained for long periods. With only a few allowances for humanity, women were allowed to knit and go for occasional walks for exercise.

To meet the demands coming from Chinese men, girls and young women, primarily from Canton, were sold to traffickers and taken to the United States. The girls were given fake documentation papers that showed they were either daughters or wives of men who already lived in America. Most young girls were sold as house servants to wealthy families or to brothels, while teenagers and young adults were sold as prostitutes.[5] In the brothels, young *mui-tsai* worked as "little sisters" to the older prostitutes, performing domestic chores and errands while training for their future work.

In the Chinese-American community in San Francisco, selling girls was a profitable business. The skewed gender ratio and enduring patriarchy brought with them justified the trade. Some girls managed to escape prostitution,

mainly by running away to missionary-run rescue homes, where they would be further indoctrinated in feminine gender roles and converted to Christianity. The Presbyterian Mission House in San Francisco's Chinatown rescued girls and women from abusive circumstances. The rescues were dangerous and often carried out as nighttime raids. Because they were so valuable, girls were often hidden behind false walls and under trap doors to keep them concealed from outsiders. Despite the best efforts of the slave owners to recover their property, the Presbyterian House helped keep the girls as safe as possible. Usually, these girls received an education and then were married off. In turn, many worked to help end the practice of *mui-tsai*, which disappeared by the 1920s.[6]

First-person stories of the experience of *mui-tsai* in America are extremely rare. For many, there is still a stigma around being a *mui-tsai* or even an immigrant. Women's and girls' stories at Angel Island are still being researched and uncovered. The recent discovery of poetry written by men who were held there shows that there might have been many tales to tell, but the women's dormitory burned down in 1940, so any graffiti or poetry has been lost. In 1983, some of the dormitories were restored and opened to the public.[7] These restored women's dormitories were where the young girls brought from China as *mui-tsai* would have lived. The present re-created dormitory can give us an idea of the physical realities, but so much of the emotional and mental trials have been erased.

Part VII
BECOMING "MODERN" AMERICAN GIRLS, 1910s TO 1940s

For many, the 20th century began on a positive trend, but the world was quickly propelled into its first major war by 1914. Girls and boys alike contributed to the war effort in productive and innovative ways. Giving girls a chance to participate proactively in society, Juliette Gordon Low started the Girl Scouts in 1912, and they quickly went to work supporting World War I efforts on the home front.

When the soldiers came home in 1918, there was an economic boom. This led to a time of excessive spending and the breaking open of social norms. Girls were riding bicycles, going to college, wearing makeup, and attending dances. The "flapper," with her free spirit and flowing clothes, became a symbol of this New Woman phenomenon. Capitalizing on this was the rapidly expanding film industry in Hollywood, California. A young Clara Bow pulled herself out of poverty and a traumatic family life to achieve movie stardom. Her iconic status and the "flapper" lifestyle led to more girls participating in sports, changing their fashion and personal needs. To accommodate these changes, girls' sanitary products changed too, as evidenced by the emergence of a range of menstrual products.

These new freedoms and extravagances proved unsustainable because the stock market crashed in October 1929, bringing about the Great Depression. America sought relief and distraction from the harsh realities of daily life in

Hollywood, especially Shirley Temple, who emerged in the 1930s to help the nation smile. Despite her efforts, the realities of the Depression forced changes for all. Significantly, millions of Blacks moved from the rural South to the North in search of work and better lives. Settling into big Northern cities like Chicago, girls had more options than ever before, yet traditions important to their history were kept alive in their play activities like jumping rope.

Overall, economic and social changes during and after World War I profoundly changed American girlhood. Gone were the days of confinement to home and domestic life because girls led more active, independent lifestyles and were more publicly recognized for their contributions. Modern America had begun, and modern American girls were there to lead it.

Girl Scout Pledge Card, 1917 to 1918

GIRL SCOUT PLEDGE CARD

TO SAVE FOR A SOLDIER:

I Will Give Up Meat one day per week.
Wheat breads and cereals one meal per day.
Candy two days per week.
Sweet drinks one day per week.

I Will Double the use of vegetables at dinner.
Double the use of fruit at luncheon or supper.
Try to help in securing milk for children of soldiers.

Patrol.............. Troop........................ Name...

Name of Captain..................................... Street................................

Date............................. City or Town...............................

NOTE.—These cards are to go to Washington. Sign and return imme-
diately to the Field Secretary, Mrs. Edna Mary Colman, 1417 Buchanan
Street, Washington, D. C.

30.1. Girl Scout Pledge Card to Save for a Soldier during World War I.

World War I began on July 28, 1914, changing the face of Europe and the geopolitical world dramatically. While a supporter of the Allied powers, the United States remained neutral until it was compelled to join on April 6, 1917, after sustained German aggression toward civilian ships crossing the Atlantic Ocean. Both the military and home front were mobilized quickly. Women and girls were incorporated into the war effort via their domestic assistance, especially through food rationing, equating this with patriotic duty. Aligned with their own mission, the newly formed Girl Scouts of America made participating in wartime support a priority. The Girl Scout Pledge Card (Figure 30.1) articulates just some of the sacrifices made by all during this time of national crisis.

Army General Lord Robert Baden-Powell began the Scouting movement in the United Kingdom in 1907. He created a model for training boys in a quasi-military fashion to teach them survival skills and physical fitness. At the first Boy Scout rally in 1909, many girls attended and declared themselves Girl Guides. The following year, Baden-Powell's sister, Agnes, officially founded the Girl Guides. During this time, American Juliette Gordon Low found herself in London, recently widowed and looking for a cause to get behind. Born in Savannah, Georgia, Juliette was raised to be a perfect Southern woman: a wife and mother, of which she was now neither. While in London, she met Baden-Powell and was inspired by his mission. In 1912, Juliette returned to Savannah and started the first Girl Guides troop with 18 girls, including her niece.

The organization quickly grew, moving its headquarters to Washington, DC, and changing the name to the Girl Scouts of America the following year. By 1915, there were over 5,000 members. Keeping with the military structure designed by Baden-Powell, local chapters, known as troops, were led by a captain with several lieutenants. Their primary goals were to make useful wives, mothers, and citizens out of each girl, including training them in skills for self-reliance.[1] Girls were given badges as a way to display mastery of a skill. This made learning housekeeping and other skills more enjoyable. However, Juliette also wanted to get girls outside and provide them with some of the same experiences that boys had. Each girl was taught woodcraft, to read a compass and map, build and put out a fire, and treat a cut finger according to first aid rules. Against social norms of the time, Low also made the Girl Scouts

open to any girl regardless of race, class, or ethnicity. While this played out with varying degrees of success, it spurred the development of nonwhite Girl Scout troops by the 1920s.

Since the turn of the century, girls, primarily in urban America, began to find their political voices. Especially during the labor movement, many participated in strikes and protests for better working conditions. This also made them aware of social movements, like temperance and suffrage. As a result, the Girl Scouts were ideally positioned to engage in politics in a socially acceptable way. Girl Scouts' advocacy focused on the practical aims of patriotism: they planted victory gardens, volunteered as ambulance drivers, made trench candles, and recycled essential material such as tin cans and glass bottles.

One method of practical patriotism is exemplified in this ration card (Figure 30.1). The Girl Scouts were quick to respond to President Woodrow Wilson's "Call to the Women of the Nation," which asked women to help conserve food through rationing and elimination of food waste.[2] With a bulk of the regular food supply now being shifted to feeding soldiers, this was a necessary sacrifice. Pledge cards were a popular way to show support of the cause. Housewives were asked to sign a pledge card showing their voluntary commitment to the rules set out by the government, suggesting days of the week that had both meatless and wheatless meals. Even First Lady Edith Wilson signed a pledge card.[3] The specific requests made of girls, both personally and through the pledge, exemplified the extent to which girls contributed to the war effort. Eating less meat, wheat, fat, and sugar, while eating more homegrown fruit and vegetables, was a way every child could be healthier and help the soldiers. This propaganda changed the way Americans ate and thought about food.

This notion of patriotic sacrifice was also used to help recruit recent immigrant girls to the Girl Scouts in order to ensure their allegiance to America. Increased immigration from southern and eastern Europe was viewed as a threat to American cohesiveness. Because these new arrivals largely did not speak English and had religions and traditions very different from earlier waves of Northern European immigrants, public sentiment was concerned with their loyalties. It was quickly realized that immigrant children, who were eager to learn English and fit in, would be easier to convince than their parents to leave the old ways behind. The Americanization of the immigrant girl was

a project eagerly taken up by the Girl Scouts. Upon joining, immigrant girls were recruited to sign ration pledge cards, helping to Americanize the way their families ate.[4]

Through individual and group service, including campaigns and competitions, Girl Scouts contributed to the war effort, from knitting socks to canning fruit and selling Liberty bonds. They raised a total of almost 10 million dollars in their war bond drives. The United States Treasury Department even produced a Girl Scout Service Medal for girls who sold the most bonds. Also, during the war, the first Girl Scout cookies were sold, with the proceeds utilized to make candy for soldiers overseas. Herbert Hoover, who was then the Secretary of the United States Food Administration, wrote to Low on more than one occasion thanking her for the work of the Girl Scouts.

The Girl Scouts, along with thousands of other girls in America, made their pledge to renounce their own pleasures so that soldiers could be well fed and well supplied while fighting. A Girl Scout War Service pin was made to recognize their enormous efforts, and objects like the pin and this pledge card serve as reminders of the personal fortitude and sacrifice girls made for their patriotic duty. Their dedication to creating spaces for girls to both learn and express their themselves increased and spread globally. Whether in times of war or peace, girls have demonstrated their ability to mobilize, go without, and contribute to the cause of patriotism, home, and family.

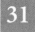
Paper Doll of Clara Bow, 1920s

31.2. Paper Doll component showing a yellow tennis dress for the Clara Bow paper doll.

THE CAROLYN AND DONALD FREPKE PAPER DOLL COLLECTION, ARCHIVES CENTER, NATIONAL MUSEUM OF AMERICAN HISTORY, SMITHSONIAN INSTITUTION

31.1. Paper Doll of Clara Bow.

THE CAROLYN AND DONALD FREPKE PAPER DOLL COLLECTION, ARCHIVES CENTER, NATIONAL MUSEUM OF AMERICAN HISTORY, SMITHSONIAN INSTITUTION

The 1920s brought great social changes for girls, including more freedom and more scrutiny. The excesses and indulgences of those who could afford it were glamorized and elevated through the new medium of film. Hollywood was the home of filmmaking and the men who used it to create much of American popular culture. While most people were not wealthy enough to look and act like movie stars, Hollywood sought to make them dream of such a life. Clara Bow, a desperately poor teenager in Brooklyn, New York, embodied this cultivated dream of fame as a way to escape her upbringing. By the 1920s, Clara became the most celebrated star with her image being reproduced worldwide—the personification of "flapper" culture and the "It" girl.

Hollywood was a fantasy machine, and teenagers around the country saved their pennies to go to the cinema and live in another world. This appeal was intense for Clara Bow, who suffered a tragic and lonely childhood. Born July 29, 1905, Clara lived in the notoriously overcrowded and unhealthy conditions of Brooklyn's Irish slums. Sarah Gordon, her mother, grew up in an abusive household and married as a teenager in order to get away. Sarah suffered from epilepsy and mental illness, and after two previous stillbirths did not expect Clara to live, so she never got a birth certificate for her.[1] Clara's father, Robert Bow, was a semi-absent alcoholic. When present, he was abusive. Clara was a tomboy, always playing in the streets in her ragged and dirty clothes. She did not have any girlfriends and attended school only sporadically until her early teens. Often, when Robert was away, Sarah resorted to prostitution to pay the bills, locking Clara in a cupboard to keep her safe during these instances.

Unfortunately, Sarah was even more of a threat to Clara's safety, having declared many times that she wanted to spare Clara the pain of a hard life by killing her. In one of his only acts of kindness during Clara's childhood, Robert moved the family to Sheepshead Bay, by the ocean, to keep the family healthy during the Influenza Pandemic of 1918. Sheepshead Bay was near the pleasures and vices of Coney Island.[2] Like a living dreamland, Clara loved the Coney Island boardwalk. At 13, she got a job slicing buns at the original Nathan's hot dog stand. Sarah went in and out of remission from her illnesses, sometimes behaving perfectly normal and attending to Clara's needs. This changed when Clara told her she wanted to be an actress. Ironically, Sarah believed actresses were prostitutes and forbade Clara from pursuing it.

In the fall of 1921, 16-year-old Clara entered a national talent competition called "Fame and Fortune."[3] She won the top prize, which included a screen

test and a feature in the January 1922 issue of *Motion Picture Classics*, naming Clara as a rising new talent. Quickly cast in her first film, Clara knew she wanted to be an actress, despite the disappointment of having her scenes cut. However, she woke up one night to see Sarah standing over her with a butcher knife. While her mother had no recollection of the incident the next day, Clara would never feel safe in her home and consequently suffered chronic insomnia for the rest of her life. Robert finally committed Sarah to a psychiatric hospital, where she died a year later. However, this did not protect Clara; Robert now directed his physical and sexual abuse toward her even while encouraging her film career. The Astoria Studios cast her in another film where she played a tomboy. For this, she earned good reviews and was discovered by Hollywood executives.

By 1923, 18-year-old Clara was on her way to Hollywood with a studio contract. Unfortunately, her father and a current boyfriend followed close behind. Robert lived with Clara and off of her money for the rest of his life. Clara enjoyed her success, despite always feeling out of place. Her friendly naïveté contrasted with her many love affairs, and the studio found it hard to manage her personal life. Professionally, she was exactly what they wanted. Flappers were fun, unpretentious, and had sex appeal. They were identified by what they looked like, did, and said. Clara's style fit this perfectly, both on and off camera.

When screenwriter Elinor Glyn named her the "It" girl and Clara starred in a film named "It," she became the top box office draw of the 1920s. She received more fan mail than any other star, around 45,000 letters per week. Millions of girls and women wanted to look and dress like her. Everything about Clara became a commodity: her signature "bob" hairstyle and interests in dancing, drinking, and smoking both as an homage to and in step with the "trends."[4] They bought her perfume and her latest fashions, all of which were dutifully reported on by fan magazines working in tandem with the studios. People are heavily influenced by images, and at the beginning of the movie industry, producers knew this, but viewers did not. Anything could be sold to an unwitting and eager audience.

The fantasy of transformation was personified by Clara.[5] One of the ways she was sold to young girls was as a paper doll (Figure 31.1). Paper dolls were being made in the United States in the early 1800s, but the Milton Bradley company began producing them in the 1920s on a commercial scale. They

were made in the likeness of celebrities and put in fashion magazines in order to sell clothes.[6] Practically speaking, paper dolls are a fairly egalitarian toy, inexpensive and easily managed by little hands, which became important during the Depression. Yet in Clara's case, they were more symbolic of her life and how fragile she was, despite her inner resilience. This doll depicts her in a coquettish pose, necessarily in her underwear. Yet in her yellow dress (Figure 31.2), she is posed holding a tennis racket, which Clara herself enjoyed playing, but was also representative of the athletic girl who was free to move and participate in games of strength.

Clara's career lasted only a decade. Her life was plagued by scandals, but it was technology that was her undoing. Once sound was introduced to movies, Clara was not comfortable with her own voice and her thick Brooklyn accent. Like many silent film stars, she struggled with the transition. Throughout her career, she wanted to be accepted as normal, once stating, "I don't think I'm very different from any other girl—except that I work harder and have suffered more. And I have red hair."[7] But Clara left it all behind in 1933, at the age of 28, having made 57 films. As a child, Clara may not have even had the money to play with the dolls that would later be made in her likeness. Yet Hollywood transformed her—both financially and personally—into a doll. A likeness to be imitated, perfected, and played with, yet never fully recognized as someone vital, vibrant, and unique.

Cashay Sanitary Puffs, ca. 1934

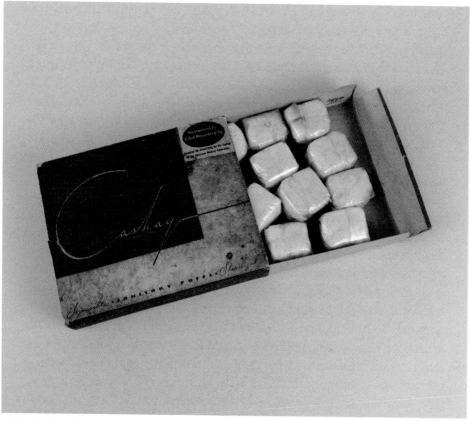

32.1. Cashay Sanitary Puffs.

In the early 20th century, there was an increased focus on girls' well-being, especially because they were less confined to domestic life. Menstruation was both universally experienced and kept completely hidden by female family members. Prior to the 20th century, it was completely normal for menstruating females not to leave the home, affecting their ability to participate fully in society, education, and the workforce. As norms for girls were changing and girls increasingly participated in society outside the house, a desire for better solutions to their personal hygiene grew. If an acceptable solution could be found, companies saw the potential for huge profits. Cashay Sanitary Puffs (Figure 32.1), which were a type of early tampon, are one of many products that became widely available and more affordable in the 1920s and 1930s.

The various methods females have used to deal with their periods over time had not changed much over the centuries. These ranged from free bleeding into clothes, to using strips of old cloth or natural objects, like moss, sea sponges, or even animal skins, to help absorb menstrual flow. However, over time, menstruation itself changed. The average age of the onset of menses declined, from age 17 in 1860 to age 13 and a half in 1902, though that was largely dependent on several factors, such as health and social class.[1] Wealthier girls with more and better food got their periods earlier than the overworked and underfed lower-class girls. Generally speaking, girls were also pregnant earlier and more often and breastfed their babies longer before the 20th century, which simply reduced the number of periods they had.

Progress in the styles of undergarments was the first step in addressing the earlier onset of menstruation. The pantaloons of the mid-1800s, which were split in the middle for toileting, were sewn up. By the 1920s, these developed into underpants. The "New Woman," a healthier, more able-bodied public woman, did not want her activities hindered by menstruation. Since many girls had used the same cotton or wool strips to bleed into for an entire menses, the possibility of infection posed health risks that doctors started to recognize. In response, products specific to menstruation were developed to replace the natural remedies. There were some women active in developing products on a small scale, but in 1896, Johnson & Johnson introduced the first commercial sanitary pads, Lister's Towels.[2] These were not successful because most women were too mortified to purchase them in public.

The idea for disposable pads came from nurses in France during World War I, who repurposed bandages for soldiers as sanitary pads. They were

filled with absorbent wood pulp and were so cheap they could be discarded after use. The Kimberly & Clark Company, which had made bandages used in the war, took the idea and improved the design for menstrual purposes. They also solved the issue of marketing by giving it a name that hides their use: Kotex. Going on the market in late 1919, Kotex was sold through "honesty boxes," where girls could deposit their money and take the products without having to interact with any salespeople.[3] This helped those who were embarrassed to buy sanitary products from male shopkeepers.

In 1927, psychologist Lillian Gilbreth conducted a study for Johnson & Johnson, interviewing thousands of college and high school girls and professional women across the country about their sanitary product preferences. For the first time, girls were able to influence some of the manufacturers' decisions. As a result, new ad campaigns focused on girls participating in sports and recreational activities, disconnecting periods from reproduction, and reinforcing the ideas of bodily autonomy and an active adolescence. The very notion of girls being asked about their periods, their preferences, and being able to take part in employment or leisure activities without having to worry about bleeding through their clothes was progress.

Other products were quick to reach the market, including tampons and menstrual cups. In 1929, tampons were made available for commercial use. Nearly a decade later, in 1937, female entrepreneur Leona Chalmers developed the menstrual cup, a reusable menstrual product, claiming, "it took a woman to ease women's most trying ordeal."[4] Yet while the Moon Cup was a safe and ecologically friendly alternative, not being able to dispose of a used product was seen as a step backward. The American cultural push was for consumption as a status symbol, with disposable items seen as more prestigious since they required wealth to keep buying new ones.

How companies positioned their products still kept girls and women in their place, ashamed of their body's normal functions, while making them feel empowered by their purchase. The manufacturer of Cashay, Park and Tilford, describes their product as such:

> Cashay is hailed as the miracle invention. No wonder! It has at last freed women from discomfort, embarrassment and social-inactivity during their "difficult days." Cashay, worn internally, eliminates chafing bulging pads, hot binding belts, offensive tell-tale odors. Cashay brings the new freedom demanded by modern women![5]

Cashay even offered free consultations on how to use its product and its benefits, emphasizing safety and freedom as its great advantages.[6] The box is stylish, yet discrete, and comes complete with a seal of approval by both *Good Housekeeping* magazine and the *Journal of the American Medical Association*. However, these were paid advertisements—an early form of native marketing. There was, however, controversy around tampon use. Claims that girls would no longer be virgins after using them and that it was unhealthy for girls to touch themselves were used to try to control girls' bodies, and they persist to this day.[7] It should also be noted that these products, like most, were aimed directly at white girls and women. At this time, the experiences of girls of color with menstruation and targeting them as consumers was not of interest or commercial concern.

Though menstruation was still something to be hidden from society, the early 20th century brought recognition of the need for menstrual products, especially because girls led more public lives. These were part of the new push that transformed girls and women into mass consumers. With manufacturers and advertising campaigns targeting girls as a part of their market, this provided greater evidence of girls' biological needs more than previous centuries. Yet these campaigns aimed to make them feel inadequate and not as pretty, happy, or healthy as the images they saw, which prompted them to buy more products. This social change, turning girls into consumers, turned every part of girls' lives into a marketing opportunity.

Stand Up and Cheer! Dress Worn by Shirley Temple, 1934

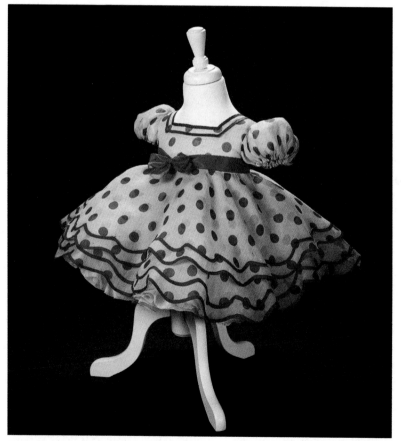

33.1. Dress worn by Shirley Temple in *Stand Up and Cheer!* (1934), which was Shirley's first breakthrough role in film.

The Great Depression affected every aspect of American's lives. In providing comfort and escape from day-to-day realities, the Hollywood machine capitalized on minds and bodies hungry for distraction and entertainment. Songs and smiles became a commodity. Movies pushed the smile of one particular toddler into the public's affection, changing both her life and the way Americans went to the movies. But in a typical Hollywood story that still plays today, this smile would age out, no longer needed to salve the public's wounds. Shirley Temple made her film debut at the age of 3, and her last film by 22 years old, during a film career that was over just after she reached voting age.

Shirley Temple was born in Los Angeles, which was already filled with movie star hopefuls, on April 23, 1928. Her mother, Gertrude Temple, enrolled her at the Ethel Meglin Dance Studio while she was still a toddler. Shirley's father, George, worked for a bank, until her fame became too distracting. Despite having two older boys, Gertrude was completely focused on making her little girl a star from the moment she was born. Gertrude became Shirley's manager as well as her costumer and hairdresser, rolling her signature 56 ringlet curls every night.[1]

After being discovered at the dance studio by the Educational Pictures company, Shirley made eight films for them from 1931 to 1934. Called "Baby Burlesks," these short films were billed as comedy spoofs, featuring toddlers dressed in diapers acting out very adult roles.[2] Reflecting mature expectations, the boys behaved rough, drank (typically, milk from bottles), and fought over social slights and the attention of a girl. Shirley was one of the only girls, usually barely clothed, playing everything from love interests to prostitutes, and dancers to lounge singers. Reflecting the structural racism of the day, servants and waiters were played by Black children. Meant as parody for adult amusement, these films bordered on soft-core pornography, combining the infantilization of women with the sexualization of children and reinforcing the trope of "boys will be boys." These themes followed Shirley throughout her career.

In her first big feature film role, at the age of 3, Shirley won over audiences in *Stand Up and Cheer!* for Fox Studios. Performing a tap dance routine learned at her dance studio, Shirley wore this red polka-dotted dress (Figure 33.1) for her big number, "Baby Take a Bow," at the end of the film. Her persona of cuteness and positivity imprinted on audiences and executives

alike, while Shirley's dresses were set at the size of a baby. The short length served several purposes: it made Shirley appear younger than she actually was, accentuated the idea of a child's body, and showed off her legs (which was against the norm for older girls). In fact, the studio published her age as a year younger than she actually was, which allowed them to "sell" her girlhood for a bit longer.

From the start of Hollywood films, it was apparent that just because a movie starred a young girl didn't mean the film was suitable for children. Many of Shirley's routines were aimed directly at men, both within the film and in the audience. Shirley was literally "manhandled" by male actors and dancers. She was physically passed around, made to sit on various laps, and held in the air by multiple sets of hands. This on-screen treatment of America's most adored child reinforced the notion that children—especially girls—were subordinate to adults. It also set expectations about the availability of children's bodies, especially girls' bodies, to adult interests.

From 1935 to 1938, Shirley was the number one box office draw.[3] But being Shirley was not easy. Once her baby blonde hair darkened, she endured weekly hydrogen peroxide washes and nightly rolling of her hair into ringlet curls to maintain her image. She also sustained a persona, which her mother claimed was never acting, only play. This blurred the boundaries between her on-screen and private self. With the studios and movie fan magazines working together to promote certain actors, Shirley's private life vanished, making her a target of both adoration and harassment. Within her thousands of fan letters were constant threats of kidnapping, and one woman even tried to shoot her during a live performance.[4] Also, despite the manufactured innocence built into her identity, Shirley became an object of desire, both on-screen and off. In her autobiography, she recalls many instances of inappropriate behavior and attempted sexual assaults by producers, directors, and actors.

Not unlike Sadie Pfeifer and girls of the textile mills, Shirley was a child laborer. Her experience was vastly different in terms of work environment and rewards, but neither of these girls' labor was regulated. In 1911, the National Alliance for the Protection of Stage Children unsuccessfully argued for uniform laws that would help regulate child labor in entertainment. When President Theodore Roosevelt implemented the Fair Labor Standards Act in 1938, there was an exception for child actors, so they remained unprotected.[5] Shirley, at 10 years old, often worked 12-hour days. Because she was groomed

to think of her work as play, everyone else bought into that idea as well. Shirley worked very hard, but did not see herself as an employee. Making the point repeatedly in her memoirs, the physical and emotional demands on child stars were very high, and they took a great toll on her personal life, though she didn't realize it at the time.[6]

Being one of the first successful and most commercialized child actors, Shirley was the total package of girl innocence. After *Stand Up and Cheer!*, Shirley began receiving around 4,000 fan letters a week.[7] She was marketed as a good girl, a moral girl, always saving the men of her films from themselves. Audience members could even buy her innocent appearance. Shirley dolls were extremely popular gifts—even she had one. Her films and products were marketed to children directly, transforming the landscape of consumer culture and society at large.

As Shirley grew older, she didn't want to maintain the persona of cuteness, and the studios struggled to find successful roles for her. Then, at only 17 years old, Shirley got married. She had a child, Linda Susan, but was divorced after only three years because her husband was abusive. In 1950, while on holiday in Honolulu, she met Charles Alden Black, a navy officer 10 years her senior who had never seen any of her movies.[8] They were married, and by age 22, she had made her last film. Shirley's stardom marked a dramatic change in the interrelation of celebrity culture and the commodification of childhood. While she remains the youngest actor—age 6—ever to win an Academy Award, Shirley went on to work as an advocate and a diplomat, including serving as Ambassador to both Ghana and Czechoslovakia, trying to make the world a better place with more than just her smile.

"Jumping Rope on Sidewalk" by Edwin Rosskam, April 1941

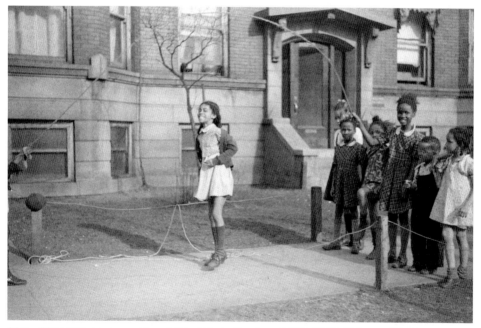

34.1. "Jumping rope on sidewalk" by Edwin Rosskam (1903–1985), Chicago, Illinois, 1941.
LIBRARY OF CONGRESS, PRINTS & PHOTOGRAPHS DIVISION

One of the largest, slow-moving human migrations occurred from roughly 1910 to 1970 in the United States. Known as the "Great Migration," around six million Black Americans made their way from all points in the South to mostly urban areas in the North and West, fundamentally changing the American sociopolitical landscape. They sought to improve their opportunities, receive higher pay, escape the constant threat of violence and oppression under Jim Crow laws, and give their children better schooling and safer neighborhoods that allowed for outside play. Many ended their journeys in Chicago, an industrial and railroad hub. Due to racist housing covenants and white resistance, Blacks settled in areas primarily on the south side of town, in rundown neighborhoods called the "Black Belt." For adults, life was still very hard, having to find work in a completely different job market and dealing with racism under new guises. But for children, especially girls, their parents' dreams were at least partially achieved: their new homes fostered greater safety and opportunities than had been unavailable in the South.

Yet even within the Black Belt, areas were segregated by economic status. New arrivals often ended up in poorer housing, while more established Black families lived in newer, better properties. Overcrowding in the slums led to poor sanitation and ill health, especially for children. Children playing in the streets were symptomatic of urban planning that did not account for overcrowding. In every city, children played in the streets and on the sidewalk, largely unsupervised, since there were no parks or playgrounds. Safety was a huge issue, with the threat of children being injured or influenced by wayward adults and criminal behavior. In some cities, it was illegal for children to "loiter" in the streets, and even the very young were arrested by the police. An early arrest often brought children into an inescapable cycle of crime and violence for the rest of their lives. This did not stop children from playing, but it did encourage city planners to start making provisions for them in the form of parks and playgrounds.[1]

Showcased in this photograph (Figure 34.1) is one game that became ubiquitous in Black neighborhoods—jump rope. Games involving jumping over rope have ancient roots, but they came to the United States with Dutch immigrants in the 1600s. Requiring only a rope or two, which were relatively easy to come by, it provided entertainment in an outdoor environment, which was presumed to be healthier than inside. Girls typically dominated the play, using clotheslines, preferably still a bit damp to provide the weight for a good

swing.[2] Jumping rope gave children an activity that spanned age groups and was instructional. The songs and rhymes that accompany jump rope have been used to transmit information. After the Civil War, education was still closely guarded by whites, who were afraid educated Blacks would threaten their control. Black girls who sought an education, even as slaves, were aware that learning was an act of resistance, and they had to be creative in sharing this contraband knowledge. The jumping rhymes were a way to learn basic literacy and other important cultural and social instructions:

> Jump rope provided oral lessons and warnings of potential difficulties in life and early academic instruction and opportunities to experiment with the rhythm of language. The words and beat of a jump rope chant demand involvement, participation, and action while simultaneously offering generational connection, encouragement, and verbal challenge.[3]

On the streets of the South Side, girls and boys could jump for hours, playing and performing as well as teaching and learning new words and moves. The jumpers, rope turners, and audience all helped to make the game successful, through the rotation, participation, and the songs.[4] While life was difficult in many ways, this opportunity to play was important for everyone. A second rope can be seen in the background of the photograph, implying the children were also playing "double Dutch." Using two ropes in tandem made for a fast-paced, thrilling game that was a challenge for players and spectators alike. By the mid-1960s, double Dutch became synonymous with Black girls' play. The American Double Dutch League was created in the 1970s as outreach to inner city girls who were seen as at risk.

Street play and many other aspects of Black girls' lives were captured by photographer Edwin Rosskam in April 1941, when he visited Chicago for the Farm Security Administration's mission to record living and working conditions of Americans. Rosskam, along with Russell Lee, recorded life in Chicago's Black Belt, ensuring hard work and success were documented alongside poverty and misery. These two white male photographers were guided by Black author Richard Wright, who was in Chicago doing research on Black folk history. Rosskam's photographs depicted young mothers in doorways, groups of unsupervised children gathered on building stoops, girls working in shops, and well-dressed girls waiting in lines to go to the movie theater or on

their way to church for Easter Sunday. The fashions and activities of the day showed the range of experiences girls were having in this urban environment. These photographs culminated into a collection called *Twelve Million Black Voices*, accompanied by Wright's text.[5]

The images of girls' lives documented by Rosskam provide more than a glimpse into a world of which most of America was unaware and provide early insights into the girlhoods of successful female artists who grew up on the South Side. Acclaimed playwright Lorraine Hansberry wrote her first play, *A Raisin in the Sun*, about a Black family on Chicago's South Side, which is loosely based on her personal experiences growing up and became the first play written by a Black woman to be performed on Broadway. Additionally, Pulitzer prize–winning poet Gwendolyn Brooks grew up in the same area, publishing her first poem in *American Childhood* when she was 13 years old, and going on to publish over 75 poems by age 17. Both women attributed growing up in Chicago as a major influence on their creative practice.

While changes occurred for both those who moved and the places they arrived, the population shift gave young Black Americans choices that simply did not exist in their previous lives. Girls found their voices and the means to express themselves. Like Lorraine and Gwendolyn, whether or not they jumped rope on the sidewalk themselves, they would have known a new sense of freedom, with the excitement of the game and the sights and sounds of girls' play echoing through the neighborhood streets.

Part VIII
VOICES, 1940s TO 1950s

As with any conflict, World War II brought changes to American girls' lives. Yet despite general social and economic shifts, one group of girls that was profoundly impacted were girls of Japanese ancestry. Shortly after Pearl Harbor was bombed in December 1941, Japanese families were rounded up and sent to live in "relocation centers," which were essentially military prisons. Elizabeth Kikuchi's letters give us insight into her internment and demonstrate that the actions of government do not always reflect the will of the people.

As the war ended, the introduction of *Seventeen* magazine encouraged girls to continue their patriotic participation and broaden their horizons before it was co-opted to instead encourage traditional gender norms and support the growing view of white teenage girls as major economic decision-makers. In contrast, the appearance of the *Patti-Jo 'n' Ginger* comic (and eventual doll) gave Black girls a voice in popular culture that amplified their feelings on discrimination, government policy, and the burgeoning civil rights movement.

As girls of color began to see themselves represented as actors rather than passive observers, their actions became more public. Sylvia Mendez, a Mexican-American girl, was instrumental in desegregating California's schools while paving the way for the landmark *Brown v. Board of Education* case that would end school segregation nationwide. Another fighter for social justice was 16-year-old Claudette Colvin, who refused to give up her bus seat

nine months before Rosa Parks, yet was passed over as a face of the civil rights movement in favor of Rosa's older, more genteel persona.

As the 1950s ended, girls were in the public eye more than ever before. Though popular culture was beginning to reflect these new norms, one of the biggest changes came with the advent of the Barbie doll. When she debuted in 1959, Barbie took the toy market by storm and inspired ideas of nondomestic success in a new generation of girls. In all these events, girls used their voices to take on more public leadership roles within their families and society, profoundly altering American society and seeking fulfillment of the American Dream in the 20th century.

Elizabeth Kikuchi's Letter to Clara Breed, May 25, 1942

> assembly center
> Santa Anita, Calif.
> May 25, 1942.
>
> Dear Miss Breed,
>
> I am sorry I did not write as soon as I received the books. Every night after I get in bed I think of writing the letter to you but next day I never get a chance to be alone because two girls live with us. We have all girls in our room so we call it the girls dormitory.
>
> The Sheep Wagon Family book was very interesting. I like adventure books very much. The book, Story Parade is very nice. I read one story each day. Our library shelf is getting very crowded because of all the books you sent us.

35.1. Letter to Clara Breed from Elizabeth Kikuchi, Arcadia, California, May 25, 1942.

JAPANESE AMERICAN NATIONAL MUSEUM (GIFT OF ELIZABETH Y. YAMADA, 93.75.IBG)

World War II affected American girls in many ways. While most remained at home, subject to rations and conditions similar to World War I, one group of girls was torn from their homes and sent far away. Families of Japanese ancestry were uprooted for "military necessity" and spent up to three years in what were called "relocation centers" but today are known as internment camps.[1] Among them was 12-year-old Elizabeth Kikuchi, who lived in District 3 of the Santa Anita Assembly Center in Arcadia, California. She corresponded with Clara Breed, a white librarian, who sent books and supplies to children throughout the centers. Her letters, like the one in Figure 35.1, are now held by the Japanese American National Museum and provide a tangible record of girlhood during Japanese internment.

Since their arrival in California in the 1840s, Japanese immigrants (*Issei*) and their children (*Nisei*) were targets of racist sentiment and segregation. In 1913, the alien land laws denied *Issei* the right to own land. By 1924, all immigration from Japan was terminated, and immigrants could not become naturalized citizens.[2] However, *Nisei*, those born in the United States, were citizens. This legal difference led to generational disconnect and social tension while enforcing racial discrimination against the Japanese.

When Japanese fighter planes attacked Pearl Harbor in December 1941, Americans reacted with fear and anger. The Federal Bureau of Investigation (FBI) quickly rounded up suspected "enemy aliens" in Hawai'i and along the West Coast; most were male community leaders who had been under surveillance before the attacks.[3] Despite little evidence to convict assumed traitors or spies, the arrests increased the fear of all Japanese. Under threat, *Issei* and *Nisei* burned family heirlooms and personal belongings they feared would arouse suspicion, from centuries-old calligraphies and artwork to documents like personal letters or children's school drawings.

In February 1942, Executive Order 9066 was issued by President Franklin D. Roosevelt. The order authorized the Secretary of War to define relocation centers under military authority where people could be excluded from American society to prevent further attacks. The order didn't name any specific group, but it was assumed to mean the Japanese. From March 31 to August 7, over 120,000 people living on the West Coast, nearly all of them Japanese, were rounded up and sent to 10 relocation centers.

Elizabeth Kikuchi and her family were among those forced to leave their homes. With less than a week to pack, they were able to bring only what they

could carry in suitcases or duffel bags. The rest of their belongings were sold or stored, though by the time they returned, almost everything was gone due to looting and vandalism. "For many children, the most traumatic experience was leaving behind their family dogs and cats, since animals were not allowed to go with them."[4] Loaded onto buses, they were transported to assembly centers at racetracks or fairgrounds, sleeping in horse stalls until enduring the long train ride to relocation centers. There, families were assigned to wards of barracks, forming small communities. Each barrack was divided into four or six rooms, and each family was assigned one room measuring 20 by 25 feet. They were given only canvas cots, a pot-bellied stove, and a lightbulb. Each ward shared a kitchen, laundry, mess hall, bathrooms, infirmary, school, and church.

Conditions at the camps were a little better than military prisons. Overseen by white directors and civilian assistants, days passed on a strict schedule: siren alarms in the morning, roll calls, and a detailed timetable for each age group. While her parents grew vegetables to supplement their rations or worked odd jobs for little pay, Elizabeth went to school and engaged in pro-longed leisure time to play games or participate in group activities like scout-ing. This system broke down traditional Japanese family life and *Issei* parents lost their authority and responsibility. As Elizabeth wrote, "My brother, David, he is too busy to write. He plays all the time with his friends. After school he goes chasing Jack Rabbits." Like many children, David had relative freedom outside of classroom time, in great contrast to their lives beforehand. Other Japanese wrote of the changes, such as Yoshiko Uchida, who noticed that "Whenever the children played house, they always stood in line to eat at make-believe mess halls rather than cooking and setting tables as they would have done at home."[5] For these children, the definition and routines of "home" had changed dramatically.

Elizabeth's letter also shows that not all Americans feared the Japanese. Some felt the internment was wrong and sought to alleviate the detainees' burdens, as evidenced by Elizabeth's correspondence with Clara Breed. Like many who denounced internment, Clara sent children's books and school supplies to the camps. As Elizabeth wrote after receiving a box of books, "I read one story each day. Our library shelf is getting very crowded because of all the books you sent us. Pretty soon my father is going to make us a bigger shelf." Clara's kindness provided some children reminders of the world they had been forced to leave.

Other *Nisei* fought for release from the camps. In July 1942, Mitsuye Endo—a *Nisei* Christian who had never been to Japan, spoke only English, and had a brother in the US Army—filed a writ of habeus corpus, which claimed her detention was unlawful and argued for her release to pursue the case in court. Endo's case was sent to the Supreme Court in 1946, which unanimously ruled that "citizens who are concededly loyal" could not be detained.[6] The day before the ruling was made public, President Roosevelt issued Public Proclamation No. 21 to rescind Executive Order 9066. After 900 days in captivity, Elizabeth and her family began the difficult process of returning home. The government gave each internee $25 and put them on trains home, leaving internees to rely on churches and charity organizations to help them resettle. Most had lost everything, and those who returned to their old homes reported being targeted by racist attacks.[7]

Regardless of age, *Issei* and *Nisei* were highly conscious of what transpired during their internment. It left irreparable wounds to their consciousness as both individuals and an ethnic group. Many were angry, melancholy, or bewildered, but most became far too busy trying to rebuild their lives to write their stories or seek reparations. "For decades after the war, many former internees repressed memories of the war because they blamed themselves for the incarceration."[8] Elizabeth stated in a 2019 interview that Clara Breed's kindness gave her hope; she kept one of the books, *House for Elizabeth*, that Breed had sent her.[9] They remained close friends until Breed's death in 1994, when Elizabeth inherited Breed's collection of letters and donated them to the Japanese American National Museum.

Elizabeth's story demonstrates how xenophobia and racism were central issues of World War II. Believing all Japanese people to be like those who attacked Pearl Harbor, unable to consider that *Issei* and *Nisei* more closely identified with America than Japan, the government systematically excluded and interned them. It took over 35 years for a federal investigation about the camps to begin. Its findings included that Executive Order 9066 was not justified by military necessity, but rather was the result of prejudice, war hysteria, and a failure of political leadership. Despite this investigation and the reparations, the effects of Elizabeth's time in camp would never go away. For her and the other detainees, the healing process continues well into the 21st century.

Seventeen Magazine, 1944

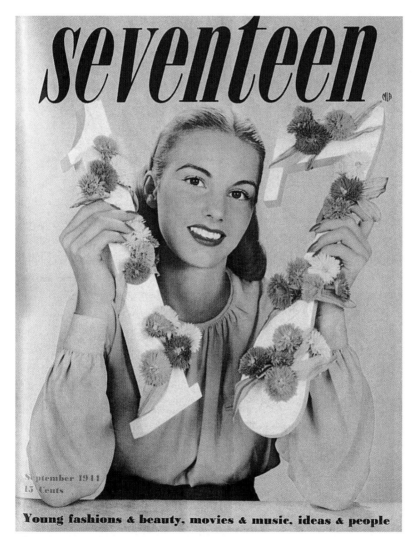

36.1. Cover of the first issue of *Seventeen* magazine, 1944.

SEVENTEEN MAGAZINE, "70 YEARS OF SEVENTEEN," 2003

Toward the end of World War II, America embraced adolescence as a distinct phase of life. First defined in 1904 by G. Stanley Hall, the efforts of retailers and advertisers made adolescents—or "teenagers"—a distinct social group and cultivated them as consumers in postwar America. A primary method of engagement was magazine advertisements. *Seventeen* magazine hit newsstands in New York City in September 1944, becoming the first magazine specifically aimed at teenage girls. It sold over 400,000 copies in two days, and in less than two years would reach over one million subscriptions, legitimating teen girls as the new consumer force in America.

Created by editor-in-chief Helen Valentine, *Seventeen* was intended to be a teen service magazine. Valentine targeted 17-year-old girls, whom she believed embodied the time when a girl was no longer a child, but not quite a woman. Stemming from the patriotic duties espoused during World War II, Valentine hoped to foster citizenship and global responsibility as the ethos of the next generation of young women. "*Seventeen*'s readership was quickly approaching voting age, and Helen believed that they needed the kind of information that would allow them to make educated decisions as voters and citizens."[1] In its first issue, the magazine's editorial and promotional content balanced fashion and beauty with articles on citizenship and work. As Valentine's first letter from the editor stated, "*SEVENTEEN* is your magazine, High School Girls of America—all yours! It is interested only in you—and in everything that concerns, excites, annoys, pleases or perplexes you."[2]

Included among the articles on fashion and beauty was advice on how to think and behave as informed politically active citizens, gender stereotypes in school classes, career paths besides homemaking, and addressing racial prejudice. "The May 1945 article 'Lassies at the Lathe' attacked gender stereotypes at school by featuring a high school carpentry class for girls."[3] It also framed domestic life as fun rather than work. In the first year of *Seventeen*, homemaking was never mentioned as a career, but rather something to be enjoyed as a hobby.

Unfortunately, market forces would derail Valentine's vision and come to define a new type of teenager. Valentine's co-founder, Walter Annenberg, saw *Seventeen* as a way to capitalize on adolescents as consumers. In particular, he focused on white upper-class girls, who had the financial means to buy new fashions, beauty, and domestic products. Despite Valentine's advocacy for including Black girls as models, Annenberg refused and quickly took over

supervising the magazine's content. *Seventeen* evolved into a magazine about fashion, fun, and domestic life, with only a nod to citizenship and intellectualism. It also focused on pleasing the consumer desires of their typical reader, which market researchers dubbed "Teena." Defined as a 16-year-old girl from a white, nuclear, upper-class family, she had an allowance, worked as a babysitter, and was serious about shopping. In all aspects of life, Teena's needs were solely within the domestic sphere.[4] Despite her youth, she was influential in directing her family's consumerism, helping achieve domestic bliss by spending money on the latest fashions, gadgets, skin care products, and other goods. By the end of its first year, *Seventeen* was 45% editorial and 55% advertisements and had created the postwar teen girl consumer.

The magazine's shift was a direct result of the postwar economic boom and focus on traditional gender roles. "Although some other jobs were opening up for women as nurses, librarians, and teachers, now the media advertised the importance of women as wives and mothers."[5] This was because the nuclear family was dependent on girls adhering to stereotypical gender norms. Articles like "How to Be a Woman" detailed domestic life as the foremost creative avenue and executive opportunity for girls, claiming that cooking, sewing, decorating, and caring for their husbands should be the most fulfilling work of their day. The shift was also a reaction to World War II's insecurity and the beginning of the Cold War, a period of geopolitical tension between the Soviet Union and the United States that lasted from 1947 to 1989. The nuclear family became the center of American life, with couples marrying in their early 20s and quickly having children. Girls were expected to raise large families, live in the newly affordable suburban housing, buy modern conveniences, and enjoy leisure time while their husbands worked. Though 38% of women held a job by 1960, the overall sentiment was that "A woman's place is in the home."[6] Though this trend lasted only through the mid-1960s, *Seventeen* continued to perpetuate similar myths into the early 21st century.

Seventeen was also instrumental in fostering the sexualization of young girls. Its content made girls hyperaware of their public appearance, emphasizing the need to be attractive in order to obtain and keep a happy husband. Beyond keeping a good house, this meant being beautiful and sexually active. *Seventeen*'s content articulated this standard by encouraging scrutiny of every aspect of a girl's body. For example, a study on traditional versus feminist messages in *Seventeen* found that, while the magazine was 48% traditional

and 52% feminist in 1945, by 1955 it had become 74% traditional and 26% feminist, reflecting the shift from Valentine's vision to Annenberg's control.[7] This content increased through the 21st century, despite the groundswell of feminism in the 1970s. A study on 2006 issues of *Seventeen*, which reached over two million readers, found that "the magazine offers the myth of sex as a consumer item. Through the purchase of make-up, clothing, hair care products and other items, girls can achieve 'sexiness.'"[8] This began changing in 2012, when *Seventeen* responded to a change.org petition led by 14-year-old Julia Bluhm of Maine and signed by over 84,000 people. *Seventeen* vowed to celebrate every kind of beauty and feature only photographs of real girls who were healthy.[9]

Seventeen's history reveals the changing narrative of postwar American teen girlhood. Before 1945, teen girls were seen as responsible, educated, emerging citizens who could foster American values of patriotism, global awareness, and morality. Yet as World War II ended and the Cold War began, consumerism and a return to traditional gender stereotypes changed teen girls into "Teena"—a consumer who led her family in their new purchasing power to buy technology, goods, and services during the postwar economic boom. Teen-focused magazines like *Seventeen* were a primary force in this change, powerfully influencing teen girls' lives and relegating their voices to adhere to traditional gender norms.

Patty-Jo Doll, 1945 to 1949

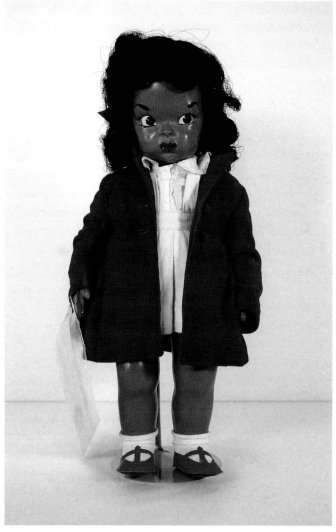

37.1. Patty-Jo doll from the Terri Lee doll company (front view, wearing coat).

While white girls were targeted by consumerist forces like *Seventeen*, Black girls experienced a new consumerism of their own. However, this consumerism was distinctly tied to the emerging civil rights movement and, unlike *Seventeen*, encouraged Black girls to have a voice. One unique form was a cartoon girl, Patty-Jo, whose fame led to one of the first American Black dolls that was comparable in quality to white dolls. Patty-Jo also more directly reflected Black girls' lives in her comics, providing insights while setting the stage for the perpetuation of stereotypes about Black girls.

During the first half of the 20th century, urban Black Americans produced two distinct cultural movements. First, the Harlem Renaissance in New York spurred the flowering of literary and visual arts during the 1920s. Next, the Chicago Renaissance occurred from the mid-1930s to the 1950s. Both sought "to produce incisive, socially critical forms of cultural expression for a predominantly African American audience."[1] Among these forms were newspaper comics, published to help sell the papers, but also to discuss what was going on and reflecting the mood of the times. In Chicago, one of the most prominent comics was *Patty-Jo 'n' Ginger* by Jacqui Ormes, published in the *Courier*. Ormes had published earlier comics about young women, including *Candy* and *Dixie to Harlem*, but Patty-Jo was her most iconic character in a series that spanned 11 years.

Patty-Jo was a 5-year-old girl from Chicago whose wisecracking, adorable antics were witnessed by her silent, pinup-style fashionista big sister, Ginger. Once a week, Patty-Jo's adventures "expressed wisdom, exposed folly, and could say what was on many people's minds and get away with it." The comic quickly rose to be the top feature in over 358,000 households.[2]

Yet Patty-Jo's antics were not confined to her home and family life. Rather, she confronted many social issues of her time. On February 8, 1947, she addressed McCarthyism (a campaign against alleged communists in the United States led by Senator Joseph McCarthy), stating, "It's a letter to my Congressman. . . . I wanta get it straight from Washington. . . . Just which is the 'American way' of life, New York or Georgia?" Three years later, in February 1950, she addressed the effects of the Cold War and nuclear development, stating, "Now you folks can REALLY stop worryin'. . . . Uncle Sam's blowing our national wad on an H-bomb for your PROTECTION. . . . Course, that don't spell HOUSING, but you gotta admit it ain't HAY, either!"

Patty-Jo's most voiced opinions were about daily life and the endemic racism that Blacks faced. On April 7, 1951, Patty-Jo looked straight at Ginger and said, "It would be interestin' to discover WHICH committee decided it was un-American to be COLORED!" She went on to advocate for the Montgomery bus boycott, equal education, and environmental activism. She also criticized the government on military adventurism, privacy, and freedom of speech. Her comments even took aim at gender stereotypes by questioning class, consumerism, and fashion as a means of keeping girls in the home, often directed at her older sister.

Communicated in a tongue-in-cheek style that used language specific to Blacks, Patty-Jo's statements provide insight into Blacks' daily lives, while also covering topics important to all Americans. Yet the cartoon also depicted the more mundane activities of Black girls' lives. Patty-Jo went to school, took music lessons, and enjoyed family vacations. These activities reflected Ormes's middle- to upper-class upbringing in what some scholars say was a message to other Blacks that the good life was attainable by everyone.[3] However, Patty-Jo's depictions rested on her status as an upper-class girl. It enabled Ginger to buy the products and fashions that made her a pinup girl, for Patty-Jo to attend school and wear nice clothes, and even allowed Patty-Jo to speak her mind and question social issues of her time. Class was as binding as race, and despite her popularity, few lower-class Black girls could enjoy the same freedoms as Patty-Jo.

Fame led to many opportunities for Ormes, including production of a Patty-Jo doll (Figure 37.1). The Terri Lee doll company, which started selling Black dolls in the 1940s, approached Ormes about creating a doll of Patty-Jo as a model of self-esteem for Black girls' play. Many had advocated for such a doll since the early 1900s, hoping that it would support Black children's development of race pride, but the market had yet to be successful. By the mid-1950s, psychologists using "racial preference" tests to assess children's self-esteem and racial identification advocated that representation in toys was critical to positive growth. The most prominent studies conducted by Kenneth and Mamie Clark featured children choosing between brown and white dolls in response to a series of questions about which doll was good/bad, which they wanted to play with, and with which they identified. Clark found that while most Black children identified with the brown doll, they wanted to play with

the nice, white one, confirming his theory that children internalize society's racist messages.[4] In later decades, the Clarks' experiments were discredited on the basis of inaccurate methods and as being more reflective of media influence than psychological damage since most portrayals of Black dolls derived from slavery and stereotypical characterizations found in novels and plays.

Using the existing Black doll made by Terri Lee, Ormes painted some of the doll's faces herself and taught company artists how to do so, making Patty-Jo the "only comic character doll whose face was painted by the cartoon artist or by factory artists directly trained by her."[5] The doll also came with an assortment of clothes and accessories, making it the first Black doll aimed at the same type of audience as white dolls. Though intended to help self-esteem, the doll in fact reinforced class differences among Blacks. Selling for almost $12 per doll, with additional purchases of clothes needed, owning a Patty-Jo doll was limited to girls of the middle and upper-classes whose parents earned more than the minimum wage of $0.45 per hour. Owning a Patty-Jo doll became a marker of prestige, much as speaking her mind was for Patty-Jo the character. The doll's production halted in December 1949, when Ormes's contract with Terri Lee expired.

Despite these issues, Patty-Jo was a highly influential Black comic and doll. Her youth enabled her to state the issues of her time in ways that were both humorous and revealing. While Patty-Jo's influence on the civil rights movement is unclear, what is clear is that the artistic forms—including comics—produced during the Chicago Renaissance changed the landscape of Black culture. Black girls gained a prominent image with which to identify, a girl who used humor as a way to understand the complex social issues they faced. If there was a negative impact, it was that Patty-Jo, as a strong-willed Black girl, was reinterpreted by whites as an angry, loudmouthed stereotype that persists today. This racialized formula was repeated by the media so often that it became internalized by many, including Black girls themselves. Today, the effects of such internalization are still felt as we struggle to define, and accept, the realities of Black girlhood.

Monument to the *Westminster* Case Children, Westminster, California, 1945 to 1947

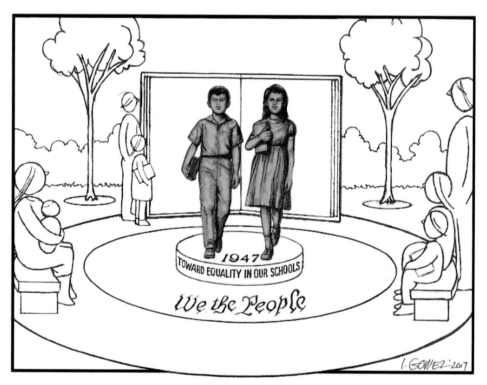

38.1. Rendering for a monument to the *Westminster* case children, including a statue of Sylvia Mendez, by Ignacio Gomez, 2017.

SERGIO CONTRERAS, CITY OF WESTMINSTER, CALIFORNIA

The American civil rights movement was driven by figures of American history who have since become household names. Led by organizations such as the National Association for the Advancement of Colored Persons (NAACP) and individuals like Martin Luther King Jr., there were many more who are not well known or appreciated. In terms of education, especially school desegregation, court cases involving people of all colors helped move society toward equal rights for all. One case integral to achieving full desegregation was brought by a girl named Sylvia Mendez and her family in Westminster, California.

In 1945, school segregation was the norm in almost every state, even those with laws against it. Lawsuits to end the practice had been filed since the 1850s, with a recorded 113 cases filed in 29 states between 1850 and 1935.[1] The first, *Roberts v. City of Boston* in 1850, was filed on behalf of 5-year-old Black girl, Sarah Roberts, and the 1927 *Gong Lum v. Rice* case was filed on behalf of Martha Lum, a Chinese-American girl. None of these cases were successful. Yet in the social aftermath of World War II, desegregation found a foothold as a grassroots movement, spearheaded primarily by girls and their families. Among them was Sylvia Mendez, a Mexican-American whose family was among the over half million farm laborers in Southern California. Sylvia's family—and all immigrants of Mexican descent—were legally defined as white, yet culturally were considered different and among the lowest classes.[2]

In September 1943, 7-year-old Sylvia and her family—including her parents, Gonzalo and Felicitas, Sylvia's two brothers, her uncle and aunt, and her cousins—moved to Westminster to manage an asparagus farm while its Japanese owners were interned during Executive Order 9066. After settling in, Sylvia's aunt took the children to register at Westminster school. The administration admitted Sylvia's light-skinned cousins, who had a French-sounding last name, but denied entry to the visibly darker and Mexican-named Sylvia and her brothers, who would have to be enrolled at the "Mexican" school a few blocks away. Refusing to participate in this racist practice, the children were homeschooled while their parents petitioned the school district for equal treatment, with no success.

In 1945, the Mendez family filed a lawsuit with attorney David C. Marcus in the Orange County court system. Knowing their case would be stronger with other families providing testimony, Gonzalo and Felicitas interviewed parents and gathered evidence revealing the endemic nature of segregation in

California. Due to the time commitment of a court case, the children went to the Mexican school, Hoover Elementary, in the meantime. "Sylvia . . . remembered having to eat lunch outside Hoover, which had no cafeteria. The school grounds abutted a cow pasture with an electrified wire fence, which worried her father. Worse, as far as Sylvia was concerned, were the flies, which, attracted by the food, settled on the children and their lunches."[3]

The Supreme Court had repeatedly ruled that segregation based on race was legal so long as it was "separate but equal" (as confirmed in the 1896 case, *Plessy v. Ferguson*). Yet in practice, treatment was not equal. Sylvia's school curriculum was different from the white one, focusing on sewing and homemaking while the boys learned blue-collar skills like boot making and blacksmithing. Books and supplies were castoffs, and the school day lasted only five hours so the children could work in the citrus groves. To avoid the issue of race, Marcus decided to argue the case using the 14th Amendment, on the grounds that segregation of Mexican-American students deprived them of their federal right to equal treatment. In denying Sylvia and other children like her, the school district purposely excluded Mexican-Americans on the basis of ancestry and provided them with inferior facilities and education. Since Mexican-Americans were legally considered part of the white race, the case became about *ethnicity* rather than race.

Marcus, the Mendez family, and their fellow plaintiffs won the first battle of *Mendez v. Westminster* in 1945. Seven months later, Judge Paul J. McCormick gave his opinion in the *Conclusions of the Court*, stating the federal government could interfere in states' education policies when there was a "clear and unmistakable disregard of rights secured by the supreme law of the land."[4] *Westminster* had demonstrated such disregard by not maintaining schools with equal rights and privileges for all children regardless of ancestry, and thus the case was ruled in favor of Mendez. In one fell swoop, *Mendez v. Westminster* had proved that the theory "separate but equal" was not equal in practice.

The school districts appealed to the US Court of Appeals for the Ninth Circuit, where *Mendez v. Westminster* garnered national attention. Amicus briefs were filed by the NAACP, American Jewish Congress, Japanese-American Citizens League, and American Civil Liberties Union. The children, including Sylvia, took the stand to provide direct evidence that they were capable, English-speaking learners. In 1947, the court ruled that the school districts had violated California law, but did not specifically address whether segrega-

tion was constitutionally permissible. That same year, California became the first state to officially desegregate public schools.

Though *Mendez* did not end segregation in full, it laid the groundwork for the landmark cases that would. A Texas case filed in June 1948 by Mexican-Americans affirmed the *Mendez* decision under Texas law, helping force integration of their schools. Further, *Mendez* had a direct impact on the NAACP, which would take *Brown v. Board of Education* to the Supreme Court eight years later, displaying the arbitrary nature of racial categories and the relationship of segregation to children's feelings of racial inferiority.[5] The NAACP's brief in Mendez was a trial run for *Brown*, which would attack segregation based on race directly and use methods that *Mendez* had pioneered, such as calling social scientists as witnesses. Additionally, in an odd twist, the governor of California during the *Mendez* case—Earl Warren—was the chief justice presiding over *Brown*.

Little has been written on Sylvia's feelings during *Mendez*, though court records indicate she was called as a witness. Her and her family's contributions to ending segregation were sidelined by the *Brown* case, only recently coming back into American memory. In 1998, the Los Angeles Board of Education issued a resolution commemorating the efforts of the Mendez family, who will be part of a new memorial (Figure 38.1) planned in Westminster. In 2010, Sylvia was awarded the Presidential Medal of Freedom for her efforts to spread awareness of the case and its impact on school desegregation across the country.

Notably, all the legal cases on segregation share a defining feature: "all save one of the early school desegregation lawsuits, which would pave the way for the cases that became *Brown v. Board of Education*, were filed on behalf of girls."[6] Sylvia, and many girls like her, waged the battle to receive an equal education. It was their call to arms, a mission where the individual aspirations of girls joined together to profoundly change America. Ultimately, Sylvia is foremost among these early girls because her case paved the way for *Brown*'s success.

Transportation Token from Montgomery, Alabama, March 1955

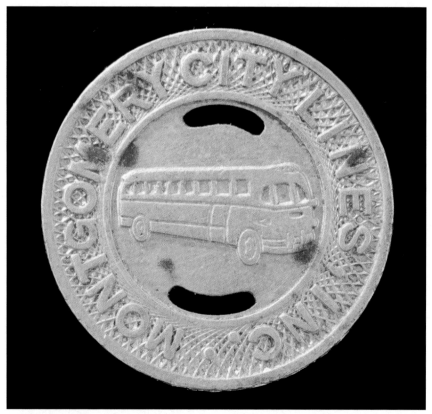

39.1. Transportation token, Montgomery City Bus Lines, circa 1955.

While racial discrimination was a national issue, the Southern Black experience was far more violent due to Jim Crow laws. Passed in the decades after the Civil War, Jim Crow laws enforced segregation in every aspect of life from which water fountains and toilets could be used by Blacks to which entrances they should use for movie theaters and restaurants. By the mid-1950s, Blacks were fighting back through everyday acts of defiance. Many of them were girls, but not all these girls were treated equally by Civil Rights leaders, the media, or history. While 42-year-old Rosa Parks's refusal to give up her seat on a bus became famous, history has neglected the teen girls who took the same actions before Parks. The first was 16-year-old Claudette Colvin, who used a token like the one in Figure 39.1 when she boarded a Montgomery bus in March 1955.

Claudette was born on September 5, 1939, in Birmingham, Alabama. She experienced racism early on, coming to understand that she was prohibited from doing many things she was interested in. "'My first anger I remember was when I wanted to go to the rodeo,' Claudette said. 'Daddy bought my sister boots and bought us both cowboy hats. That's as much of the rodeo as we got. The show was . . . only for white kids.'"[1] Her father left the family early in her childhood, so Claudette was sent to live with her aunt in Montgomery. In 1952, as Claudette began high school, she witnessed fellow Black student, 16-year-old Jeremiah Reeves, be arrested and charged with sexually assaulting several white women; despite his innocence and youth, Reeves was convicted and sentenced to death. As a sophomore, Claudette read literature about human rights and democracy for her English and history classes. She became a member of the National Association for the Advancement of Colored People's Youth Council, where she learned that a local ordinance outlawed segregation on buses if the bus was filled to capacity. Armed with this knowledge, she was ready to stand up for herself.

In March 1955, 15-year-old Claudette boarded a bus with three friends and sat in the middle section, considered a neutral zone between the white and colored sections. When a white woman wanted Claudette's seat because the white section was full, her friends moved, opening up three empty seats, but Claudette refused to give hers up. The white woman refused to sit by Claudette, demanding that she move. The bus driver steered to the Court Square, a busy transfer station, where a transit officer boarded the bus and demanded that Claudette move. She again refused. The driver drove to an intersection

where two policemen boarded and demanded Claudette vacate the bus. She refused, stating, "No, I do not have to get up. I paid my fare. . . . It's my constitutional right!"[2] Claudette later stated her bravery came from the literature she read in class. She was then forcibly removed from the bus, handcuffed, and arrested for violating the city's segregation laws. During her journey in the squad car and at the station, officers made lewd comments at her and tried to guess her bra size. She was placed in the city jail, which refused to allow her a phone call. Luckily, classmates who witnessed the altercation called her family, so Claudette's mother and church pastor came to the jail and bailed her out.

As Claudette's case proceeded to court, she gained the attention of Civil Rights activists in Montgomery. Martin Luther King Jr., became involved, helping form a citizens' committee to meet with bus executives to discuss the altercation. On March 18, Claudette was convicted of violating segregation laws and assaulting a police officer; she was placed on indefinite probation. Despite appeals, her sentence was not lifted. Claudette received many letters of support, but was shunned by others, including classmates and neighbors. Within a few months, Claudette became pregnant, so Civil Rights leaders deemed her too controversial to be a figurehead for the movement.

Despite being a plaintiff in the landmark 1956 case, *Browder v. Gale*, which went to the Supreme Court and ultimately ended Jim Crow laws, Claudette was silenced and her narrative pushed aside. She was 17 years old with a 9-month-old son, unable to find work until she moved to New York City and became a nurse's aide. Claudette watched as other girls, like teenager Mary Louise Smith, engaged in similar altercations for refusing to give up their bus seats. Many of these teenagers were deemed unsuitable for the movement, with Mary's rejection stemming from her father's alcoholism. Civil Rights leaders wanted a picture-perfect figurehead for the Montgomery bus boycott. They didn't have to wait long. Just nine months after Claudette's refusal, on December 1, 1955, Rosa Parks refused to relinquish her seat to a white passenger. Parks was a "medium-sized, cultured mulatto woman; a civic and religious worker; quiet, unassuming, and pleasant in manner and appearance; dignified and reserved; of high morals and a strong character."[3] Rosa met the requirements needed, and her moment became what is remembered, while Claudette disappeared into obscurity.

Claudette's story demonstrates how leaders, politicians, and the media create a narrative. In this case, Civil Rights leaders wanted to frame the move-

ment as one deserving of equality, with Blacks held up as civilized American citizens whose lives were similar to those of whites. Despite the fact that white girls also became young mothers, Claudette's dismissal was also tied intimately to her class. She was from a poor family, with an absent father, while Parks was considered of high moral standard. Claudette and several other Black girls were sidelined and eventually forgotten due to forces beyond their control. It would be decades before Claudette chose to tell her story, realizing her moment was as important as Parks's in the civil rights movement. Today, Claudette is celebrated for her bravery, though only a school snapshot and a Montgomery bus token survive to illustrate that time of her life.

Barbie Teen-Age Fashion Model, 1959

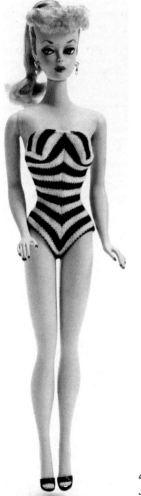

40.1. Barbie Teen-Age Fashion Model (Barbie #1), 1959.
JOHN "JACK" W. RYAN, RUTH HANDLER, CHARLETTE JOHNSON, MATTEL,
INC. LOS ANGELES COUNTY MUSEUM OF ART

Until the 1960s, childhood consumerism was aimed primarily at teenage girls. Through mediums like magazines, teen girls became a driving force in the American economy. In 1959, however, little girls would find their consumerist power too in one of the most controversial toys of the 20th century—the Barbie doll. Becoming a cultural icon by reflecting the many values and beliefs of society, this doll changed how the world thought about toys and little girls.[1]

Barbie was created by Ruth Handler, who observed her daughter Barbara's play habits and noticed she lost interest in baby dolls, the primary one available for girls, at a young age. Other available dolls were glamorous ones designed to sell beauty products, but Barbara preferred the paper dolls she cut from magazines. Paper dolls came with changeable outfits, which allowed for a variety of narratives in play, but were delicate and easily torn. In 1956, during a family trip to Europe, Handler found a solution. She encountered a Bild-Lilli doll, a sexy novelty gift for men, and saw its potential as a fashion doll for young girls.

Handler and her husband, owners of the Mattel toy company, created a more childlike version of Bild-Lilli, aiming for her to be a teenage fashion model whose clothing and accessories were interchangeable. Following product testing and surveys of girls playing with the doll, Handler finalized Barbie as part of Mattel's toy line and debuted her at the New York Toy Fair in 1959. She marketed the doll as a real teenager, starting with Barbie's first commercial in March 1959. Visitors to the Toy Fair were not very interested, but Barbie's popularity suddenly picked up over the summer. By the new school year, girls across America were playing with Barbie, who enabled them to act out their dreams and, ultimately, "perform" their girlhood.

Among these performances were girls' own reflections on their future careers, bodies, and societal roles. Playing with Barbie enabled girls to enact various scenarios, with adults assuming that girls imposed their own self-identities on the doll. As part of this play, Handler developed a series of careers for Barbie, each with its own distinct outfits and accessories. In the first few years, Barbie became a teacher, stewardess, nurse, and candy striper (hospital) volunteer, which were common roles for women. But by the mid-1960s, Barbie was breaking barriers. Four years before the moon landing, Barbie became an astronaut. In 1973, Barbie became a surgeon, although her outfit, a scrub dress that fell to the middle of her thighs with no pants under-

neath, was not realistic. Despite this fashion setback, an analysis of Barbie's careers compared to US Census data for women's careers between 1959 and 1989 reveals that Barbie is a symbol of the ideal career woman who has broken the glass ceiling, opening career paths before real women did.[2] She was the "It" girl of the latter 20th century, empowering girls to imagine themselves in traditionally male careers and able to feminize the masculine code of dress and behavior for those careers.

However, another performance related to girls' bodies. Barbie's body was an anatomically unattainable feminine ideal. It depicted the equivalent of a seven-foot woman with 38-18-33 measurements and weighing 110 pounds—measurements that would be diagnosed as severe anorexia today. Barbie's design was intentional, but not because of expectations for young girls. Rather, Handler wanted to ensure Barbie's form was flexible but could stay in place when posed, strong enough to survive bite and tear tests, resistant to environmental factors like heat, and easily able to be dressed and undressed by children. These factors were disregarded by critics, who used several studies to illustrate that Barbie negatively impacted girls' body image, while ignoring studies that showed girls' body image is more influenced by their mothers' attitudes than a doll.

One more performance for Barbie was that of white, upper-class consumerism. As the ultimate "It" girl, Barbie came with hundreds, and eventually thousands, of accessories that could be purchased separately. These included outfits, houses, cars, and pets. Her careers and fluid backstory, having no defined parents or origins, empowered Barbie with the economic independence to purchase infinite consumer goods. This reflected girl-led consumerism of postwar America and capitalized on the increased presence of women in the workforce, which increased from 32% in 1960 to 45% in 1990.

However, Barbie's early years were—like *Seventeen* magazine—a distinctly white phenomenon. The first successful Black Barbie did not debut until 1968 and was framed as a friend rather than Barbie herself. Other Barbies of color were not created until the 1980s. As many scholars assert, "Although Barbie has had friends of color since the 1960s and has herself been marketed in Black, Asian, and Hispanic versions over the past fifteen years, Barbie is stubbornly white."[3] This whiteness reflects other aspects of dominant American culture. Barbie was marketed as having a boyfriend, Ken, whom she eventually married. She also lived in a world of safety, where gender-based violence

was entirely absent. She represented a dream of healthy, energetic youth that is safe and secure, unaware of the cruelties of age, class, gender, and race.[4]

These performances worried adults, even in the early 1960s. They saw Barbie as an impossible ideal that would irreparably harm girls' self-esteem and relationships to their bodies, especially for girls of color. A nonwhite version named "Barbie" did not premiere until 1980. Yet many girls of the 1960s who later reflected on Barbie play did not affirm this fear. They recall Barbie as a positive force, and their own views as children being distinctly different from adults' views on Barbie. As Cynthia G. La Ferle recalled,

> I've gotten a kick out of Barbie since I first played with her in the 1960s, when the feminist movement was gaining momentum. And I think Gloria Steinem would have approved of the way my Barbie and her best friend Midge carved out their futures.
>
> In the fantasy world I crafted for them, both dolls went to college. [. . .] If nothing else, she showed us a woman could do anything she wanted to, and looking fabulous was just another bonus.[5]

As La Ferle remembers, Barbie's foremost power was her ability to make choices. She was the first true personality doll, whose glamorous adventures and ability to take on various roles and identities empowered girls into believing they too could be anything.

Through her many controversial attributes, Barbie participated in the renegotiation of gender roles and perpetuated girl-led consumerism of postwar America. She embodied the "irresolvable openness of girlhood itself" through her ideal lifestyle: an openness to which her consumers may generate their own stories of ascendancy both to Barbie and to themselves.[6] Through Barbie, little girls first experienced the burgeoning educational and professional opportunities for women and experimented with imagined futures through doll play.

Part IX
REVOLUTIONS, 1960s TO 1970s

The 1960s saw the full range of revolutions—political, social, and sexual. As in earlier decades, girls were at the forefront of these movements, questioning patriarchal authority and making their voices heard. Balancing the wins, like the approval of the first birth control pills in 1961 and the ratification of the Civil Rights Act of 1964, with the losses, like the Vietnam War and the failure of the Equal Rights Amendment in 1972, there was no longer a standard way to be an American girl. Nor were there conventional expectations of what to become as adults or the paths to take to get there.

In 1960, for the first time in pop music, girls sang about their choice to be sexually active in The Shirelles' number one hit, "Will You Still Love Me Tomorrow." Meanwhile, kachina doll traditions among Hopi girls showed that despite efforts to eliminate Native American culture, they continued to keep customary ways of life alive. In 1970, more taboos about girls' physical health and psychological well-being were broken by the watershed publication of *Are You There, God? It's Me, Margaret,* by Judy Blume. Meanwhile, as the Vietnam War raged, 13-year-old Mary Beth Tinker became the face of a Supreme Court case that affirmed students' rights to free speech. Finally, in 1975, Peggy Oki became the first girl skateboarder to break gender barriers

both competitively and culturally. Together, these girls helped break down the racial, ethnic, sexual, constitutional, and athletic barriers that, in reality, were only societal constructions.

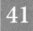

"Will You Still Love Me Tomorrow" by The Shirelles, 1960

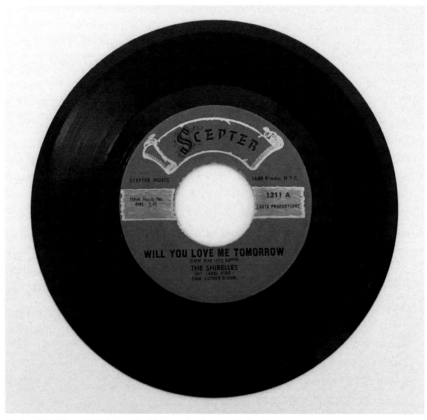

41.1. "Will You Still Love Me Tomorrow" record single.
PHOTOGRAPHER: ASHLEY E. REMER

Music had a huge impact on American culture during and after World War II. Because almost every household in America owned a radio, people had access to music nearly all the time. Rock 'n' roll dominated the 1950s, with masculine voices and themes from the likes of Elvis and Jerry Lee Lewis. However, female singers at the time, like Connie Francis and Doris Day, primarily sang about male approval and the supremacy of romantic love. Yet teenage girls wanted something new and different to hear—themselves.[1] By the end of the decade, girls started to take over the scene. At the Brill Building in midtown Manhattan, a girl created the first number one hit for the first successful girl group, "Will You Still Love Me Tomorrow" (Figure 41.1). The song itself was significant for addressing female sexuality, but so were the girls who wrote and sang it.

Carole Klein, a 17-year-old from Brooklyn, New York, started piano lessons at age 4 and knew she wanted to make music. Toward the end of high school, she started her first band and changed her last name to King. Carole met a boy, Gerry Goffin, when she started college and soon became pregnant. They were quickly married and got jobs, writing songs together in the evenings. With a few songs sold, Carole got her work through the door of the Brill Building and to music executives. Soon after, they were both commissioned to write a song for an up-and-coming new girl group, The Shirelles.[2]

Just over the Hudson River in Passaic, New Jersey, four 17-year-old girl singers, Doris Coley, Addie "Micki" Harris, Beverly Lee, and Shirley Owens, signed on to Tiara Records with Florence Greenberg after they auditioned in her living room.[3] Newly named The Shirelles, their first hit song was "Tonight's the Night," co-written by Shirley, their lead singer. Girl singers were used to singing lyrics written by men about how they should behave to secure and please a husband. But this song was a forthright conversation telling a boy that they weren't sure if they were ready for anything to happen between them.

> You said you're gonna kiss me,
> Tonight's the night,
> Well I don't know,
> Said I don't know right now
> I might love you so.[4]

After hearing this song, the songwriting duo wanted to find out what happened to this girl. "Tonight's the Night" created the situation that "Will You Still Love Me Tomorrow" extended. What happens next? How does she feel about the choice of whether or not to take the next step and have sex with her boyfriend? While still so young themselves, but newly married with a young baby, Carole and Gerry certainly had the experience to pose and explore these questions.

Is this a lasting treasure
Or just a moment's pleasure
Can I believe the magic in your sighs
Will you still love me tomorrow?[5]

By even asking this question, Carole and the Shirelles showed that girls have a choice about their own sexuality, as well as deep feelings about it. This was the first time sexuality was presented from a girl's perspective, especially in popular music.[6] Additionally, the song addressed the long-term questions a teenage couple might have, revealing different gender-based attitudes toward sex.

I'd like to know that your love
Is a love I can be sure of
So tell me now and I won't ask again
Will you still love me tomorrow?[7]

The girl hopes that this one instance of lovemaking will seal their fate, which continues a stereotype of female romanticism and naïveté toward relationships and sex. By blatantly asking the boy if sex means love, she undercuts her own power by saying she will take his word for it and move on. At the same time, she asserts that her needs are important and she doesn't necessarily trust him.

Initially, Shirley was not very interested in the song. This was primarily due to its sound and arrangement, which she felt was not The Shirelles' style. Determined to make it work, Carole took charge of the recording, rearranging it and adding violins and drums, which she played herself since no studio musician could make it sound the way she wanted. The scene of five teenage girls

taking on the older established music industry to make a record is one that should not be underestimated. However, race, class, and marital status played the usual roles in how this song was made, understood, and remembered. The Shirelles were four single, working-class Black teens. The song was written for them by Carole, who was a year younger, but being white, middle class, and married with a child gave her more power and respect in the moment.[8] Still, they were all subject to the rules and machinations of the male-dominated music industry, which used their talent and skills for the purpose of making money more than making an impact.

"Will You Still Love Me Tomorrow" was a number one hit, the first ever for a Black girl group.[9] Despite success, The Shirelles had only two years of real success. Their contract was sold and rebought when Tiara became Scepter Records, and their royalty money was put into a trust for when they turned 21. However, that trust was never executed; both sides filed lawsuits, and they ended up settling out of court. The Shirelles were bound by contract to Scepter until 1966, yet as the industry shifted to Detroit and Motown Records, with competition from girl groups like The Supremes and music of the British Invasion, they had little to show for their hard work. Their last song as the original group barely cracked the top 100 in 1967. While Carole went on to be one of the most successful American women songwriters of all time, almost nothing about her contributions to the song machine of the 1960s was known until she made her own album, *Tapestry*, in 1972. Even now, most people don't realize a teenage girl wrote many of that decade's hits.

As the American social landscape changed radically from the 1950s to the 1960s, so did the messaging of popular songs for teenage girls. The expectations and desires of girls were coming to the forefront as gender norms shifted. Teenage girl singers and groups like The Shirelles became popular and important in the American pop culture of the 1960s, both as a reaction to and a distraction from the anxiety and social turmoil of the times. And the opportunities for girls to write songs or become famous performers hadn't really existed on the same scale before. "Will You Still Love Me Tomorrow" was covered by many artists throughout the decades since it was first released because the questions it asks are still relevant today.

Kachina Doll, 1964

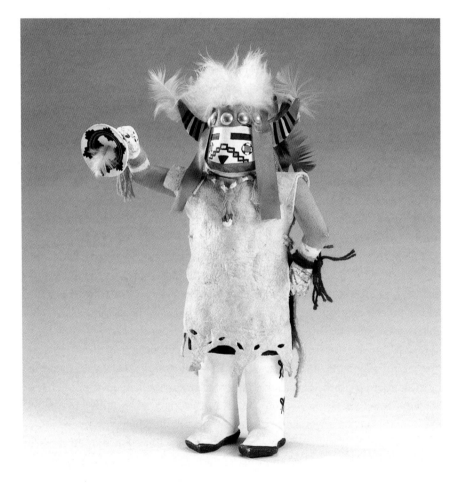

42.1. Supai Girl kachina by Earl Yowytewa, Hopi Pueblo, 1964–1965.

A mong the many social movements of the 1960s and 1970s, Native Americans were also fighting for their rights. Externally, they fought through discriminatory laws, while internally they sought to preserve traditional ways of life. This included greater study, as well as the continuation of ancestral beliefs. One of these is the kachina, found among the Hopi. First illustrated by J. Walter Fewkes of the Smithsonian in 1894, kachina dolls are one of the most well-known Native art forms. By the 1960s, movements to preserve kachina traditions, while also supplying the "tourist-grade" doll market, were well under way.

Kachina dolls, and girls' participation in kachina dances, is significant, both as part of their learning and as a form of cultural persistence. Culturally, kachinas are integral to Hopi religion. They take three forms: the supernatural being, a masked impersonator during dances and in kivas, and the kachina doll. Both the impersonator and the doll are meant to represent supernatural beings, of which there are many. Each controls different aspects of the world, such as temperature, wind, or rain, and live on Black Mountain in what is now the San Francisco Peaks.[1] During half of the year, the kachinas descend from the peaks to the villages, where they dance through their impersonators in the hopes of summoning rain and a good harvest. It is also believed that the spirits of the dead go to the peaks, where they become kachinas and return to the village as clouds.[2]

The kachina in Figure 42.1 is made from dried roots of dead cottonwood trees, then painted with clay. It was made by a father, brother, or uncle for a girl in the family. Stylistically, the form has been consistent since the 1800s, which makes identifying the exact kachina it is associated with easier. The colors—red, yellow, white, and blue-green—represent the cardinal directions. Markings on the doll include an inverted V shape over the mouth, a white mask, chin segments, and a circular head—indicating this kachina is an official (higher up) in the Hopi spiritual system, likely affiliated with the First or Second Mesa (a division of the tribe). It is a warrior, as identified by the red marks and tools it carries: a bow, arrow, and rattle.

This doll was likely given to a girl during a kachina dance. Men dress to embody the kachina spirits, and during the dance, give these figures to girls in their families. Throughout the 1800s and early 1900s, the dancing kachinas give bows and arrows to boys and dolls to girls, while both children receive fruit, corn, and candy. When a child receives the gift, a smile is shown for ap-

preciation. These dolls are not given to girls as toys; rather, they are "objects to be treasured and studied so that the young Hopis may become familiar with the appearance of the Kachinas as part of their religious training."[3] The doll is taken home, where it is hung on the wall or from the rafters as a reminder of what the kachina looks like and with which aspects it is associated. In essence, the kachina doll is a teaching tool in traditional Hopi ways of life.

When a Hopi girl reaches puberty, she undergoes the *Powamu* initiation with the help of her godmother. During *Powamu*, the girl spends several hours in a *kiva* (a partially underground chamber used for religious rites) listening to the priests pray and sing sacred songs, and they sprinkle her with water and cornmeal. Feathers are tied into her hair, and she performs rituals before an altar, including making sand paintings. This means that she can now be involved in the kachina dances, primarily by helping to cook for the dancers (who are always male) and carrying food and water to them.

Kachina dolls are integral to a girl's cultural training before the *Powamu*. As part of Hopi yearly ceremonies, which are a part of life from birth to death, a girl focuses on learning the different kachinas. She may also use them as a means of learning about her gender role. Since kachinas are impersonated only by men and girls are given dolls only during the dances (not tools like the boys receive), kachina dolls may indicate that a girl's role is strictly domestic. By hanging them in the home, she is reminded of where her place is in the tribe. She is not allowed in the other places kachinas inhabit, such as the *kivas* and San Francisco Peaks. Thus, kachina dolls are her primary connection to the spirit world during her lifetime and serve as markers of social expectations: a reminder that home is her domain.

Yet the most important aspect of kachina dolls is as a form of cultural persistence. After centuries of persecution, oppression, and relocation, Native Americans became highly visible in the 1960s and 1970s as they reclaimed their beliefs and cultures. For the Hopi, the cultural continuity represented by kachina dolls was integral to retaining ceremonial practices and their beliefs. While generic kachina dolls were made for tourists, traditional kachinas remain significant to Hopi tribes, where they are still given to young girls during the rituals and used to teach children religious and cultural beliefs.

Unfortunately, some studies note this cultural persistence was not as ingrained in younger generations. During the mid to late 20th century, some children took kachina dolls to the trading stores, where they exchanged the

dolls for modern sweets like bubble gum. These sacred dolls were then sold to tourists, ending up in homes as decoration and museums as Hopi cultural artifacts. Their spiritual connections were severed, devaluing their religious meaning into a decorative curiosity rather than a deeply symbolic practice. This pattern of commodification was repeated across Native American tribes, resulting in both cheap tourist quality "Native" crafts (produced by both Natives and others) and higher-level fine quality, aimed at the art and museum market. Yet Hopi dolls like this one remain in museums and Hopi homes to remind us that behind each doll is a girl and her beliefs.

Are You There God? It's Me, Margaret by Judy Blume, 1970

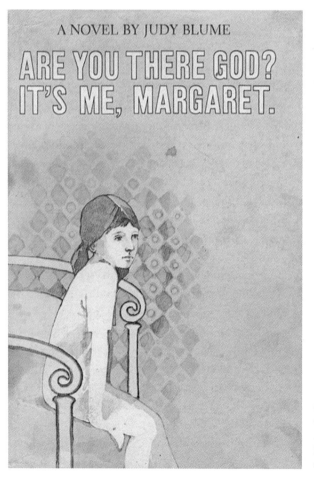

43.1. First edition cover of *Are You There God? It's Me, Margaret* book by Judy Blume, 1982.
WIKIPEDIA

Girls in most American fiction were looking for romance or portrayed as victims in need of rescue, especially through the 1950s when teenagers became their own demographic.[1] There was a marked increase in fiction aimed at teens as a consumer group. Yet by the 1960s, girl characters were not just looking for love, but growing in strength, experience, and wisdom, as evidenced in books like Madeleine L'Engle's *A Wrinkle in Time* (1962) and E. L. Konigsburg's *From the Mixed-Up Files of Mrs. Basil E. Frankweiler* (1967). The literature developed and responded to the changing needs and perspectives of American girls, becoming rawer and candid by the end of the decade. But very few were as forthright and honest about the difficulties of being a teenage girl as Margaret Simon in *Are You There God? It's Me, Margaret*, written by Judy Blume and published in 1970.

Born in 1938 in Elizabeth, New Jersey, Judy loved to read and make up stories, even as a young girl.[2] Not intending to become an author, she trained as a teacher at New York University. Once her children started attending preschool, she began writing down the stories in her head. The books she wrote did not shy away from topics that were important to young teenagers, despite being uncomfortable for adults. Because she spoke to experiences that so many young people could relate to, her books sold over 82 million copies worldwide and have been translated into 32 languages. *Are You There God? It's Me, Margaret*, like many of her books, is set in New Jersey because it is where she grew up. While not autobiographical, Judy wrote about a girl not unlike herself, who is confused by her developing body and challenged by new environments and emotions. Margaret brings a humor and candor to feelings and situations that can be awkward for most girls.

The main storyline is about Margaret, an 11-year-old girl who, just before starting middle school, moves to a new suburban town very different from the city where she grew up. Challenged by the move, having to make new friends with different priorities, and being an only child resonated with many girls. Margaret's father is Jewish and her mother Catholic, so their marriage caused strife within the family. As a consequence, Margaret was raised without any formal religion, giving her the choice to explore her own spirituality. This gives us the title of the book, as Margaret chooses to speak directly with her God, to question and seek comfort on her own terms. This mirrored how Judy herself approached her relationship with God, as a friend and confidante.[3]

Above all, Margaret is honest with readers, so girls can relate to her. She tells us that she is not happy about being moved from her home in New York City to the suburbs in New Jersey. Making new friends is not easy, especially when she discovers everyone in her neighborhood belongs to a religious organization. She feels peer pressure to be part of a clique and is subject to mean girls and gossip-peddling. She gets a crush and ends up kissing a boy she doesn't like during a party game.

Giving girls information about puberty, as well as a choice about religious beliefs, did not go unnoticed by those seeking to police girls' bodies and minds. In the 1980s, the newly empowered family values groups claimed that the book was sexually explicit and religiously blasphemous and led to libraries and school districts banning the book.[4] When Margaret and her girlfriends look through one of their father's *Playboy* magazines, they have a frank conversation about adult women's bodies, but the controversy was as much about their curiosity as their conversation. Informed discussions about puberty cannot be had without details about bodies, blood, and breasts, which became the most controversial yet beloved parts of the book. Most notably, the scene in which Margaret and her friends, the self-named Pretty Young Things (PYTs), flex their chests and chant, "I must, I must, I must increase my bust," is a classic moment in 1970s pop culture.[5]

The accusations of irreverence stemmed from both the portrayal of Margaret's Christian grandparents and the presumptuousness of Margaret having a personal relationship with her God, not requiring a religious framework or house of worship. Her mother's parents disowned her for marrying a Jewish man, and that meant Margaret had no relationship with them. When they try to come back into her life, they exhibit the same inflexibility about Margaret's religious choices they had with her mother, leading to more conflict. And while she gets along very well with her father's mother, who is Jewish, she also repudiates her assumption that eventually Margaret will also choose to be Jewish. The result, unsurprisingly, is a girl who rejects both belief systems. Judy was writing about the experience of many children of the 1960s and 1970s whose parents came from different religious backgrounds and experienced difficulties as a result.[6]

Today, the book is still used by many as a companion to girls' pubescence. Mothers still buy it, relying on the information Judy provided via her tween

heroine to help girls navigate early puberty.[7] Almost nothing has come into the market to replace *Are You There God? It's Me, Margaret*, so updates to the details of sanitary products used when Margaret gets her period were made to reflect the products available today, rather than the sanitary belts of the 1960s.

As such, the book is both unique in its intentions and executions. The character of Margaret provides girls with a friend for a confusing time, a friend who is not perfect, has real emotions, and is both strong and apologizes when she is wrong. On her website, Judy shares a letter from a girl who encapsulates why Margaret is still so significant:

> Dear Judy,
> I don't know where I stand in the world. I don't know who I am.
> That's why I read, to find myself.
> Elizabeth, age 13[8]

These concerns are universal to children, but those giving answers to girls in particular have competing agendas. While the American Library Association's list of the 100 most challenged books has shown a decrease in the banning of *Are You There God? It's Me, Margaret*, going from 60th place in the 1990s to 99th in the 2000s, there are libraries in America that still require parental consent to check out the book. *Are You There God? It's Me, Margaret* was awarded the Outstanding Book of the Year in 1970 by the *New York Times* and in 2005 named as one of *Time* magazine's 100 best novels of all time.

Mary Beth Tinker's Black Armband, 1965 to 1969

44.1. Mary Beth Tinker at the Newseum (Washington, DC) in front of the black armband she wore during the protest.

NEWSEUM/MARIA BRYK

During the second half of the decade, the Vietnam War dominated the American social and political consciousness. By 1965, over 190,000 American troops were fighting the spread of communism in Vietnam. Many Americans felt the war was unnecessary and were protesting in the streets and in schools. In November 1965, a march was held in Washington, DC, to pressure the government to pull out of the war. Among the marchers was Lorena Tinker, whose 13-year-old daughter, Mary Beth, was inspired to protest in her own way.

Lorena taught at university and held a master's degree in psychology. Her husband was a Quaker minister. Believing that faith should be put into action, Mary Beth and her siblings were encouraged by their parents toward civic engagement, including with the civil rights movement and the Quakers' antiwar pacifism. When her father became Secretary of Peace and Education for the American Friends Service Committee, Mary Beth and her brothers accompanied him on his travels to speak at several churches.[1] By late 1965, the children were ready to take action themselves.

Because the Vietnam War was the first to be broadcast into people's homes, the general public was more aware than ever before of the atrocities of war, including casualties, guerrilla tactics, and refugees. As Mary Beth later recounted, "We knew that young people in Des Moines were being sent to war, and some were coming home in coffins."[2] In November, Lorena announced that she and Mary Beth's elder brother, John, would attend the protest march in Washington, DC. Afterward, all of the children were inspired to do more. In December, Mary Beth and many of her friends attended a meeting led by John. They decided to wear black armbands to school as a message of mourning for the dead and to support reaching a truce by that Christmas.

On December 15, John went to North High School wearing his black armband, while his friend, Christopher Eckhardt, wore one to Roosevelt High School. However, student protest was heavily frowned upon by many teachers and administrators. Mary Beth's math teacher "spent half of his class talking about the evils of student protest. . . . He ended by saying that any student who wore an armband in his class would be thrown out of the room."[3] That evening, Mary Beth organized her classmates to wear armbands the next day. Her father was initially hesitant to allow it, but relented when "Mary Beth expressed her heart to mourn the casualties and told him she really wanted to advocate for a truce in the war, just as Senator [Robert] Kennedy had proposed."[4]

They wore their armbands to school as planned. Unlike her brother and Christopher, who were quickly punished, Mary Beth experienced no backlash until math class. She was sent to the principal's office, where she was told that, if she took the armband off, she could go back to class. Mary Beth took the armband off and returned to math class. However, within minutes, her adviser came and took her back to the principal's office. She was told the rules against armbands had specific punishments, so she was suspended.

The students weren't permitted to return to school until after the holidays. Since the truce opportunity had passed, they had agreed to stop wearing armbands. Yet Mary Beth's parents believed her right to free speech had been violated. On behalf of Mary Beth, John, and Christopher, they contacted the American Civil Liberties Union (ACLU) and filed a First Amendment lawsuit, *Tinker v. Des Moines Independent Community School District*. The case continued for four years, eventually getting to the Supreme Court. During this time, Mary Beth and her family had red paint thrown at their house (insinuating they were communist sympathizers), received hate mail and nasty phone calls, and heard encouragements of physical attacks on them by local radio talk show hosts. The persecution extended into the schools, where Mary Beth and John, who had been top students, received failing grades and were excluded from activities. Mary Beth even "received a call from a woman who said, 'Is this Mary Beth?' And she said, 'Yes.' And she said, in these exact words, 'I'm going to kill you.'"[5]

On February 24, 1969, the Supreme Court ruled that students do not "shed their constitutional rights to freedom of speech or expression at the schoolhouse gate."[6] This meant that the First Amendment protects the rights of students in public schools to express themselves and that officials cannot censor student speech unless—as the court stated—it disrupts the educational process. Mary Beth, John, and their friends had been within their rights to wear the armbands. The majority opinion, written by Justice Abe Fortas, stated,

> School officials do not possess absolute authority over their students. Students . . . are possessed of fundamental rights which the State must respect, just as they themselves must respect their obligations to the State. [. . .] They may not be confined to the expression of those sentiments that are officially approved. In the absence of a specific showing of constitutionally valid reasons to regulate their speech, students are entitled to freedom of expression of their views.[7]

The ruling followed previous cases that had upheld students' rights, including the right to refuse saluting the flag (*West Virginia v. Barnett's Supra*). Citing that case, Justice Fortas reiterated that educating children for citizenship demands protecting individual constitutional freedoms, such as free speech, stating: "And our history says that it is this sort of hazardous freedom . . . that is the basis of our national strength."[8]

Tinker v. Des Moines is a landmark case in American history because it set the precedent on the rights of students. Refuting the adage that children should be seen and not heard, the decision affirmed that students have the right to free speech so long as it does not disrupt the educational process. The case also helped the ACLU continue to defend the rights of students, such as wearing anti-abortion armbands, pro-LGBT shirts, and shirts critical of public figures as well as participating in movements like Black Lives Matter and March for Our Lives.

Mary Beth went on to earn a master's in public health and nursing, but her activism did not stop at the court case. She has continued to educate young people about their rights and is frequently quoted in news stories. She also runs the Tinker Tour USA, a speaking tour to help empower youth voices, often stating, "Schools aren't supposed to only teach things like math and science—they're also supposed to prepare students to participate in society. The ability to speak out and make up your own mind through freedom of expression lies at the core of what it means to live in our society."[9] In its first year, Mary Beth's tour covered over 15,500 miles and made 58 stops at schools, colleges, churches, courts, and youth detention facilities. Like her 13-year-old self, Mary Beth continues to lead and inspire others to action.

"Peggy Oki" by Pat Darrin, 1975

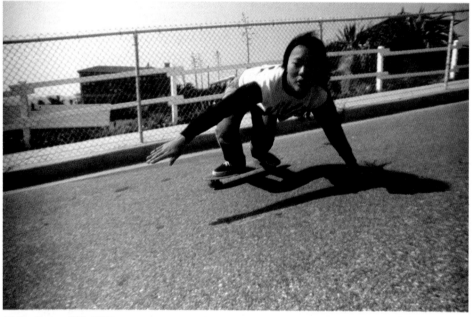

45.1. Peggy Oki, 1975.

PHOTOGRAPHER: PAT DARRIN

While girls gained incremental social freedoms by the early 1970s, in the area of fashion there were major changes. Schools altered their dress codes, no longer requiring girls to wear skirts or dresses. Pants, shorts, and jeans gave girls a new flexibility of movement to run, jump, climb trees, and participate in a wider range of sports. In Southern California, one activity that emerged as a boys-only domain was skateboarding, but it didn't take long for girls to show up and make their mark. Peggy Oki broke down barriers as the only girl on the skateboarding team that would revolutionize skateboarding forever.

Peggy was born in 1956 to refugees from Hiroshima, who left after the United States military dropped an atomic bomb on the city in 1945. While her family was firmly middle class, she grew up in a part of Santa Monica that became known as Dogtown. This was a rough, lower socioeconomic area that had fallen into disrepair after an early 1960s boom, leaving many public facilities condemned. Even the popular Pacific Ocean Park Pier and its amusement park rides fell into disrepair. However, the concrete wasteland became a playground for local kids, who repurposed the spaces for their hobbies of surfing and skateboarding.

Being raised near the beach, Peggy was drawn to the sea. She started surfing when she was 6 years old. But since the waves were often flat or there was too much wind, local kids needed something else to do instead. Skateboarding became a natural extension of surf culture in Dogtown. Peggy's father bought her and her older brother skateboards when she was 9 years old.[1] These were the wooden boards with clay wheels that were extremely dangerous: they simply stopped rolling if there was a pebble or even a sidewalk crack in the way. It wasn't until the development of urethane wheels, which were more maneuverable and had a better grip, that Peggy became enthusiastic about skateboarding. While there weren't many girls skating at the time, Peggy wasn't concerned about what girls were meant to be doing. She would skate near the beach, around Bicknell Hill, right near the Zephyr Surf Shop.

Started in 1971, Jeff Ho Surfboards and Zephyr Productions was the hub of Dogtown surfing, having started their first surf team that same year. By 1975, there was enough interest for the Zephyr Shop to start a skateboarding team as well. Peggy recalls that it was the young Jay Adams, 13 years old at the time, who was impressed with her skating and asked her to join the Zephyr team.[2] Alongside 11 boys, all younger than she, 19-year-old Peggy became the only

girl on a team that would transform skateboarding forever. Their style came straight from the waves, mimicking and building on the movements of Larry Bertlemann, a highly admired Hawaiian surfer. In the 1960s, when skateboarding had its first wave of popularity, it was focused on verticality, upright tricks, spins, and more stiff-legged movements. This group, which became known as the Z-Boys, were more fluid in their motion, with a lower crouching style, more horizontal, as if they were riding concrete waves.

As a team, they were tight knit. While there were rivalries, they pushed each other to be better through daily practice. Peggy's natural style was described as graceful, a more feminine way of saying fluid, which is what they were all doing. Peggy was essentially skating like the boys. Photographer Pat Darrin captured this iconic image of Peggy in motion (Figure 45.1). Being a girl didn't seem to be an issue because the boys respected her skills and dedication, which was what mattered the most. "I just knew that I loved skateboarding. I wanted to skate, and these guys wanted to skate, and that's all we focused on."[3] They were all there to have fun, which was most important to Peggy; the freedom and self-expression that she felt skating was her motivation. Also, since girls and boys were separated in the competitions, she wasn't a direct threat to the rest of her team's opportunity to win.

In 1975, the first international skateboarding championships, the Bahne-Cadillac Del Mar Nationals, were held in Del Mar, California. Peggy and the Z-Boys team represented a completely new style and attitude toward skateboarding. This radical change—from the clean-cut, more gymnastic look of everyone else at the competition to the tough, street-style, ripped clothes look of the Z-Boys—completely revolutionized the sport.[4] While Z-Boys placed well overall, despite confounding the judges on how to score moves that no one had really seen before, it was Peggy who placed first. Winning the girls freestyle, Peggy was given grief from the other girls in the competition, who complained to the judges that she was skating like a boy. Peggy happily recalls that "Some of the judges said I skated better than the boys."[5]

While the boys immediately got offered sponsorship deals and went on to international fame and some fortune, Peggy left the team to go to college at the University of California, Santa Barbara (UCSB), studying environmental biology and animal behavior. For the boys, who were all younger than she, skating was seen as their career path, while Peggy had always done it for fun.[6] She had other life plans. Eventually, Peggy went on to complete a degree in

painting focusing on environmental art. She skated the entire time she was at UCSB. Peggy's passion for surfing and skateboarding meant she spent most of her time outside, so it was natural for Peggy to become an environmentalist. Her love of the ocean and sea life, especially the dolphins, which also surf the waves, led her to become an activist and artist.[7] At almost 70 years old, Peggy still lives in California, surfing, skating, rock climbing, painting, and advocating for the environment. In 2012, Peggy was inducted into the Skateboarding Hall of Fame, and she has her own signature board.

Part X
GIRL POWER, 1980s TO THE PRESENT

As the 20th century came to a close, icons emerged that brought girls to the forefront of American culture in new ways, proving that youth was not a barrier to full participation in society or the ability to make broad social impacts. These icons built on those who came before them, seeking to fully eradicate the glass ceilings that prevented girls of color from participating as fully as white girls. In music, Selena Quintanilla broke barriers for women in Tejano music, bringing it into the national spotlight and opening doors for Latina girls and women to more fully participate in the music industry. In sports, Dominique Dawes became the first Black girl gymnast to compete for the United States in the Olympic Games.

Additionally, with the advent and increasing use of the internet, girls found a new medium in which to express themselves. Building on the zine movement of the late 1980s and early 1990s, *Rookie* magazine created a digital zine culture that empowered girls to freely express themselves. *Rookie*'s subsequent *Yearbook* publications, rounding up girls' submissions from each year between 2011 and 2014, provide a tangible record of girl culture in the same way that individual zines did during the 1990s. Utilizing internet-based social media and crowdfunding, girls participated in fourth wave feminism by seeking greater opportunities in traditionally male fields and continuing to advocate for causes important to their communities. Debbie Sterling utilized Kickstarter to create GoldieBlox—a company and toy focused on encouraging girls

to pursue science, technology, engineering, and math studies (STEM) while merging gender norms for girls and boys. Meanwhile, environmental activists like Anna Lee Rain Yellowhammer and Mari Copeny were able to take their on-the-ground protests global by using the internet as a forum to advocate for change. These movements proved that girls are still major forces for change in American society, maintaining a role in communities and the nation that they have held since the first North American settlements.

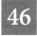

Selena Quintanilla Memorial, Corpus Christi, Texas, 1995

46.1. Selena Quintanilla Memorial in Corpus Christi, Texas.

SIMIPROF VIA WIKIMEDIA COMMONS

Girls continued to be influential in music during the 1990s, but represen-
tation in the music industry remained restricted to primarily white and
Black girls. In 1989, a Latina girl broke through the racial barriers of the music
industry and introduced Americans to a new sound. Shattering record sales,
Selena Quintanilla-Perez became the "Queen of Tejano Music," and her short
life had lasting effects on American music and culture.

Born in Lake Jackson, Texas, in 1971, Selena was the youngest child of Mar-
cella and Abraham Quintanilla, whose love of music was shared by their chil-
dren. Selena's musical talent was noticed by her father at a young age. By 1980
she was performing in her father's restaurant, Papa Gayo's. Her music, played
by her siblings in a band, blended a variety of Latin music genres with pop.
In 1981, the restaurant closed and the family went bankrupt, so they moved
to Corpus Christi to start fresh. There, Abraham formalized his children into
a band, Selena y Los Dios. They played on street corners, in weddings, and
quinceañeras, and at fairs.

Having to work to make money for the family, Selena was forced to quit
school in the eighth grade. Tejano music was a male-dominated scene, which,
alongside her lack of education, presented many challenges, both personally
and professionally. Born in Texas, Selena spoke only English and had to learn
Spanish phonetically in order to perform for her audiences. Yet she and her
siblings persevered, recording their first LP in 1984 for Freddie Records.

Their young age presented many challenges in securing a record deal, but
this changed in 1987 when Selena won the Tejano Music Award for Female
Vocalist of the Year. This was the first of nine consecutive wins for her.
In 1989, Selena signed with EMI Latin and recorded her self-titled debut
album. Within three years, her subsequent albums reached #1 on the US
Billboard Regional Mexican Albums for eight consecutive months, and her
1992 song "Como la Flor" became her breakthrough hit. The album, *Entre
a Mi Mundo*, went on to be certified 10 times platinum for sales of over
600,000 in the USA, and helped her win acclaim throughout the country
and Mexico.

Around this time, Selena's personal life changed rapidly. To complete her
education, she finished her high school diploma via correspondence school
and enrolled at Pacific Western University. She eloped with her first boyfriend,
Chris Perez, who had been a member of her band. Her career continued to
skyrocket, culminating with winning the Best Mexican/American Album at

the 1994 Grammy awards. She was the first female Tejano artist to receive the award, and the album, *Amor Prohibido*, became one of the best-selling Latin albums of all time. She also began a side business in fashion, designing and manufacturing clothing at self-titled boutiques in Corpus Christi and San Antonio. Both were managed by Yolanda Saldivar, her friend since 1991 and fan club president.

However, Yolanda was not Selena's friend. Within a year, the boutiques were suffering and staff raised the alarm. They alerted Selena's father to Yolanda's erratic behavior and their concerns that the friendship was negatively affecting Selena. By January 1995, evidence was mounting that Yolanda was embezzling funds from both the fan club and boutiques and that the friendship was unhealthy. Yolanda was seemingly obsessed with Selena. On March 9, Abraham and Selena confronted Yolanda and threatened to call the police. Less than a month later, Selena went to Yolanda's hotel room to confront her and obtain financial records. During their talk, Yolanda pulled out a gun and shot Selena in the back of her shoulder, indicating Selena was trying to flee. As Selena ran, she collapsed in the hotel lobby where a clerk heard Yolanda cursing and slurring.

On that day, March 31, 1995, Selena died, at only 23 years old. Her death "became a community, rather than a family tragedy. There was a shared sense of loss, bewilderment, and in some cases, anger" in Corpus Christi and throughout the US and Mexico.[1] Though many Americans were unaware of Selena's career, her death rapidly increased interest and record sales, causing Selena to be dubbed the "Tex-Mex Madonna." Yet as the media sought more information and learned of Selena's impact on Tejano music, the nickname was dropped since it did not accurately reflect her music or achievements. Instead, she was named "Queen of Tejano Music" and catapulted the community into the national spotlight.

Selena's death remains one of the most well known of the 1990s and pushed her album sales into national acclaim. Her funeral at Bayfront Auditorium welcomed thousands, many who visited to be healed or described sightings of her spirit offering encouragement and hope.[2] Most of all, Selena is remembered for being "one of them" among the Latinx community—a Mexican-American who represented an entire ethnicity on the national stage and helped the media pay attention to a group that had been in America longer than most.

Her 1995 album, *Dreaming of You*, released after her death, made her the first Latin artist to debut on the Billboard 200 and became a role model for future performers of color.[3] Ironically, her crossover was a return to her native language (English) and home (Texas) after years of performing in Spanish. Regardless, Selena's posthumous crossover success opened doors for hundreds, if not thousands, of Tejano female artists who were playing in hotel rooms, kitchens, and parks. It also brought attention to the migrant population of Texas that relied on traveling performances for entertainment but now, finally, could enjoy the same mainstream avenues of music as other Americans. In so doing, Selena redefined Latin, Tejano, Cumbia, and Latin pop musical styles as subgenres of American music. In May 1997, just two years after her death, these accomplishments were immortalized in a memorial at the Corpus Christi Bayfront (Figure 46.1), where Selena stands as a reminder of the Mexican-Americans who inhabited the Southwest and the vibrant culture that produced her success.

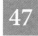

47

Dominique Dawes's Leotard, 1996

47.1. Olympic gymnastics leotard, worn by Dominique Dawes.

DIVISION OF CULTURE AND THE ARTS, NATIONAL MUSEUM OF AMERICAN HISTORY,
SMITHSONIAN INSTITUTION

Sports became important in the late 19th century as a way to promote national and colonial agendas, as seen in the 1904 World's Fair and the Fort Shaw Native Girls Basketball team. Similar to the World's Fair as a way to bridge differences and bring people together to celebrate human achievement, the first modern Olympics were held in 1896 at their birthplace of Athens, Greece. Gymnastics was included in these first games, but females were not permitted to compete until the 1928 Amsterdam Games, and then not again until 1936 when they were hosted by the newly elected Nazi Party in Berlin, Germany. While the Americans came in second place to Germany in overall medals, Jesse Owens led the charge to undermine assertions of white racial superiority by winning four gold medals. However, because he was Black, his achievement was not acknowledged by Hitler or, more importantly, the White House. This sexism and racism continued well into the late 20th century, with Black girls like Alice Coachman and Wilma Rudolph winning national gymnastic competitions, but receiving little recognition or the opportunity to participate in the Olympics. That changed in 1992 when Dominique Dawes joined US Women's Olympic Gymnastics as the first Black team member.

Olympic-level gymnastics was dominated by the Soviet Union for decades. The US Women's Gymnastics only won the team bronze in the 1948 Summer Olympics and did not secure another medal until 1984 when they won silver. With this win, the US became real contenders, and girls who could compete on the world stage were sought from all over the country. Born November 20, 1976, in Silver Spring, Maryland, Dominique was highly disciplined and an early achiever. Generally speaking, top athletes begin training in some form when they are children, and Dominique began tumbling at the age of 6. Her father, Don Dawes, said that at age 9, Dominique began to write the word "determination" in shaving cream on her bathroom mirror before competitions.[1] Just a year later, she was competing at the junior elite level. She participated in her first international event in Australia when she was 12. By the time Dominique was 14, she placed third all round in the national championships.

In 1992, Dominique competed in the Barcelona Summer Olympic Games, winning the team bronze. However, it was at the 1993 World Gymnastics Championships in Birmingham, England, that she won two silver medals, in the uneven bars and balance beam. These were the first ever won by a Black girl gymnast, and she was named USA Gymnastics 1993 Athlete of the Year.

As competition from Romania and China became fiercer, American gymnasts became symbols of exceptionalism, freedom, and democracy. And for the girls, this meant they had to have a certain look. The American women's gymnastics team was petite, cute, usually blonde, and always smiling. Black girls faced racial stereotypes that dictated they were not these things, so they were at a disadvantage. Different body types combined with racialized expectations often made Black female athletes the object of curiosity, ridicule, and exoticism, rather than celebration. Dominique knew about racism firsthand. Her detractors critiqued her body, her hair, and her style.[2]

Dominique's difference was highlighted by the tight-fitting, minimalist clothing required in order to complete the routines. The gymnastics leotard evolved from being a costume for ease of movement to a stylish statement of sparkles and skin. In the 1970s, the leotards that gymnasts wore were purposefully plain, but by the 1990s, they were tight fitting with higher cuts on the legs to make short girls look longer and leaner. Márta Károlyi, head coach of the 1996 Olympic team, influenced the leotard design, wanting the athletic bodies of the girls to be on display. "Marta insisted on white bodies. . . . She wanted to show off the abs of the athletes."[3] That the bodies of the girls were as much on display as their strength and skills should not be surprising. The display of their girlishness was as important as winning the gold. For Dominique, a positive attitude helped her rise above the criticism of her appearance. More importantly, her performance demonstrated that she deserved a place in this sport where girls like her weren't expected to achieve.

The 1996 Olympics was the first time the USA dominated women's gymnastics. Known as the "Magnificent Seven," the team included Dominique, Kerri Strug, Shannon Miller, Dominique Moceanu, Amanda Borden, Amy Chow, and Jaycie Phelps. Before they were a team, they had been fierce rivals. Each girl had ups and downs during the competition, and they just barely won the overall team gold. Dominique won the individual bronze for her floor routine, the first Black girl ever to do so. Nicknamed "Awesome Dawesome," 20-year-old Dominique's leotard from the 1996 Atlanta Olympics (Figure 47.1) was collected by the Smithsonian Museum of American History.

After the Olympics, the team was celebrated and invited to the White House. Dominique received attention from many corners of the entertainment industry. She appeared in a music video for the singer Prince, who was a fan. She also landed her first theatrical job as Patty Simcox in a 1997 Broadway

revival of *Grease* and appeared in television shows and commercials. Despite these asides, Dominique continued her career as a gymnast longer than most girls. She is one of only three gymnasts to participate in three Olympic games and win medals at all of them (1992, 1996, 2000). From 2004 to 2006, she served as the youngest president of the Women's Sports Foundation. Like many former Olympians, she became a gymnastics broadcaster, lending an authenticity to the public expectations and commentary on gymnasts' performances. In 2010, Dominique became the co-chair of President Obama's Council on Fitness, Sports and Nutrition.

With a long and varied career, Dominique made a great impact on women's gymnastics. Her strength, style, and presence paved the way for other girls of color to succeed in gymnastics. She also elevated the perceptions of gymnasts of color through her career as their president and then a broadcaster. Dominique's perseverance paved the way for Gabby Douglas, Simone Biles, and Maria Hernandez, who were a part of the most diverse and successful Olympic team ever in 2018.[4] Simone, at 22, is currently the most decorated American gymnast in history, with Dominique having paved the way.

Rookie Yearbook One, 2011

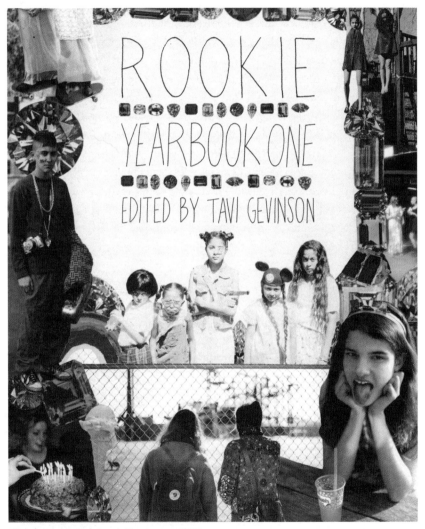

48.1. *Rookie Yearbook One* cover, 2012.
PHOTOGRAPHER: TIFFANY ISSELHARDT

In the 1990s, a distinctly girl-produced phenomenon emerged: zine culture. This underground movement became highly covered by the media, magazines, and academia and turned a do-it-yourself (DIY) effort into a national phenomenon. Zines were "do-it-yourself publications made primarily by and for girls and women" that featured cut-and-paste collages, intelligent and political writing, and self-reflection.[1] The authors tackled issues that were personal, gender specific, and universal. They looked at body image, sexuality, gender-based violence, class, self-esteem, relationships, music, art, and history, all through personal stories, fiction, rants, poetry, and essays. What they held in common was their DIY nature and content produced straight from real, heartfelt lives, attempting to help girls reconnect with themselves and each other.

In 2011, zine culture moved from girls' bedrooms and onto their computers. Tavi Gevinson, a 15-year-old Chicago fashion blogger, founded the online magazine *Rookie*. Combining the concept of the zine with the virtual medium of the internet, *Rookie* was an online magazine for teenage girls with monthly themed issues delivered via website, email, and social media. "For each issue of *Rookie*, [Tavi] routinely wrote open hearted letters flecked with big ideas, lingering thoughts, asides, and pop-culture references, missives that delved into that given month's editorial theme" and revived the personal nature of printed zines.[2]

Beyond her letters, each issue of *Rookie* featured photo galleries and stories (fiction and nonfiction) submitted directly from young girls. Some examples include galleries of teen girl rooms that demonstrate commonalities and differences, playful and vulnerable photographs of the girls, letters and diaries of their experiences, and collages or hand illustrations evocative of earlier zine culture. This style helped girls form their identities and connect over issues related to being a girl in the postmodern, highly digital world. Their thoughts and feelings were "treated with validity and care instead of condescension and preachiness," cultivating a space where readers could engage in self- and group reflection.[3] Tavi also frequently cited or included information about zines produced in the 1990s, notably those within the Riot Grrrl movement. Her interviews with Kathleen Hanna and Carrie Brownstein, two founders of Riot Grrrl, gave young girls of the 2000s information on how to make their own DIY zines, exposing them to 1990s girl culture and music, and introducing important feminist movements.

The online magazine garnered over one million pageviews in less than a week after its launch, prompting Tavi to embark on a 2012 summer road trip to promote the launch of its first physical publication, *Rookie Yearbook One* (Figure 48.1). As Tavi stated:

And so, we created *Yearbook* in an attempt to do justice to our very best pieces from the September 2011–May 2012 school year. This is the stuff that needed to be in pages adorned with doodles and glitter, that is revisited in times of angst and crisis, and that couldn't be just stared at on a screen for such an occasion. I mean, being able to actually HOLD art and writing that you love is kind of sort of really special.[4]

Yearbook One was an anthology of posts from *Rookie*'s first year, printed and edited by Tavi and illustrated by famous female artists. Opening the pages, readers found a school yearbook-like layout, complete with handwritten notes about the impact *Rookie* had on individual girls. The format combined zines' cut-and-paste mentality with traditional magazine anthology elements such as credits, a typewritten table of contents, and chronological layout of content. Each article was credited to its original online author, ranging from advice on how to combat stress and inner demons to getting through the first year of high school. Other articles provided how-to guides, such as "How to Bitch-face," or answered girls' frequently asked questions on sex, relationships, and other issues. In "Never Been Kissed," Rachael recounted her experiences as a 23-year-old virgin and answered "a bunch of questions that I wish someone had answered for me" including ones on masturbation, orgasms, and porn.[5]

There were also personal essays about pop culture and its meanings, such as what *The Rocky Horror Picture Show* meant to contributor Kevin Townley, and observations that helped reveal the lives of transgender girls, meanings of home, being fangirls of bands, and those with eating disorders. Every article demonstrated a real social or cultural issue in girls' lives, expressing their thoughts on, and participation in, dominant and alternative cultures. Photo anthologies also showed girls' real lives, including both natural and staged photos of school, girls' rooms, fashion shows, girl gangs, and seasonal activities. *Yearbook* included sticker sheets, do-it-yourself activities such as the "Crown of Love" to be worn, and tear-out fake albums with recommended playlists typewritten on them, empowering readers to customize the *Yearbook*

to their liking, thus participating in the zine-making process. The success was later followed by three more yearbooks in 2013, 2014, and 2015. Unfortunately, *Yearbook* ended after its fourth volume.

In 2018, *Rookie*'s online magazine ended because Tavi had grown older and had other interests that superseded the teen girl magazine. In her last letter from the editor, Tavi described her struggles to reckon with *Rookie*'s growth and needing to seek sponsors to keep the magazine going. Her letter reflected sentiments that had forced the zine culture to diminish, such as "feeling constantly marketed to in almost all forms of media" and "being seen as a consumer rather than a reader or person" and discouragement with the financial reality of running a magazine.[6] For many of its readers, *Rookie*'s end signified the closing of a door to an online space where they felt seen, could dream, and met other girls who were smart and introspective.

Rookie Yearbooks remain a tangible record of the online magazine, providing a collective printed diary of girl culture in the 2010s. It celebrates girlhood, from 2011 to 2015, enabling scholars and girls to connect across generations, much as zine culture did in the 1990s. While zines are typically viewed as part of the underground, *Rookie* helped catapult them into an international and highly visible spotlight, cementing girls' unique voices and culture for a new, digital-driven generation.

The impact of *Rookie* on girls was summed up by Lucia Santos, a 13-year-old contributor: "The effect of scanning my illustration and sending it off across the county—to be published on this website that so many people kind of rely on—felt so good, so validating and so uplifting. I felt so empowered."[7] Lucia shows *Rookie* was a lived experience, helping to negotiate and understand culture while forming a place in it. Through empowering girl authors and illustrators, providing a space for their voices and images, and creating an online community across multiple cultural divides (race, age, place, and gender identity), *Rookie* helped girls create their own national culture and identity. It continued the DIY ethos of zine culture while empowering girls through the internet and providing a home for their voices and stories, otherwise often silenced and ignored. While *Rookie* is no more, the *Yearbooks* left behind are a memory of this empowerment and the continuation of vulnerable, mutually sharing, positive girl culture despite patriarchal attempts to define and capture it.

49

GoldieBlox and the Spinning Machine, 2012

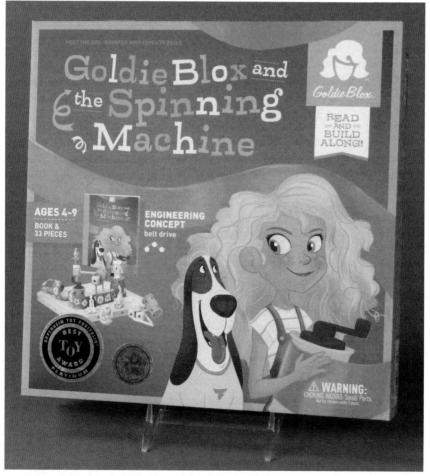

49.1. GoldieBlox and the Spinning Machine set, 2012.
THE STRONG, ROCHESTER, NEW YORK

In the 2010s, the fourth wave of feminism arose, focused on the empower-ment of women through a different medium: the internet. As part of this movement, there was a growing emphasis on women in nontraditional ca-reers, notably the science, technology, engineering, and math (STEM) fields. In 2012, a new toy emerged to encourage girls toward STEM fields and shatter the gender bias among girls' toys: GoldieBlox and the Spinning Machine.

GoldieBlox was the brainchild of Debbie Sterling, a female mechanical engineer whose college class of 700 included only 181 women. After working as an engineer for seven years, Debbie noticed the lack of girls in engineering wasn't just in college—it was in every level of school and the workplace and even in toy aisles. In response, Debbie created a toy she hoped would encour-age girls toward STEM fields. She debuted the toy at the New York Toy Fair in 2012, but the skeptical, male-dominated toy industry was not interested, much like they had been uninterested in Barbie in 1959. So Debbie turned to the internet and the power of crowdfunding on the Kickstarter platform. Her campaign raised over $258,000 in one month to manufacture the first GoldieBlox and the Spinning Machine (Figure 49.1). The toy features a young girl named Goldie, dressed in overalls and a tool belt, who builds a conveyor belt to help her dog, Nacho, chase his tail. Children follow the story narra-tive included in order to build the kit. Storytelling is the unique aspect of GoldieBlox, blending construction with "interesting and relevant characters, recognizable cultural symbols, and easy-to-follow and entertaining plots."[1]

GoldieBlox and the Spinning Machine won Intuit's Small Business, Big Game fan-favorite contest in 2013, becoming the first small business to show an advertisement during the Super Bowl. It also appeared on a float in the 2014 Macy's Thanksgiving Day Parade. Yet Goldie was not immune to criti-cism. Her use of the color pink and small, thin body were criticized in a simi-lar way to Barbie. Critics wondered if something was wrong with the color pink, while others stated Goldie's use of pink was another gender marketing trap to lure parents into buying something framed as empowering but still "the same old glittery crap."[2] Other critics saw Goldie's body as too blonde, white, and thin to be a good role model for girls while relegating diversity to her friends—the Black Ruby Rails, Latina Valentina Voltz, and Asian Li Gravity—perpetuated racism.

Despite these criticisms, GoldieBlox and the Spinning Machine made a significant impact on the toy industry and marketing. It put a spotlight on

the "pink aisle," a nickname for the traditional layout and content of toy aisles aimed at girls. Featuring an overabundance of pink-colored marketing, this aisle traditionally displays dolls, dress-up clothing, princess-inspired toys, and beauty accessories, in stark contrast to the blue-colored boys' aisles with things like trucks, action figures, sports, and construction sets. GoldieBlox, a brightly colored set amidst princesses and baby dolls, was the first prominent toy to cross this boundary. It broke stereotypes of the traditional narrative found in girls' toys by being "smart but not nerdy; she remains cute, but not because of unrealistic beauty standards, and her hijinks make her relatable but still cool."[3] In so doing, it challenged gendered assumptions about what girls want in toys.

GoldieBlox and the Spinning Machine also highlighted the lack of girls in STEM fields. Goldie challenged children—and grown-ups—to think about how girls are predisposed to learn and are prevented from going into the STEM fields. She highlighted several international studies that show gender differences in the pursuit of STEM are culturally, not biologically, dictated. "Even a subtle reference to gender stereotypes has been shown to adversely affect girls' math test performance. Stereotypes also influence girls' self-assessments in math, which influence their interest in pursuing science, technology, engineering, and mathematics subjects and careers."[4] By highlighting these studies, GoldieBlox further empowered girls and challenged the educational and social upbringing of girls. The use of Kickstarter and Debbie Sterling's achievement of 190% of her initial goal showcased how crowdfunding could be used to empower girls through new toys, games, and cultural products. By democratizing funding and utilizing social media, rather than relying on corporate toy companies in traditional venues like the New York Toy Fair, girls and women could promote and create products that suited their actual, rather than assumed, needs.

Most of all, GoldieBlox and the Spinning Machine amplified discussions about the gendered nature of toys to a national, perhaps even international, stage. The toy was part of a larger cultural movement to break out of the pink aisle and shatter gender stereotypes, in the hopes of inspiring the next generation of girls to defy social norms in the pursuit of their dreams. GoldieBlox's corporate narrative challenged 100-year-old assumptions about what girls, and boys, wanted in toys and how toys could be used to cultivate their emerging skill sets and interests. As Kasey Hudak pointed out,

The problem, as GoldieBlox sees it, is twofold: on one hand, toy store aisles separate boys and girls from the type of toys that cultivate the skills necessary for them to become professional equals, which are reinforced by toy marketers. On the other hand, there are significant and deeply embedded cultural contexts that young girls and boys are already taught at a young age, which need to be addressed long before the choice of toys become part of the conversation.[5]

After GoldieBlox's launch in 2012, the toy market changed significantly. In 2013, GoldieBlox reached sales of over one million dollars while inspiring a United Kingdom–based petition that forced Toys-R-Us stores in the UK to stop gendered marketing of toy aisles, though the same did not happen in the United States. GoldieBlox used STEM fields, crowdfunding, and social media to lead the charge against gender stereotyping in children's toys and change the conversation about how girls are exposed to, and cultivated in, the STEM fields. Today, the nation is full of girl inventors and scientists who are proving that girls can not only pursue STEM careers, but are just as naturally inclined to those fields as boys.

Letter by Anna Lee Rain Yellowhammer and Photograph of Mari Copeny, 2016

4/9/16

To the Army Corps of Engineers,

My name is Anna Lee Rain Yellow Hammer. I'm 13 years old and I am an enrolled member of the Standing Rock Sioux Tribe. I lived all my life in Fort Yates, North Dakota. I play basketball for Standing Rock Middle School and I am also on the Student Council.

I am writing this letter to stop the Dakota Access Pipeline. My great grandparents are originally from Cannon Ball, North Dakota where the pipeline will cross the Missouri River. They lived along the Missouri River all their life. They raised gardens, chikens and horses. I want to be the voice for my great grandparents and my community to stop the building of the Dakota Access pipeline. If the pipeline breaks the oil will spill on the ground and into the water. Grass, crops, trees and animals will not be able to grow and live because of the oil. People will not be able to drink from the river or use the water. The time and the cost to clean up oil spills will take years and probably millions of dollars.

Water to the Dakota people is the First Medicine. Mni Wiconi - Water is life.

Say no to the Dakota Access Pipeline. Please sign our petition.

Sincerely,

Anna Lee Rain Yellow Hammer
Standing Rock Middle School

50.1. Letter by Anna Lee Rain Yellowhammer to US Assistant Secretary Darcy and the US Army Corps of Engineers regarding the Dakota Access Pipeline, April 9, 2016.

ANNA LEE RAIN YELLOWHAMMER

As children, we learn very early on that water creates and sustains life. However, access to water, especially clean drinking water, has become a pawn for commercial and political interests. In the 1960s, the environmental movement began as a response to the post–World War II population boom and hyperindustrialization of America. These concerns were sustained primarily by women alongside the feminist movement of the 1970s and into the early 2000s. Already in 21st century America, there have been several water crises, most visibly in North Dakota at the Standing Rock Sioux Reservation and in Flint, Michigan. With their communities threatened, 13-year-old Anna Lee Rain Yellowhammer and 8-year-old Mari Copeny deployed the new tools of online action—social media—to organize, protest, and reach out to the world to share their stories.

While the situations in Standing Rock and Flint have different origins, there are common threads: institutionalized racism within government policy, and those who value money over life. The Dakota Access Pipeline (DAPL) was built to transport fracked oil across four states, from the Bakken shale fields of North Dakota to Patoka, Illinois. The route of this pipe is purposeful, running through land owned by the Lakota, where Anna Lee lives, and underneath the Missouri River, destroying sacred sites and affecting the health and livelihood of the local people. Yet for the company building the DAPL, this was preferable to threatening the white communities of Bismarck.[1] Similarly, in Mari's hometown of Flint, the local government was responsible for the crisis. In April 2014, in an effort to save money, they changed the city water supply to the polluted Flint River. Very soon, the water was undrinkable. After years of denial, it was proven that the levels of lead and other harmful chemicals were damagingly high. Because of the racial makeup of the city, the Black population was disproportionately affected by the harmful effects of the tainted water.[2]

Girls from marginalized communities have always been at the forefront of protests, standing up for their rights. Anna Lee and Mari have much in common, both acknowledging the value of clean water and using similar strategies to mobilize the public to their cause. Anna Lee and her friends started an indigenous youth group called "ReZpect Our Water" to bring attention to these issues. Getting the attention of those who can help often begins with a simple step, like writing a letter. Both girls wrote letters to voice their concerns and asked for their leaders to take action. On April 6, 2016, Anna Lee wrote to

the US Army Corps of Engineers asking them to sign her change.org petition and help stop the pipeline (Figure 50.1). They had already approved it, yet had not done their due diligence with the tribal permissions and environmental impact studies.[3] Her letter makes clear both the significance of the unspoiled land and the dangers of inevitable future oil spills to herself, family, and community. She coined the phrase, "Mni wiconi" (Water is Life), which became an important rallying cry at the protests that followed.

That same year, Mari wrote to President Barack Obama to make sure he knew what was happening to her city. She asked for help to fix the broken water system and get clean water to her community. "I am one of the children that are affected by this water, and I've been doing my best to march in protest and to speak out for all the kids that live here in Flint."[4]

Typically, letters are not enough to convince leaders to act for the concerns of minority communities. But these girls got the attention they needed at the time. Using the hashtag #NoDAPL and starting an Instagram account for the ReZpect Our Water group, Anna Lee wrote a petition at change.org, accompanied by a powerful video made by her and other teen activists, and spurred Americans into action. The tribe was fighting the pipeline through the courts, but as the construction came closer to the reservation, the unarmed protestors used peaceful and nonviolent methods, including prayer vigils, to halt its progress. However, the government response was violent, as the youth leaders were maced, set on by police dogs, shot with rubber bullets, and threatened by local police.[5]

The protests drew attention from around the world, dividing people over their support of either the "water protectors" or the pipeline. While thousands of people came to Standing Rock to support the protectors, tensions grew. By the time the governor of North Dakota ordered everyone to leave, hundreds of people had been arrested and injured from tear gas and water cannons. While making no specific commitments, President Obama said that the Army Corps of Engineers would study another route for the pipeline that would not disturb the Native lands. Ultimately, the DAPL was approved by the next administration's executive order and has since been completed.

In the hierarchy of things that can be achieved, politicians often make a choice, consciously or not. While the political will was not behind stopping the DAPL, it was in regard to the water crisis in Flint. When Mari wrote directly to President Obama, she also used social media, primarily Instagram, to promote her message.

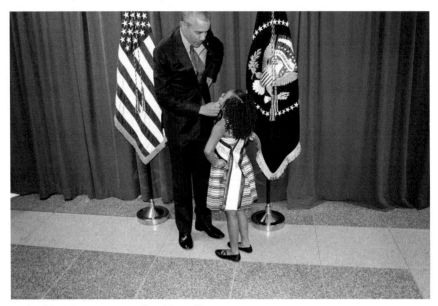

50.2. Mari Copeny meets President Obama.
MARI COPENY

Obama was moved by Mari's letter, visiting Flint himself in May 2016, where he met with Mari, who had been nicknamed "Little Miss Flint" (Figure 50.2). He also granted 100 million dollars toward upgrading and replacing the outdated and dangerous water system. While it took many years, the Flint water crisis has been resolved in terms of the water itself, but the damage to the community of Flint is ongoing.[6] Lawsuits are pending, including criminal charges against government officials who were knowingly negligent or acted willfully to harm the community. Mari continues her social campaigning and, as she gets older, is able to do even more for her community and water activism around the world. Despite the mistrust that comes from betrayal by the local government, the people tasked with the job of protecting the community, the lesson Mari has taken from her experience is that you have to keep fighting, yet she will "never trust tap water ever again."[7]

Protecting their communities and environments from present and future dangers, Anna Lee and Mari used their voices as well as old and new channels of communication. Through social media channels such as Facebook and Instagram, and action platforms like change.org, Anna Lee and Mari were able

to raise money and awareness. Despite the ongoing polarization of American society, even when it comes to protecting the environment, there are young leaders out there fighting for cleaner, safer communities, and a better future for themselves and for the country.

Afterword

The Future of American Girlhood

Around 108 billion people have been born on Earth since 50,000 BCE. Roughly half of these births have been female, and those who survived grew into women. Girls' activities are part of our collective past, but only a select few have been recorded as significant and worthy of commemoration. As we have shown in this book, through a mere 50 objects and sites, girls have been crucial to the creation of America as a concept, a place, and a people.

However, these 50 just scratch the surface of the thousands—perhaps millions—of girls' stories that are worthy of elevating in the historic narrative. We have tried to be inclusive in our selections, while focusing on girls whose stories are clearly identified at a historic site or in an artifact. Additionally, given the need to encompass all of American history, we selected girls whose stories help address broad movements and themes. This limited our ability to provide more in-depth, as well as contradictory, perspectives of the American experience or to represent those that we felt deserve more attention, such as Native, Black, Latina, and Asian girls who are far more present in the American story than traditionally taught. Thus, this book does exclude many of the diverse, untold stories of American girls that are still waiting to be told. In order to move beyond lists and develop a holistic view of the past, we appeal to historians and interpreters to reevaluate who and what is worth remembering for posterity and to support a more inclusive and intersectional future.

The importance of collecting and preserving these stories and their related objects or sites cannot be overstated. Historians and museums alike should refocus their research priorities and collection practices to better serve these absent voices. In gathering and sharing these stories of American girls, we hope to correct a misconception that the past must be taught through the lens of great achievements by rich, white, heterosexual men, or that girls were not important actors in the formation of America and its identity. Within the shared experiences of colonization, slavery, oppression, exploitation, and segregation, the daily lives of girls provide us valuable lessons on responsibility, community, compassion, and heroism.

What can be seen from the stories we have shared are two basic truths. Firstly, everyone who lives in America contributes to our nation, and each one of them or their ancestors came from somewhere else. Whether by need or by force, girls came to this continent and helped establish communities—past and present—to which they contributed and, at times, profoundly shaped. Their contributions may have been ignored in national narratives, but their artifacts and the spaces they inhabited remain, primarily within legend, local history, and archaeology. Selecting just 50 was no easy task, and there is more to discover about these girls and the many more whose stories still remain to be told. Secondly, there is no one thing that defines a girl's identity or experience. Diversity is as old as life itself and has the advantage of resilience. It stands to reason that the enduring stereotype of the passive, obedient, weak girl holds little truth when held up against the realities of girls' lived experiences. Through their lives, these girls have shown that there are an infinite number of ways to be a girl, let alone an American girl.

What these girls have in common is resourcefulness, generosity, passion, and bravery. Their collective actions have produced 21st-century girls, whose enthusiasm and dedication to the future are boundless. While the founders of this country did not include them in their original vision, girls today, like their ancestors, continue to demonstrate why they have always been a part of the American story. Their hard work made life richer and fuller, some even making the elusive American Dream come true. They act on their beliefs, utilize new technologies, and seek out better lives for themselves and their communities. We hope that these girls of the past will inspire the girls of today and the future to pursue their dreams, and to strive toward a nation where all are free and equal.

Notes

INTRODUCTION

1. Jack Page, *In the Hands of the Great Spirit: The 20,000-Year History of American Indians* (New York: Free Press, 2004), 17.

2. Russell E. Dickenson, forward to *Interpreting Our Heritage*, by Freeman Tilden (University of North Carolina Press, 2008), iv.

PART I IN SEARCH OF HOME, 9500 BCE TO 1590S CE

1. Jake Page, *In the Hands of the Great Spirit: The 20,000-Year History of American Indians* (New York: Free Press, 2004), 4.

2. Steven Mithen, *After the Ice: A Global Human History, 20,000-5,000 BC* (London: Weidenfeld & Nicholson, 2003), 218.

CHAPTER 1

1. Ben Potter, "Upward Sun River Details," United States Department of Agriculture, Forest Service, Alaska Region, last modified December 10, 2015, https://www.fs.usda .gov/detail/r10/learning/history-culture/?cid=fseprd508062.

2. Ben Potter and Robert Sattler, "Upward Sun River Site Frequently Asked Questions," Tanana Chiefs, last modified 2007, https://www.tananachiefs.org/ upward-sun-river-site-faq/.

3. Potter and Sattler, "Upward Sun River Site Frequently Asked Questions."

4. Ben A. Potter, Joel D. Irish, Joshua D. Reuther, and Holly J. McKinney, "New Insights into Eastern Beringia Mortuary Behavior: A Terminal Pleistocene Double Infant Burial at Upward Sun River," *PNAS Early Edition* (October 9, 2014), 2.

5. Potter et al., "New Insights into Eastern Beringia Mortuary Behavior," 3.

6. Ben Potter, Joel D. Irish, Joshua D. Reuther, Carol Gelvin-Reymiller, and Vance T. Holliday, "A Terminal Pleistocene Child Cremation and Residential Structure from Eastern Beringia," *Science* (February 2011), 1059.

7. Potter et al., "New Insights into Eastern Beringia Mortuary Behavior," 1–2.

CHAPTER 2

1. The Lapita culture flourished from 500 BCE to 1000 CE in Polynesia.

2. PBR Hawaii & Associates, Inc., "Hāʻena State Park Master Plan, Draft Final Report," Department of Land & Natural Resources, Division of State Parks, May 2018, https://dlnr.hawaii.gov/dsp/files/2018/03/Haena-MP-FINAL.pdf.

3. PBR, "Hāʻena State Park Master Plan," 2–7.

4. Gary Y. Okihiro, *Island World: A History of Hawaiʻi and the United States* (University of California Press, 2008), 177.

5. Dorothy B. Barrere, Marion Kelly, and Mary K. Pukui, *Hula: Historical Perspectives* (Hawaiʻi Bishop Museum Press, 1980), 1–2.

6. Lydia K. Kualapai, "Cast in Print: The Nineteenth-Century Hawaiian Imaginary" (PhD diss., University of Nebraska, 2001), 141.

CHAPTER 3

1. Timothy R. Pauketat, *Cahokia: Ancient America's Great City on the Mississippi* (New York: Penguin Group, 2009), 2.

2. Pauketat, *Cahokia*, 104.

3. Natalie G. Mueller and Gayle J. Fritz, "Women as Symbols and Actors in the Mississippi Valley: Evidence from Female Flint-Clay Statues and Effigy Vessels," in *Native American Landscapes: An Engendered Perspective,* ed. Cheryl Claassen (Knoxville: University of Tennessee Press, 2016), 141.

4. Mueller and Fritz, "Women as Symbols," 111.

5. William Iseminger, *Cahokia Mounds: America's First City* (Charleston, SC: The History Press, 2010), 156.

6. Pauketat, *Cahokia*, 159–60.

CHAPTER 4

1. Huguenots were French Protestants of the 16th and 17th centuries who suffered persecution by Catholics. As a result, many Huguenots emigrated from France to other European countries or the Americas.

2. "The Display with Which a Queen-Elect is Brought to the King," Florida Memory, State Library & Archives of Florida, accessed November 11, 2018, https://www.floridamemory.com/items/show/254315.

3. Carolyn Niethammer, *Daughters of the Earth: The Lives and Legends of American Indian Women* (New York: Simon & Schuster Paperbacks, 1977), 35.

4. "Theodor de Bry's Engravings of the Timucua," Florida Memory, State Library & Archives of Florida, accessed November 11, 2018, https://www.floridamemory.com/find?keywords=debry.

5. "Theodor de Bry's Engravings of the Timucua."

6. Niethammer, *Daughters of the Earth*, 23.

7. Niethammer, *Daughters of the Earth*, 112.

8. Laura Fishman, "Old World Images Encounter New World Reality: Rene Laudonnière and the Timucuans of Florida," *The Sixteenth Century Journal* 26, no. 3 (Autumn 1995): 557.

9. Theodor de Bry, *Thomas Hariot's Virginia. March of America Facsimile Series, Number 15* (Ann Arbor, MI: University Microfilms, Inc., 1966).

10. Jerald T. Milanich, *The Timucua* (Oxford: Blackwell Publishers Ltd., 1996), 157.

11. Niethammer, *Daughters of the Earth*, 23.

12. Thomas S. Kidd, *American Colonial History: Clashing Cultures and Faiths* (New Haven: Yale University Press, 2016), 14.

CHAPTER 5

1. Giles Milton, *Big Chief Elizbeth: How England's Adventurers Gambled and Won the New World* (London: Hodder and Stoughton, 2000), 210–11.

2. David Beers Quinn, ed., *The Roanoke Voyages 1584-1590: Documents to Illustrate the English Voyages to North America Under the Patent Granted to Walter Raleigh in 1584, Volume II* (London: The Hakluyt Society, 1955), 531–32.

3. Giles, *Big Chief Elizbeth*, 243.

4. Giles, 264–65.

5. Giles, 379.

6. David Stick, *Roanoke Island: The Beginnings of English America* (Chapel Hill: University of North Carolina Press, 1983), 219.

7. Giles, 382–83.

CHAPTER 6

1. Rebecca K. Jager, *Malinche, Pocahontas, and Sacagawea: Indian Women as Cultural Intermediaries and National Symbols* (Norman: University of Oklahoma Press, 2015), 72.

2. Paula Gunn Allen, *Pocahontas: Medicine Woman, Spy, Entrepreneur, Diplomat* (San Francisco: Harper San Francisco, 2004), 132.

3. Jager, *Malinche, Pocahontas, and Sacagawea*, 106.

4. The Mattaponi were part of the Powhatan alliance and claim descendancy from Matoaka's people. Today, they are a state-recognized tribe in Virginia.

5. Dr. Linwood "Little Bear" Custalow and Angela L. Daniel "Silver Star," *The True Story of Pocahontas: The Other Side of History* (Golden: Fulcrum Publishing, 2007), 61–63.

6. Allen, *Pocahontas*, 283.

7. Custalow and Daniel, *The True Story of Pocahontas*, 83.

8. Betty Louise Bell, "'Little Mischief' and the 'Dirty Men,'" *Studies in American Indian Literatures*, 6, no. 1 (Spring 1994): 65.

9. Jager, *Malinche, Pocahontas, and Sacagawea*, 102–103.

CHAPTER 7

1. Matthew Dennis and Elizabeth Reis, "Women as Witches, Witches as Women: Witchcraft and Patriarchy in Colonial North America," in *Women in Early America*, ed. Thomas A. Foster (New York University Press, 2015), 71.

2. Emerson W. Baker, *A Storm of Witchcraft: The Salem Trials and the American Experience* (New York: Oxford University Press, 2015), 87.

3. Baker, *A Storm of Witchcraft*, 15.

4. Baker, 20.

5. "SWP No. 125: Tituba," Salem Witch Trials Documentary Archive and Transcription Project, accessed February 10, 2019, http://salem.lib.virginia.edu/n125 .html.

6. Spectral evidence is witness testimony that claims an accused person's spirit or spectral shape appeared in a dream of vision. Such evidence was accepted in Salem under the belief that the devil and his minions were powerful enough to send spirits to religious people in order to tempt them.

7. Stacy Schiff, *The Witches: Suspicion, Betrayal, and Hysteria in 1692 Salem* (Back Bay Books, 2016), 133.

8. Schiff, *The Witches*, 8.

9. Schiff, 392.

10. Baker, *A Storm of Witchcraft*, 235.

CHAPTER 8

1. "Pocketbook," Winterthur Museum, Garden & Library, accessed December 26, 2018, http://museumcollection.winterthur.org/single-record.php?resultsperpage=20 &view=catalog&srchtype=advanced&hasImage=&ObjObjectName=&CreOrigin=&E arliest=&Latest=&CreCreatorLocal_tab=&materialsearch=&ObjObjectID=&ObjCate gory=&DesMaterial_tab=&DesTechnique_tab=&AccCreditLineLocal=&CreMarkSig nature=&recid=1955.0003.009#.XCPrwxpMGhA.

2. Catherine A. Brekus, *Sarah Osborn's World: The Rise of Evangelical Christianity in Early America* (New Haven: Yale University Press, 2013), 198.

3. Anne Sebba, *Samplers: Five Centuries of a Gentle Craft* (Thames and Hudson, 1979), 81–82.

4. Sebba, *Samplers*, 55–57.

5. Sebba, 9.

6. "Roundabout chair," The Rhode Island Furniture Archive at the Yale University Art Gallery, accessed December 26, 2018, http://rifa.art.yale.edu/detail .htm?id=108045&type=0.

CHAPTER 9

1. Kathryn Zabelle DeRounian-Stodola, ed., *Women's Indian Captivity Narratives* (New York: Penguin Books, 1998), 138.

2. DeRounian-Stodola, *Women's Indian Captivity Narratives*, 142.

3. The Seneca were one of the Five Nations who lived in what is now New York state and the Ohio region. They were a matrilineal, agriculturally based people who lived in seasonal settlements and cultivated corn.

4. DeRounian-Stodola, 144.

5. Victorian Bissell Brown and Timothy J. Shannon, *Going to the Source: The Bedford Reader in American History, Volume 1: To 1877, Second Edition* (Boston: Bedford/St. Martin's, 2008), 27.

6. DeRounian-Stodola, 149.

7. Brown and Shannon, *Going to the Source*, 28.

8. June Namias, *White Captives: Gender and Ethnicity on the American Frontier* (Chapel Hill: University of North Carolina Press, 1993), 184.

CHAPTER 10

1. James A. Levernier, "Phillis Wheatley (ca. 1753-1784)," *Legacy* 13, no. 1 (1996): 66.

2. "Phillis Wheatley," African American and the End of Slavery in Massachusetts, accessed January 13, 2019, http://www.masshist.org/endofslavery/index.php?id=57.

3. "Old South Meeting House and Phillis Wheatley (1753-1784)," Boston Literary District, accessed January 12, 2019, http://bostonlitdistrict.org/venue/old-south -meeting-house-and-phillis-wheatley-1753-1784/.

4. Corinne T. Field, Tammy Charelle-Ownes, Marcia Chatelaine, Lakisha Simmons, Abosede George, and Rhian Keyse, "The History of Black Girlhood: Recent Innovations and Future Directions," *Journal of the History of Childhood and Youth* (2016): 384; and Shannon Lugers-Manuel, "The Privileged and Impoverished Life of Phillis Wheatley," JSTOR Daily (March 30, 2018), https://daily.jstor.org/the-privileged-and-impoverished-life-of-phillis-wheatley/.

5. R. Lynn Matson, "Phillis Wheatley—Soul Sister?" *Phylon* 33, no. 3 (1972): 227.

6. Kristin Wilcox, "The Body into Print: Marketing Phillis Wheatley," *American Literature* 71, no. 1 (March 1999): 5.

7. "Phillis Wheatley," African Americans and the End of Slavery in Massachusetts.

CHAPTER 11

1. Anna Green Winslow, *Diary of Anna Green Winslow, a Boston School Girl of 1771*, ed. Alice Morse Earl 1894, accessed December 27, 2019, http://www.gutenberg.org/ebooks/20765?msg=welcome_stranger.

2. Penny Colman, *Girls: A History of Growing Up Female in America* (Scholastic Inc., 2000), 52.

3. Anna Green Winslow, *Diary of Anna Green Winslow*.

4. Joan Hoff Wilson, "The Illusion of Change: Women and the American Revolution" in *Our American Sisters: Women in American Thought and Life*, ed. Jean E. Friedman, William G. Shade, and Mary Jane Capozzoli (Lexington, MA: D. C. Heath and Company, 1987), 80–81.

5. "Lucy Knox to Hannah Urquhart," April 1777 (Gilder Lehrman Institute).

CHAPTER 12

1. Susan Casey, *Women Heroes of the American Revolution: 20 Stories of Espionage, Sabotage, Defiance, and Rescue* (Chicago Review Press, 2017), 105–106.

2. "At Half His Age, Sybil Ludington Rose Twice as Far as Paul Revere (But for the Same Reason)," New England Historical Society, accessed February 17, 2019, http://www.newenglandhistoricalsociety.com/half-age-sybil-ludington-rode-twice-far-paul-revere-same-reason/.

3. *The Petition of Deborah Gannett to the House of Representatives*, Tuesday, November 28, 1797, recorded in *Journals of the House of Representatives*, vol. 3, 90.

4. Lavinia Elizabeth Ludington and Charles Henry Ludington, *Colonel Henry Ludington: A Memoir* (1907), 89–90.

5. Paula D. Hunt, "Sybil Ludington, the Female Paul Revere: The Making of a Revolutionary War Heroine," *The New England Quarterly*, LXXXVIII, no. 2 (June 2015), 221–22.

CHAPTER 13

1. Emory and Ruth Strong, *Seeking Western Waters: The Lewis and Clark Trail from the Rockies to the Pacific* (Oregon Historical Society Press, 1995), 66.

2. Rebecca K. Jager, *Malinche, Pocahontas, and Sacagawea: Indian Women as Cultural Intermediaries and National Symbols* (Norman: University of Oklahoma Press, 2015), 247–48.

3. Stephanie Ambrose Tubbs, *Why Sacagawea Deserves the Day Off and Other Lessons from the Lewis & Clark Trail* (University of Nebraska Press, 2008), 94.

CHAPTER 14

1. Eric W. Nye, "Pounds Sterling to Dollars: Historical Conversion of Currency," accessed March 22, 2019, https://www.uwyo.edu/numimage/currency.htm; and David Dobson, *More Scottish Settlers, 1667-1827* (Genealogical Publishing Company, 2005), 67.

2. Deborah Gray White, "The Life Cycle of the Female Slave" in *The Girls History and Culture Reader: 19th Century*, ed. Miriam Forman-Brunell and Leslie Paris (University of Illinois Press, 2010), 16.

3. White, "The Life Cycle of the Female Slave," 20.

4. Wilma King, *Stolen Childhood: Slave Youth in Nineteenth-Century America, Second Edition* (Bloomington: Indiana University Press, 2011), 277.

5. Joshua Rothman, "In a Digital Archive of Fugitive Slave Ads, a New Portrait of Slavery Emerges," *The Conversation*, May 18, 2016, https://www.pri.org/stories/2016-05-18/digital-archive-fugitive-slave-ads-new-portrait-slavery-emerges.

CHAPTER 15

1. Patricia Campbell Warner, *When the Girls Came Out to Play: The Birth of American Sportswear* (Amherst: University of Massachusetts Press, 2006), 160–61. "Battledore" was a game played with a shuttlecock and rackets, much like badminton.

2. Gayle V. Fischer, "'Pantalets' and 'Turkish Trowsers': Designing Freedom in the Mid-Nineteenth-Century United States," *Feminist Studies* 23, no. 1 (Spring 199), 118.

3. Fischer, "'Pantalets' and 'Turkish Trowsers,'" 4.

CHAPTER 16

1. Emmy E. Werner, *Pioneer Children on the Journey West* (Westview Press, 1995), 3.

2. Quotes from Virginia in this chapter are from Virginia Reed Murphy, *Across the Plains in the Donner Party: A Personal Narrative of the Overland Trip to California, 1846-47* (VistaBooks, 1995), 16, 21–24, 40–41.

3. Werner, *Pioneer Children on the Journey West*, 46–47.

4. Werner, 52.

CHAPTER 17

1. Lenore Skomal, *The Lighthouse Keeper's Daughter* (Old Saybrook, CT: Globe Pequot Press, 2010), 27–28.

2. Mary Louise Clifford, "Keeper of the Light," *American History* 31 (September 1996): 24.

3. Skomal, *The Lighthouse Keeper's Daughter*, 32–33.

CHAPTER 18

1. Belle Boyd, *Belle Boyd in Camp and Prison* (New York: Blelock & Company, 1865), 73.

2. Boyd, *Belle Boyd in Camp and Prison*, 78.

3. Boyd, 64.

4. Kat Eschner, "Belle Boyd, Civil War Spy," *Smithsonian Magazine*, May 9, 2017, accessed December 10, 2018, https://www.smithsonianmag.com/smithsonianmag/belle-boyd-civil-war-spy-180963131/.

5. Eliza McGraw, "A Rebel to the Core (Americans)," *American History* (June 2003): 15.

6. Ibid.

CHAPTER 19

1. Susie King Taylor, *Reminiscences of My Life in Camp* (Boston: Published by the Author, 1902), 2.

2. Tracey Jean Boisseau, "Travelling with Susie King Taylor," *Third Space: A Journal of Feminist Theory and Culture* 7, no. 2 (Winter 2008): 7.

3. Whittington B. Johnson, "Free African-American Women in Savannah, 1800-1860: Affluence and Autonomy Amid Adversity," *The Georgia Historical Quarterly* 76, no. 2 (Summer 1992): 277.

4. Taylor, *Reminiscences of My Life in Camp*, 9.

5. Stephanie McCurry, "'In the Company' with Susie King Taylor," *America's Civil War*, HistoryNet (May 2014): 26.

6. Taylor, *Reminiscences of My Life in Camp*, 25.

7. McCurry, "In the Company," 26.

8. Taylor, *Reminiscences of My Life in Camp*, 67.

CHAPTER 20

1. Joan Lemp, "Vinnie Ream and Abraham Lincoln," *Woman's Art Journal* 6, no. 2 (Autumn 1985–Winter 1986): 24.

2. Carmine A. Prioli, "'Wonder Girl from the West': Vinnie Ream and the Congressional Statue of Abraham Lincoln," *Journal of American Culture* (Winter 1989): 2.

3. Prioli, *Wonder Girl from the West*, 4.

4. Prioli, 6–10.

5. Melissa Dabakis, "Sculpting Lincoln: Vinnie Ream, Sarah Fisher Ames, and the Equal Rights Movement," *American Art*, 22, no. 1 (2008): 85.

6. Lemp, "Vinnie Ream and Abraham Lincoln," 27.

7. Prioli, *Wonder Girl from the West*, 17.

CHAPTER 21

1. Esther Schor, *Emma Lazarus* (New York: Schocken, 2006), 10.

2. Diane Lichtenstein, "Words and Worlds: Emma Lazarus's Conflicting Citizenships," *Tulsa Studies in Women's Literature*, 6, no. 2 (Autumn, 1987), 248.

3. Schor, *Emma Lazarus*, 20.

4. Schor, 21.

5. Schor, 36.

6. As of 2019, the bronze plaque with the poem was moved to the new Statue of Liberty Museum.

CHAPTER 22

1. Robert E. Tomasson, "Alice Austen's View of the Harbor," *New York Times*, July 4, 1986.

2. Tee A. Corinne, "Alice Austen," *Encyclopedia of Lesbian, Gay, Bisexual and Transgender History in America*, ed. Marc Stein (New York: Charles Scribner's Sons, 2004).

3. "About Alice Austen: Her Life," Alice Austen House, accessed January 25, 2019, www.aliceausten.org/her-life/.

4. Laura Piemer, "Alice's Identity Crisis: A Critical Look at the Alice Austen House Museum," *History of Photography* 24, no. 2 (Summer 2000), 175.

CHAPTER 23

1. The disease was likely either scarlet fever or meningitis.

2. Helen Keller, *The Story of My Life*, Project Gutenberg, November 2000, 31.

3. Keller, *The Story of My Life*, 23.

4. Keller, 32.

5. Joseph Chamberlain, "Helen Keller as She Really Is," *American Annals of the Deaf* 44, no. 4 (June, 1899), 299.

6. Chamberlain, "Helen Keller as She Really Is," 287.

CHAPTER 24

1. History and Culture, Ellis Island, National Park Service, accessed February 25, 2019, https://www.nps.gov/elis/learn/historyculture/index.htm.

2. Jesse Green, "Immigrant Number One," *New York Magazine*, May 9, 2010, accessed February 24, 2019, http://nymag.com/news/features/65902/#print.

3. Niamh O'Sullivan, "Scary Tales of New York: Life in the Irish Slums," *The Irish Times*, March 23, 2013, accessed February 23, 2019, https://www.irishtimes.com/culture/scary-tales-of-new-york-life-in-the-irish-slums-1.1335816.

4. "Landed on Ellis Island: New Immigration Buildings Opened Yesterday," *New York Times*, January 2, 1892.

5. Green, "Immigrant Number One."

6. Annie Moore: First Immigrant Through Ellis Island, The Statue of Liberty–Ellis Island Foundation, accessed February 24, 2019, www.libertyellisfoundation.org.

7. Sam Roberts, "A New Verse in the Ballad of Ellis Island's First Immigrant," *New York Times*, March 30, 2016.

CHAPTER 25

1. Arthur B. Caldwell, *History of the American Negro and His Institutions* (Atlanta: Caldwell Publishing Co., 1917), 21.

2. Karen Morris, "The Founding of the National Medical Association," 2007, Yale Medicine Thesis Digital Library, 360, xx, http://elischolar.library.yale.edu/ymtdl/360.

3. Caldwell, *History of the American Negro and His Institutions*, 378.

4. Dr. Georgia Rooks Dwelle Biography, The Changes Face of Medicine, U.S. National Library of Medicine, accessed February 16, 2019, https://cfmedicine.nlm.nih.gov/physicians/biography_91.html.

5. John Dittmer, *Black Georgia in the Progressive Era, 1900-1920* (Urbana: University of Illinois Press, 1977), 13.

6. "Georgia R. Dwelle," Gale Biography in Context, accessed February 19, 2019, http://link.galegroup.com/apps/doc/K1650002423/BIC?u=lincclin_bcc&sid =BIC&xid=1995e834. (Website requires a login.)

CHAPTER 26

1. Mindi Reid, "Flower of the Nation: Hawai'i's Princess Ka'iulani," *Native Peoples* (May/June 2005): 62.

2. Jennifer Fahrni, "Princess Ka'iulani: Her Life and Times," *The Ka'iulani Project*, 2006, 3, accessed March 25, 2019, http://princesskaiulaniproject.com/about_princess _kaiulani.htm.

3. Janet Hulstrand, "Ka'iulani: Hawaii's Island Rose," *Smithsonian Magazine*, May 7, 2009, 1.

4. Fahrni, "Princess Ka'iulani: Her Life and Times," 3.

5. Marilyn Stassen-McLaughlin, "Unlucky Star: Princess Ka'iulani," *The Hawaiian Journal of History* 33 (1999), 38.

6. Reid, "Flower of the Nation," 62.

7. Hulstrand, "Ka'iulani: Hawai'i's Island Rose," 2.

CHAPTER 27

1. United States Government, *Office of Indian Affairs/Annual Report of the Commissioner of Indian Affairs, for the Year 1891*, Part 1 (Washington, DC: Government Printing Office), 17.

2. Ojibwa, "The Fort Shaw Boarding School," *Native American Netroots*, accessed March 18, 2019, http://nativeamericannetroots.net/diary/1241.

3. Ojibwa, "The Fort Shaw Boarding School."

4. Linda Peavy and Ursula Smith, "'Leav[ing] the White[s] Far Behind Them' the Girls from the Fort Shaw (Montana) Indian School, Basketball Champions of the 1904 World's Fair," *The 1904 Anthropology Days and Olympic Games: Sport, Race, and American Imperialism*, (Lincoln: University of Nebraska), 2008, 254.

5. Peavy and Smith, "Leav[ing] the White[s] Far Behind Them," 254.

6. Peavy and Smith, 251.

CHAPTER 28

1. Porsche Louise Sims, "Child Labor in North Carolina Textile Mills," accessed March 6, 2019, https://sites.google.com/site/childlabornctextilemills/Home.

2. Walter B. Palmer, "Woman and Child Workers in Cotton Mills," *Publications of the American Statistical Association* 12, no. 94 (June 1911), 588–89.

3. Lewis Hine, International Photography Hall of Fame, accessed March 8, 2019, http://iphf.org/inductees/lewis-hine/.

4. Palmer, "Woman and Child Workers in Cotton Mills," 599.

5. Joe Manning, "Sadie Phifer, Lancaster, South Carolina," *Mornings on Maple Street* December 29, 2014, accessed March 5, 2019, https://morningsonmaplestreet .com/2014/12/29/sadie-phifer/.

CHAPTER 29

1. Angel Island Immigration Station Foundation, "Angel Island Immigrant Journeys," 2004, accessed March 15, 2019, https://www.aiisf.org/curriculum.

2. Judy Yung, "Chinese Prostitution-Frontier Women," interview by Dmae Roberts, *Crossing East*, March 26, 2017, http://www.crossingeast.org/ crossingeastarchive/2017/03/26/judy-yung-on-chinese-prostitution/.

3. Rachel Leow, "Do You Own Non-Chinese Mui-Tsai? Re-Examining Race and Female Servitude in Malaya and Hong Kong, 1919-1939," *Modern Asian Studies* 46, no. 6 (2012), 1740.

4. Judy Yung, "Becoming American: The Chinese Experience," *Program Two: Between Two Worlds*, interview by Bill Moyers, Public Affairs Television, Inc., March 2003.

5. Miriam Forman-Brunell, ed., "Asian American Girls," *Girlhood in America: An Encyclopedia Volume 1 A-I* (Santa Barbara, CA: ABC-CLIO 2001), 49.

6. Yung, "Chinese Prostitution-Frontier Women," March 26, 2017.

7. Angel Island Immigration Station Foundation, "Angel Island Immigrant Journeys," 2004.

CHAPTER 30

1. Rebekah E. Revzin, "American Girlhood in the Early Twentieth Century: The Ideology of Girl Scout Literature, 1913-1930," *The Library Quarterly: Information, Community, Policy* 68, no. 3 (July 1998): 268.

2. United States Food Administration, "War Economy in Food with Suggestions and Recipes for Substitutions in the Planning of Meals" (Washington, DC: Government Printing Office, 1918), 5.

3. United States Food Administration, 4.

4. Leslie Hahner, "Practical Patriotism: Camp Fire Girls, Girl Scouts, and Americanization," *Communication and Critical/Cultural Studies* 5, no. 2 (June 2008): 115.

CHAPTER 31

1. David Stenn, *Clara Bow: Runnin' Wild* (New York: Cooper Square Press), 9.

2. Stenn, *Clara Bow*, 18.

3. Marsha Orgeron, "Making It in Hollywood: Clara Bow, Fandom, and Consumer Culture," *Cinema Journal* 42, no. 4 (2003): 78.

4. Orgeron, "Making It in Hollywood," 81–82.

5. Stenn, *Clara Bow*, 77–81.

6. Catherine Keen, "Paper Dolls and Ready-to-Wear Brought Flapper Fashion to the Masses," *Smithsonian National Museum of American History Kenneth E. Behring Center*, November 10, 2014, accessed March 28, 2019, https://americanhistory.si.edu/ja/blog/paper-dolls-and-ready-wear-brought-flapper-fashion-masses.

7. Clara Bow, "My Life Story as Told to Adela Rogers St. Johns," *Photoplay*, April 1928, 127.

CHAPTER 32

1. Gabrielle Moss, "The Average Age We Used to Get Our First Period," *Bustle*, October 2, 2015, accessed April 2, 2019, https://www.bustle.com/articles/114490-the-average-age-women-got-their-first-period-throughout-history.

2. Vern L. Bullough, "Merchandising the Sanitary Napkin: Lillian Gilbreth's 1927 Survey," *Signs* 10, no. 3 (Spring, 1985): 615.

3. Kat Eschner, "The Surprising Origins of Kotex Pads," *Smithsonian Magazine*, August 11, 2017.

4. Natalie Shure, "Why Has It Taken the Menstrual Cup So Long to Go Mainstream?" *Pacific Standard*, June 14, 2017, accessed April 4, 2019, https://psmag .com/news/why-has-it-taken-the-menstrual-cup-so-long-to-go-mainstream.

5. Cashay Sanitary Puffs, *Smithsonian National Museum of American History*, accessed April 3, 2019, https://americanhistory.si.edu/collections/search/object/ nmah_729450.

6. Cashay ad, April 25, 1939, ProQuest Historical Newspapers, *Washington Post*, 13.

7. Ashley Fetters, "The Tampon: A History," *The Atlantic*, June 1, 2015, accessed April 5, 2019, https://www.theatlantic.com/health/archive/2015/06/history-of-the-tampon/394334/.

CHAPTER 33

1. John F. Kasson, *The Little Girl Who Fought the Great Depression* (New York: Norton 2014), 75.

2. Kasson, *The Little Girl Who Fought the Great Depression*, 49.

3. Kristen Hatch, *Shirley Temple and the Performance of Girlhood* (Rutgers: Rutgers University Press, 2015), 46.

4. Shirley Temple Black, *Child Star* (New York: Warner Books, 1988), 298.

5. Kasson, *The Little Girl Who Fought the Great Depression*, 59.

6. Kasson, 233.

7. Kasson, 204.

8. Black, *Child Star*, 453–54.

CHAPTER 34

1. Michael Hine, "'They Do Not Know How to Play': Reformers' Expectations and Children's Realities on the First Progressive Playgrounds of Chicago," *Journal of the History of Childhood and Youth* 10, no. 2 (Spring 201): 209–10.

2. "Rope Skipping History," International Skipping Rope Federation, accessed May 25, 2019, http://www.fisac-irsf.org/rope-skipping-history.html. (Website no longer exists.)

3. Ming Fang He, *Personal, Passionate, Participatory Inquiry into Social Justice Education* (Detroit: Wayne State University Press, 2008), 142.

4. Ivory Ibuaka, "Jumping Rope, Pushing Back," *The Silences and Sounds of Black Girlhood*, January 7, 2017, 2–3, accessed May 20, 2019, https://pages.shanti.virginia .edu/The_Silences_and_Sounds_of_Black_Girlhood/2017/01/07/jumping-rope-pushing-back/.

5. Richard Wright, *12 Million Black Voices: A Folk History of the Negro in the United States* (New York: Viking, 1941).

CHAPTER 35

1. Albert Marrin, *Uprooted: The Japanese American Experience During World War II* (New York: Alfred A. Knopf, 2016), 6.

2. Alice Yang Murray, *What Did the Internment of Japanese Americans Mean?* (Boston: Bedford/St. Martin's, 2000), 5.

3. Murray, *What Did*, 3.

4. Michael O. Tunnell and George W. Chilcoat, *The Children of Topaz: The Story of a Japanese-American Internment Camp, Based on a Classroom Diary* (New York: Holiday House, 1996), 9.

5. Tunnell and Chilcoat, *The Children of Topaz*, 37.

6. *Ex parte Endo*, 323 US 283, 70 (Supreme Court of the United States, December 18, 1944).

7. Murray, *What Did*, 18.

8. Murray, vi.

9. Rina Nakano, "San Diego Librarian's Letters Give Hope During World War II Japanese Internment," ABC 10 News San Diego, May 24, 2019, https://www.10news .com/news/local-news/san-diego-librarians-letters-give-hope-during-world-war-ii -japanese-internment.

CHAPTER 36

1. Kelley Massoni, *Fashioning Teenagers: A Cultural History of Seventeen Magazine* (Walnut Creek, CA: Left Coast Press Inc., 2010), 40.

2. Massoni, *Fashioning Teenagers*, 49.

3. Massoni, 65.

4. Rachel Devlin, *Relative Intimacy: Fathers, Adolescent Daughters, and Postwar American Culture* (University of North Carolina Press, 2005), 97–98.

5. Penny Coleman, *Girls: A History of Growing Up Female in America* (Scholastic, Inc., 2000), 159.

6. "Postwar Gender Roles and Women in American Politics," History, Art & Archives of the United States House of Representatives, accessed July 29, 2019, https://history.house.gov/Exhibitions-and-Publications/WIC/Historical-Essays/ Changing-Guard/Identity/.

7. Jennifer A. Schlenker, Sandra L. Caron, and William A. Halteman, "A Feminist Analysis of Seventeen Magazine: Content Analysis from 1945 to 1995," *Sex Roles* 38, no. 1–2 (1998): 135–49.

8. Meenakshi Gigi Durham, "Sex and Spectacle in Seventeen Magazine: A Feminist Myth Analysis," presentation, International Communication Association, San Francisco, CA, 2007, 23.

9. "Julia Bluhm, 14, Leads Successful Petition for Seventeen Magazine to Portray Girls Truthfully," HuffPost.com, July 5, 2012, https://www.huffpost.com/entry/julia -bluhm-seventeen-mag_n_1650938.

CHAPTER 37

1. Nancy Goldstein, *Jackie Ormes: The First African American Woman Cartoonist* (University of Michigan, 2008), 24.

2. Goldstein, *Jackie Ormes*, 79.

3. Goldstein, 40–41.

4. Gwen Berger, "Black Children, White Preference: Brown v. Board, the Doll Tests, and the Politics of Self-Esteem," *American Quarterly* 61, no. 2 (June 2009): 299.

5. Goldstein, 42.

CHAPTER 38

1. Rachel Devlin, *A Girl Stands at the Door: The Generation of Young Women Who Desegregated America's Schools* (New York: Basic Books, 2018), xviii.

2. Philippa Strum, *Mendez v. Westminster: School Desegregation and Mexican -American Rights* (University Press of Kansas, 2010), 21.

3. Strum, *Mendez v. Westminster*, 47.

4. Strum, 123.

5. Strum, 2.

6. Devlin, *A Girl Stands at the Door*, x.

CHAPTER 39

1. Penny Coleman, *Girls: A History of Growing Up Female in America* (Scholastic, Inc., 2000), 163.

2. Coleman, *Girls*, 163–64.

3. Robert D. Marcus and David Burner, *America Firsthand: Readings from Reconstruction to the Present, Volume Two* (Boston: Bedford Books, 1997), 260.

CHAPTER 40

1. Mary F. Rogers, *Barbie Culture* (London: SAGE Publications, 1999), 2–6.

2. Tiffany Rhoades, "Barbie: The Bitch Who Has Everything," presentation, Brian F. Bertoti Graduate Conference, Virginia Tech, April 2013, 10.

3. Rogers, *Barbie Culture*, 47.

4. Rogers, 84–85.

5. Cynthia G. La Ferle, "Barbie: Her Figure Isn't Everything," *The Christian Science Monitor*, December 12, 1997.

6. Catherine Driscoll, "Barbie Culture," in *Girl Culture*, ed. Claudia Mitchell and Jacqueline Reid-Walsh (Greenwood Publishing Group, 2007), 45.

CHAPTER 41

1. Sean MacLeod, *Leaders of the Pack: Girl Groups of the 1960s and Their Influence on Popular Culture in Britain and America* (Lanham, MD: Rowman & Littlefield Publishers, 2015), 16.

2. Mary E. Rohlfing, "'Don't Say Nothing Bad about My Baby': A Re-Evaluation of Women's Roles in the Brill Building Era of Early Rock 'n' Roll," *Critical Studies in Mass Communication* 13, no. 2 (June 1996): 99.

3. MacLeod, *Leaders of the Pack*, 13.

4. Luther Dixon and Shirley Owens, *Tonight's the Night*, Scepter, 1960.

5. Gerry Goffin and Carole King, *Will You Still Love Me Tomorrow*, Scepter, 1960.

6. Will Stos, "Bouffants, Beehives and Breaking Gender Norms," *Journal of Popular Music Studies* 24, no. 2 (2012): 127.

7. Goffin and King, *Will You Still Love Me Tomorrow*, 1960.

8. Jacqueline Warwick, *Girl Groups, Girl Culture: Popular Music and Identity in the 1960s* (New York: Routledge, 2007), 111.

9. Helen Brown, "The Life of a Song: Will You Still Love Me Tomorrow," *Financial Times*, June 25, 2016, accessed January 15, 2019, https://www.ft.com/content/35974eaa-3234-11e6-bda0-04585c31b153.

CHAPTER 42

1. Wayne Dennis, *The Hopi Child* (New York: John Wiley & Sons, Inc., 1967), 69.

2. Edwin Earle, *Hopi Kachinas* (New York: Museum of the American Indian, Heye Foundation, 1971), 4.

3. Harold S. Colton, *Hopi Kachina Dolls with a Key to their Identification* (Albuquerque: University of New Mexico Press, 1973), 5.

CHAPTER 43

1. Ashley Strickland, "A Brief History of Young Adult Literature," April 15, 2015, accessed August 12, 2019, https://edition.cnn.com/2013/10/15/living/young-adult-fiction-evolution/index.html.

2. Susan Dominus, "Judy Blume Knows All Your Secrets," *New York Times Magazine*, May 18, 2015, accessed August 7, 2019, https://www.nytimes.com/2015/05/24/magazine/judy-blume-knows-all-your-secrets.html.

3. Judy Blume on the Web, *Are You There God? It's Me, Margaret*, accessed August 1, 2019, http://www.judyblume.com/books/middle/margaret.php.

4. Book on Trial, *Are You There God? It's Me, Margaret*, accessed August 14, 2019, https://www.booksontrial.com/are-you-there-god-its-me-margaret-the-passages -that-got-this-book-banned.

5. Judy Blume, *Are You There God? It's Me, Margaret* (London: Macmillan Children's Books, in association with Gollancz, 2015), 35.

6. Naomi Schaefer Riley, "Interfaith Unions: A Mixed Blessing," *New York Times*, April 5, 2013, accessed August 20, 2019, https://www.nytimes.com/2013/04/06/ opinion/interfaith-marriages-a-mixed-blessing.html.

7. Gwen Ihnat, "*Are You There God? It's Me, Margaret* Remains a Guide for Puberty," AV Club, June 6, 2017, accessed August 12, 2019, https://www.avclub.com/are-you -there-god-it-s-me-margaret-remains-a-guide-fo-1798262614.

8. Judy Blume on the Web, "Censorship," accessed August 16, 2019, http://www.judy blume.com/censorship.php.

CHAPTER 44

1. Kelly Shackelford, "Mary Beth and John Tinker and Tinker v. Des Moines: Opening the Schoolhouse Gates to First Amendment Freedom," *Journal of Supreme Court History*, 10594329, 39, no. 3 (November 2014).

2. Mary Beth Tinker and John Tinker, "A Supreme Court Milestone for Students' Free Speech Rights," ACLU, February 20, 2019, accessed September 25, 2019, https://www.aclu.org/blog/free-speech/student-speech-and-privacy/supreme-court -milestone-students-free-speech-rights.

3. Shackelford, "Mary Beth and John Tinker."

4. Shackelford, "Mary Beth and John Tinker."

5. Shackelford, "Mary Beth and John Tinker."

6. "Tinker v. Des Moines - Landmark Supreme Court Ruling on Behalf of Student Expression, ACLU, accessed September 1, 2019, https://www.law.cornell.edu/ supremecourt/text/393/503.

7. "Tinker v. Des Moines," ACLU.

8. "Tinker v. Des Moines Independent Community School District," 393 US 503, argued November 12, 1968, Cornell Law School, accessed September 20, 2019, https://www.law.cornell.edu/supremecourt/text/393/503393US503.

9. Tinker and Tinker, "A Supreme Court Milestone."

CHAPTER 45

1. Maki Nishiyama, "Peggy Oki," Bad Things Apparel, May 6, 2016, accessed September 2, 2019, https://www.badthingsapparel.com/blogs/q-a/76818819-peggy -oki. (Website no longer exists.)

2. Peggy Oki, "About Me—Dogtown and Z-Boys," accessed September 1, 2019, https://www.peggyoki.com/about-me/peggy-oki-dogtown-and-z-boys.

3. Caroline Ryder, "Life After Dogtown," *Huck Magazine*, April 22, 2015, accessed September 2, 2019, https://www.huckmag.com/perspectives/activism-2/dogtown -legend-peggy-oki-fighting-protect-oceans/.

4. G. Beato, "When Skateboarding Shook the World," *The Guardian*, August 24, 2001, accessed September 2, 2019, https://www.theguardian.com/film/2001/aug/24/ artsfeatures3.

5. Peggy Oki, "About Me."

6. The Skateboarding Hall of Fame, "Peggy Oki," 2012, accessed September 2, 2019, http://www.skateboardinghalloffame.org/projects/2012-peggy-oki-2/.

7. Peggy Oki, "About Me."

CHAPTER 46

1. Bilaye R. Benibo, Pamela S. Meyer, and Javier Villarreal, "Anglo- and Mexican American Attitudes Towards Selena's Memorialization," *Hispanic Journal of Behavioral Science* 21, no. 1 (February 1999): 80.

2. Jennifer L. Willis and Alberto Gonzalez, "Reconceptualizing Gender Through Intercultural Dialogue: The Case of the Tex-Mex Madonna," *Women and Language* 20, no. 1 (Spring 1997): 9–12.

3. Ramona Liera-Schwichtenberg, "Passing or Whiteness on the Edge of Town," *Review and Criticism*, September 2000, 371.

CHAPTER 47

1. Kim Washburn, "Heart of a Champion: The Dominique Dawes Story," Zonderkidz, 2012, 21–22.

2. Morgan Jenkins, "The Unconventional Legacy of Dominique Dawes," ESPN, July 21, 2016, accessed August 15, 2019, https://www.espn.com/espnw/culture/story/_/id/17118998/the-unconventional-legacy-gymnast-dominique-dawes.

3. Dvora Meyers, "The Complete Evolution of the Gymnastics Leotard From the 1930s to Today," June 27, 2016, *Elle*, accessed August 16, 2019, https://www.elle.com/fashion/a37371/evolution-of-gymnastics-leotard/.

4. Angelica Jade Bastién, "U.S. Women's Gymnastics Team's Greatness Is Revolutionary," *Rolling Stone*, August 5, 2016, accessed August 15, 2019, https://www.rollingstone.com/culture/culture-sports/why-the-womens-gymnastics-teams-greatness-is-revolutionary-249786/.

CHAPTER 48

1. Karen Green and Tristan Taormino, ed., *A Girl's Guide to Taking Over the World: Writings from the Girl Zine Revolution* (New York: St. Martin's Griffin, 1997), xi.

2. Paula Mejia, "Rookie Brought the Inclusive Spirit of Zines to the Internet Era," *The New Yorker*, December 3, 2018.

3. Mejia, "Rookie."

4. Erin Della Mattia, "Zine Culture and the Embodied Community of Rookie Mag," Issuu.com, May 9, 2016, https://issuu.com/erindellamattia/docs/zine_culture_and_the_embodied_commu, 11.

5. Rachael, "Never Been Kissed," in *Rookie Yearbook One*, ed. Tavi Gevinson, 50–53.

6. Mejia, "Rookie."

7. Jaclyn Peiser, "Rookie Magazine: Grown Up, Now Moving On," *New York Times, Late Edition*, December 6, 2018.

CHAPTER 49

1. Kasey Clawson Hudak, "Deceiving or Disrupting the Pink Aisle? Goldieblox, Corporate Narratives, and the Gendered Toy Debate," *Communication and Critical/Cultural Studies* 14, no. 2 (2017): 159.

2. Hudak, "Deceiving or Disrupting," 159.

3. Hudak, 168.

4. AAUW, "Why So Few? Women in Science, Technology, Engineering, and Mathematics," Executive Summary, https://www.aauw.org/resources/research/the-stem-gap/.

5. Hudak, 169.

CHAPTER 50

1. Sam T. Levin, "Dakota Access Pipeline: The Who, What and Why of the Standing Rock Protests," *Guardian*, November 3, 2016, accessed September 10, 2019, https://www.theguardian.com/us-news/2016/nov/03/north-dakota-access-oil-pipeline-protests-explainer.

2. Anna Clark, Clean Affordable Drinking Water Is a Racial Issue," *Washington Post*, September 24, 2019, accessed Sept 30, 2019, https://www.washingtonpost.com/opinions/2019/09/23/clean-affordable-drinking-water-is-racial-issue/.

3. Levin, "Dakota Access Pipeline."

4. Mari Copeny, accessed September 16, 2019, https://www.maricopeny.com/.

5. Erin Longbottom, Why the Dakota Access Pipeline Is a Feminist Priority," National Women's Law Center, September 15, 2016, accessed September 12, 2019, https://nwlc.org/blog/why-the-dakota-access-pipeline-is-a-feminist-priority/.

6. CNN Library, Flint Water Crisis Fast Facts, CNN, August 8, 2019, accessed August 30, 2019, https://edition.cnn.com/2016/03/04/us/flint-water-crisis-fast-facts/index.html.

7. Mari Copeny, https://www.maricopeny.com/.

Selected Bibliography

Albert Marrin, *Uprooted: The Japanese American Experience During World War II* (New York: Alfred A. Knopf, 2016).

Arthur B. Caldwell, *History of the American Negro and His Institutions* (Atlanta: Caldwell Publishing Co., 1917).

Belle Boyd, *Belle Boyd in Camp and Prison* (New York: Blelock & Company, 1865).

Carlos Andrade, *Ha'ena: Through the Eyes of the Ancestors* (Honolulu: University of Hawai'i Press, 2008).

Carmine A. Prioli, "'Wonder Girl from the West': Vinnie Ream and the Congressional Statue of Abraham Lincoln," *Journal of American Culture* (Winter 1989).

Corinne T. Field, Tammy Charelle-Ownes, Marcia Chatelaine, Lakisha Simmons, Abosede George, and Rhian Keyse, "The History of Black Girlhood: Recent Innovations and Future Directions," *Journal of the History of Childhood and Youth* (2016).

David Stenn, *Clara Bow: Runnin' Wild* (New York: Cooper Square Press, 2000).

Deborah Gray White, "The Life Cycle of the Female Slave," in *The Girls History and Culture Reader: 19th century*, ed. Miriam Forman-Brunell and Leslie Paris (University of Illinois Press, 2010).

Encyclopedia of Gay, Lesbian, Transgendered History in America (New York: Charles Scribner's Sons, 2004).

Esther Schor, *Emma Lazarus* (New York: Schocken, 2006).

Helen Keller, *The Story of My Life* (Project Gutenberg, November 2000).

Ivory Ibuaka, "Jumping Rope, Pushing Back," *The Silences and Sounds of Black Girlhood*, January 7, 2017.

Jacqueline Warwick, *Girl Groups, Girl Culture: Popular Music and Identity in the 1960s* (New York: Routledge, 2007).

Jake Page, *In the Hands of the Great Spirit: The 20,000-Year History of American Indians* (New York: Free Press, 2004).

Janet Hulstrand, "Ka'iulani: Hawaii's Island Rose," *Smithsonian Magazine*, May 7, 2009.

Joan Lemp, "Vinnie Ream and Abraham Lincoln," *Woman's Art Journal* 6, no. 2 (Autumn 1985–Winter 1986).

John F. Kasson, *The Little Girl Who Fought the Great Depression* (New York: Norton, 2014).

Judy Blume, *Are You There God? It's Me, Margaret* (London: Macmillan Children's Books, in association with Gollancz, 2015).

Judy Yung, "Chinese Prostitution-Frontier Women," interview by Dmae Roberts, *Crossing East*, March 26, 2017.

Karen Green and Tristan Taormino, eds. *A Girl's Guide to Taking Over the World: Writings from the Girl Zine Revolution* (New York: St. Martin's Griffin, 1997).

Kelley Massoni, *Fashioning Teenagers: A Cultural History of Seventeen Magazine* (Walnut Creek, CA: Left Coast Press Inc., 2010).

Kim Washburn, *Heart of a Champion: The Dominique Dawes Story*, Zonderkidz, 2012.

"Landed on Ellis Island: New Immigration Buildings Opened Yesterday," *New York Times*, January 2, 1892. Gave Annie Ten Dollars, The Statue of Liberty-Ellis Island Foundation, https://www.libertyellisfoundation.org/annie-moore-nytimes (Accessed February 22, 2019).

Laura Piemer, "Alice's Identity Crisis: A Critical Look at the Alice Austen House Museum," *History of Photography* 24, no. 2 (Summer 2000).

Lenore Skomal, *The Lighthouse Keeper's Daughter* (Old Saybrook, CT: Globe Pequot Press, 2010).

Leslie Hahner, "Practical Patriotism: Camp Fire Girls, Girl Scouts, and Americanization," *Communication and Critical/Cultural Studies* 5, no. 2 (June 2008).

Linda Peavy and Ursula Smith, "'Leav[ing] the White[s] Far Behind Them' The Girls from the Fort Shaw (Montana) Indian School, Basketball Champions of the 1904 World's Fair," *The 1904 Anthropology Days and Olympic Games: Sport, Race, and American Imperialism* (Lincoln: University of Nebraska, 2008).

Mary F. Rogers, *Barbie Culture* (London: SAGE Publications, 1999).

Miriam Forman-Brunell, ed. *Girlhood in America: An Encyclopedia Volume 1 A-I* (Santa Barbara, CA: ABC-CLIO, 2001).

Patricia Campbell Warner, *When the Girls Came Out to Play: The Birth of American Sportswear* (Amherst: University of Massachusetts Press, 2006).

Paula Gunn Allen, *Pocahontas: Medicine Woman, Spy, Entrepreneur, Diplomat* (San Francisco: HarperSanFrancisco, 2004).

Peggy Oki, "About Me—Dogtown and Z-Boys," https://www.peggyoki.com/about-me/peggy-oki-dogtown-and-z-boys (Accessed September 1, 2019).

Penny Coleman, *Girls: A History of Growing Up Female in America* (Scholastic, Inc., 2000).

Rachel Devlin, *A Girl Stands at the Door: The Generation of Young Women Who Desegregated America's Schools* (New York: Basic Books, 2018).

Rebecca K. Jager, *Malinche, Pocahontas, and Sacagawea: Indian Women as Cultural Intermediaries and National Symbols* (Norman: University of Oklahoma Press, 2015).

Richard Wright, *12 Million Black Voices: A Folk History of the Negro in the United States* (New York: Viking, 1941).

Sean MacLeod, *Leaders of the Pack: Girl Groups of the 1960s and Their Influence on Popular Culture in Britain and America* (Lanham, MD: Rowman & Littlefield Publishers, 2015).

Stacy Schiff, *The Witches, Salem, 1692* (New York: Little, Brown and Company, 2015).

Susan Casey, *Women Heroes of the American Revolution: 20 Stories of Espionage, Sabotage, Defiance, and Rescue* (Chicago Review Press, 2017).

Susie King Taylor, *Reminiscences of My Life in Camp* (Boston: Published by the Author, 1902).

Timothy R. Pauketat, *Cahokia: Ancient America's Great City on the Mississippi* (New York: Penguin Group, 2009).

Vern L. Bullough, "Merchandising the Sanitary Napkin: Lillian Gilbreth's 1927 Survey," *Signs*, 10, no. 3 (Spring, 1985).

Virginia Reed Murphy, *Across the Plains in the Donner Party: A Personal Narrative of the Overland Trip to California, 1846-47* (VistaBooks, 1995).

Walter B. Palmer, "Woman and Child Workers in Cotton Mills," *Publications of the American Statistical Association* 12, no. 94 (June 1911).

Index

Page references for figures are italicized.

abolitionism, 26, 44; abolitionist, 45
abuse, 129–30, 138–39, 148
Academy Award, 148
ACLU. *See* American Civil Liberties
 Union
activism, 94, 165, 173, 196, 200, 202,
 221–22. *See also* advocate
actress, 138–39
Adams, Jay, 198
Admetus and Other Poems, 93–94
adolescence, 143, 160
adoption, 28, 30, 41, 67, 128
advertisement, 37, 47, *61*–64, 144,
 160–61, 216
advocate, 73, 94, 148, 165, 194, 201–2.
 See also activism
Africa, 63
African, 25, *61*–62, 111–12, 132, 164,
 168, 177, 220
agency, 2, 47–48, 50, 59, 64
Alabama, 95, *101*–2, 171–72
Alaska, *5*–6
Allied Powers, 134

ambassador, 16, 117, 148. *See also*
 diplomat
amendment: Equal Rights, 179; First, 195;
 Fourteenth, 169
American Civil Liberties Union, 169,
 195–96
American Dream, 95–96, 124, 154, 226
American Friends Service Committee, 194
American Jewish Congress, 169
American Library Association, 192
American Medical Association, 111, 144
American Revolution, 41, 44, 47, 50, 52,
 55–56, 74
Americanization, 113, 135
Anagnos, Michael, 103
ancestry, 153, 156, 169. *See also* genealogy
Angel Island, 114, *127*–30
Annenberg, Walter, 160
annexation, 113, 116–18
anorexia, 177. *See also* eating disorder
antiwar, 194
archaeological, 3, 6–7, 10, 12, 15–16,
 31, 226
Arctic, 6
Argall, Samuel, 29

Arguelles, Martin De, 24
arrest, 33, 45, 80–81, 84, 150, 156,
 172–73, 221
art, 12, 25, 36–37, 73, 88–90, 93, 118,
 156, 164, 186–88, 200, 212–13; artist,
 18, 73, 88–90, 99, 152, 166, 184, 200,
 205–6, 213; collage, 212; craft, 15, 37,
 121, 188. *See also* drawing
artifact, 25, 188, 225–26
Asia, 6–7
Asian, 7, *127*–29, 177, 216, 225
assassination, 89, 117
Athens, 208
athlete, 99–100, 120, 122, 140, 179, 208–9
Atlanta Baptist Female Seminary, 110
Atlantic Ocean, 51, 106, 134
atomic bomb, 198
Austen, Alice, 95, *97*–100
Australia, 208
autobiography, 62–64, 147. *See also*
 memoir

Baby Burlesks, 146
Bahamas, 22
Baker, Susie. *See* Taylor, Susie King
Barbie, 154, *175*–78, 216
basketball, 113, *119*–22, 208
battle, 73, 169–70; Battle of Ridgefield,
 54–55; First Battle of Manassas, 81
Bayfront Auditorium, 205
Beasley, Mary, 84
beauty, 37, 88, 160, 162, 176, 217
Bell, Alexander Graham, 102
Belle Époque, 118
Beloved Woman, 25, 28–30
Beringia, 6
Beringian Standstill Model, 7–8
Berlin, Germany, 208
Bertlemann, Larry, 199
Bible, 37, 44, 125

bicycle, 100, 131
Biles, Simone, 210
bill of sale, *61*–62
biography, 40
birth, 22, 33, 58, 66, 72, 102, 138, 179,
 187, 225; control, 179
Bishop, Bridget, 33
Black, 34, 50, 104, 132, 146, 148, 186,
 193–94, 216, 220, 225; athletes, 208–9;
 doctors, 111; dolls, 164–66, 177;
 enslaved, 47, 81, 162–63; free, 44–45,
 84–86; girl, 26, 44–47, 62, 64, 73, 86,
 151, 153, 160, 164–66, 168, 174, 184,
 201, 204, 208–9; girl culture, 26, 44,
 153; history, 45, 112, 151; as models,
 160; play, 151, 165; troops, 85; woman,
 84–86, 111–12, 152
Black Belt, 150–51
Black Lives Matter, 196
blind, 95, 102, 124
Blount, James H., 117
Bluhm, Julia, 162
Blume, Judy, 179, *189*–90
boardinghouse, 84
Borden, Amanda, 209
Boston Massacre, 51
Bow, Clara, 131, *137*–40
boycott, 50–52, 165, 173
Boyd, Belle, 73, *79*–82
Bradley, Milton, 139
Braille, 103–4
Breed, Clara, *155*–58
Britain, 47, 50
British, 41, 45, 50–52, 54, 184
Broadway, 104, 152, 209–10
Brooks, Gwendolyn, 152
brothel, 129
Browder v. Gale, 173
Brown v. Board of Education, 153, 170
Brownstein, Carrie, 212

burial, 6–8, 10, 14–16, 30. *See also* grave; mortuary practices
Burton, Minnie, 121
bus, 153, 157, 165, 171–74
business, 62, 80, 92, 116, 124, 128–29, 205, 216
Butch, Genie, 121

Cahokia, 3, *13–16*
California, 70–72, *127*–28, 131, 153, *155–56*, *167–70*, 198–200
camera, 98–100, 139
Canada, 24, 82
Capitol Building, 88
captivity, 24–25, 28–29, 40–42, 44, 54, 82, 84, 89, 98, 151, 158, 199
Carlisle Indian Industrial School, 120
cartoon, 164–66. *See also* comic
Cashay Sanitary Puffs, *141*–42
Castle Garden, 106
Catholic, 108, 190
celebrity, 33, 104, 140, 148
ceremonial, 15, 18, 28, 30, 40, 88, 90, 187. *See also* ritual
Chalmers, Leona, 143
championship, 120, 199, 208
Charbonneau, Toussaint, 58
Chesapeake Bay, 22–24
Chicago Renaissance, 164, 166
China, 114, 128–30, 209
Chinese, 128–29, 168; Exclusion Act, 128
Chow, Amy, 209
Christianity, 22, 29, 36–37, 80, 84, 88, 92, 112, 130, 158, 191
Christmas, 71, 194
church, 34, 50, 54, 84, 108, 110, 112, 152, 157–58, 173, 194, 196
cinema, 138
citizen, 41, 134, 156, 158, 160–62, 169, 173–74, 196

Civil Rights Act of 1964, 179
civil rights movement, 153–54, 164, 166, 168, 174, 194
Civil War, 73, 80, 82, 84, 86, 88, 92, 95, 102, 110–11, 113, 124, 151, 172
Clark, William, 58–60
Clary, *61–62*, 64
Cleghorn, Ka'iulani. *See* Ka'iulani, Princess
Cleveland, Grover, 117
clinic, 112. *See also* hospital
Coachman, Alice, 208
Cold War, 161–62, 164
Coley, Doris, 182
college, 80, 88, 103, 110, 131, 143, 178, 182, 196, 199, 216. *See also* university
colonization, 3, 6, *21–26*, 28–30, 36, 44, 46, 226
Columbia College, 88
Colvin, Claudette, 153–54, 172
comic, 153, 164, 166. *See also* cartoon
commercial, 139, 142–44, 176, 210, 220
commercialized, 12, 148
commission, 73, 89
communism, 194
Coney Island, 138
Confederate, 73, 80–82, 85, 102
Congo, 121
Connecticut, 36, 54
consumerism, 144, 148, 160–62, 164–65, 176–78, 190, 214
consumption, 143
Continental Army, 51, 54
Copeny, Mari, 202, 220, *222*
Corn Mother, 15–16
Corps of Discovery, 58
Corsey, Eliza Hopewell, 81
costume, 11, 67, 99, 121, 209; bathing, *97*. *See also* dress; fashion

court, 33, 45, 158, 168–70, 172–73, 179, 184, 195–96, 221. *See also* lawsuit
criminal, 125, 150, 222
Croatoan, 22–23
crowdfunding, 201, 216–18

Dakota Access Pipeline (DAPL), *219*–21
Darrin, Pat, *197*, 199
Daughters of Liberty, 50–51
Dawes, Dominique, 201, *207*–9
Day, Doris, 182
De Bry, Theodore, *17*–19
deaf, 95, 102; deafblind, 104
Deficiency Act, 88
deity. *See* gods
Delaney, Lucy, 63
democracy, 118, 172, 209
Department of Commerce, 124
Department of the Interior, 89, 121
deportation, 128
desegregation, 168, 170
diaries, 47, *49*–52, 55, 70, 212, 214
Dickewamis, 40
diplomat, 30, 148. *See also* ambassador
discrimination, 3, 111, 153, 156, 172
disease, 20, 22, 29, 42, 50, 66, 98, 102–3, 106, 111–12, 116, 129
DIY. *See* do-it-yourself
do-it-yourself, 212, 213
doctor, 102, 110–11, 129, 142
Dogtown, 198
Dole, Samuel, 117
doll, *69*–72, *137*, 139–40, *145*, 148, 153–54, *163*–66, 176–79, *185*–88, 217; paper, *137*, 139–40, 176
domestic, 22, 36–37, 40, 42, 44, 48, 58, 63, 66, 76, 78, 84–85, 99, 120, 129, 132, 134, 142, 160–61, 187; servant, 32, 44, 62, 88, 99, 104, 120, 128–29, 146
Donner Party, 48, *70*–72

dormitory, 126–*27*, 129–30
double Dutch, 151
Double Dutch League, 151
Douglas, Gabby, 210
drawing, 18–19, 22, 36, 156, 212. *See also* art
dress, 28, 62–63, 66–67, 71, 78, 81, 121, *137*, 139–40, *145*–47, 176–77, 186, 198, 217; code, 177, 198. *See also* costume
dusky maidens, 122
Dwelle, Georgia Rooks, 96, *109*–12

earnings, 125. *See also* employment
eating disorder, 213. *See also* anorexia
education, 36–37, 70, 80, 82, 84, 86, 92, 95, 98, 104, 110–11, 113, 117, 120, 125–26, 130, 142, 151, 153, 165, 168–70, 194, 204; equal, 165, 168, 170; girls', 36–37, 84, 86, 95, 130, 148. *See also* school
Educational Pictures Company, 146
electricity, 116
Elizabeth I, Queen, 23
Ellis Island, 95, 98, *105*–6, 108, 128
emancipation, 84, 88; Emancipation Proclamation, 88
embroidery, 25, 36, 38
Emerson, Ralph Waldo, 93–94
employment, 88, 95, 125–26, 143. *See also* earnings; job
empowerment, 214
Endo, Mitsuye, 158
England, 6, 22–23, 28–30, 33, 41, 45, 67, 81, 117, 208
English, 3, 22–24, 28–30, 44, 63, 94, 107, 135, 158, 169, 172, 204, 206
enslaved, 20, 47, 62, 64, 85–86
entertainer, 12
espionage, 81

European conquest, 3, 30
European settlement. *See* colonization
excavation, *5*, *31*
execution, 28, 30, 33, 192
Executive Order 9066, 156, 158, 168
exercise, 66, 103, 120, 129

Facebook, 222–23
Fair Labor Standards Act, 126, 147
"Farewell to America," 45
Farm Security Administration, 151
farmer, 36, 41, 54, 70, 120
fashion, 47, 50, 66–67, 99, 131, 134,
 139–40, 152, 160–61, 165, *175–77*,
 198, 205, 212–13. *See also* costume
Federal Bureau of Investigation, 156
feminism, 67, 161–62, 178, 201, 212,
 216, 220
Fernandez, Captain, 22–23
film. *See* movie
flapper, 131, 138–39
Florida, 18–20, 24
Fort Caroline, 18–19
Fort Pulaski, 84
Fort Shaw Indian School, 113, *119–20*
Fortas, Abe, 195
Fox Studios, 146
France, 42, 117, 142
Francis, Connie, 182
fraud, 34
freedom, 25, 40, 45–46, 48, 55, 63–64,
 66–67, 74, 86, 95, 99–100, 110, 131,
 138, 143–44, 152, 157, 165, 170,
 195–96, 198–99, 209; from slavery, 40,
 45–46, 63–64, 86, 110; of speech, 165,
 179, 195–96
French, 18, 36, 40–41, 58, 60, 92–93,
 104, 168
French and Indian War, 40–41
friendship, 41, 44, 99, 205

From the Mixed-Up Files of Mrs. Basil E.
 Frankweiler, 190
frontier, 25–26, 40–42

game, 6, 40, *119–20*, 122, 124, 140,
 150–52, 157, 191, 201, 208, 210,
 216–17
Gannett, Deborah, 55
gender, 56, 63, 80, 88–89, 93, 95, 129–30,
 183–84, 187, 212, 214, 216–18; norms,
 78, 153, 161–62, 184, 202; roles, 34, 47,
 51, 66, 77, 130, 161, 178; stereotypes,
 160, 162, 165, 217
genealogy, 11, 37. *See also* ancestry
Georgia, 73, 84, 96, 110, 134, 164
German, 66, 92–93, 104, 107–8, 134
Gevinson, Tavi, 212
Gilbreth, Lillian, 143
girl culture, 2, 26, 201, 212, 214
girl gangs, 213
Girl Guides, 134
Girl Museum, 1
Girl Scouts, 131, *133–36*
girlfriend, 99, 138, 191
girlhood, 1–2, 4, 12, 34, 63–64, 78, 100,
 104, 112, 132, 147, 152, 156, 162, 166,
 176, 178, 214, 225
Glyn, Elinor, 139
gods, 10, 15, 28, 92; God, 33, 179, *189–92*;
 goddess, 10–11
Goffin, Gerry, 182
gold, 107, 208–9
goldfields, 128
Goldieblox, 201–2, *215–18*
Good Housekeeping magazine, 144
Good, Sarah, 32–33
Gordon, Sarah, 138–39
gossip, 191
Grammy Awards, 205
Grand Voyages, 18

Grant, Ulysses S., 77
grave, 6–8, 14, *39–40. See also* burial;
 mortuary practices
Great Depression, 131–32, 146
Great Migration, 150
greed, 116, 124
Greenberg, Florence, 182
Grest, Valentine, 84
Grier, Eliza Ann, 111
gymnastics, 66, 201, *207*–10; leotard,
 207, 209
gynecology, 111

habeus corpus, 158
Hale, Sarah, 66
Handler, Ruth, *175–76*
Hanna, Kathleen, 212
Hansberry, Lorraine, 152
harassment, 62, 80, 147
Harlem Renaissance, 164
Hawai'i, *9*, *115*–16; Nepali, 10
Hawaiian, 10–12, 113, 116–18, 199
health, 45, 47, 67, 110–12, 116, 142, 150,
 179, 196, 220; care, 110–12; public,
 196, 220
Healy, Genevieve, 121
Hernandez, Maria, 210
heroine, 56, 78, 92, 192
Hidatsa, 58–60
Hine, Lewis, *123–125*
Hiroshima, 198
Hispanic, 177. *See also* Latina
historian, 30, 33–34, 55, 225–26
A History of America in 101 Objects, 1
Holbrook, Samuel, 51
Hollywood, 131–32, 138–40, 146–47
Hoover, Herbert, 136
Hopi, 179, *185–88*
Hosmer, Harriet, 90
hospital, 112, 139, 176. *See also* clinic

housing covenants, 150
Howe, George, 22
Hubbard, Elizabeth, 32
Hudak, Kasey, 217–18
Huguenots, 18–19
hula, 3, 10–12, 116; *kumu hula,* 11;
 seminary, 10; teacher, 11
huskanasquaw, 29

Ice Age, 2, 3
Idaho, *57*, 120
identity, 1–2, 4, 10, 12, 32, 47, 81, 92, 147,
 178, 212, 214, 226
Illinois, *13*–14, 70, *149*, 220
illness: mental, 106, 138. *See also* disease
illustrations. *See* drawing
immigration, 66, 94–95, 106–8, 113,
 127–28, 135, 150, 156, 168
imperialism, 113, 117
imprisoned. *See* arrest
inappropriate behavior. *See* harassment
Incidents in the Life of a Slave Girl, 62
indentured, 32
independence, 47, 50, 56, 177
Indian Hill, 121
industry, 70, 95, 113, 120, 131, 139, 184,
 201, 204, 209, 216
infant, 6–8, 19, 60, 98
infantilization, 146
Influenza Pandemic of 1918, 138
Instagram, 221–23
internet, 112, 201–2, 212, 214, 216
internment, 153, 156–58
interpretation, 1–3, 28
Intuit, 216
inventor, 218
Iolani Palace, 116, 118
Ireland, 40, 95, 106
Irish, 40, 106–8, 138
Iroquois, 41

Issei, 156–58

Jacobs, Harriet, *61*–62
Japan, 121, 156, 158
Japanese American National Museum, *155*–56, 158
jeans, 198
Jemison, Mary, 25–26, *39*–42
Jewish, 92–93, 169, 190–91
Jim Crow Laws, 110–11, 150, 172–73
job, 45, 59, 76–77, 85, 88–89, 125, 138, 150, 157, 161, 182, 209, 222. *See also* employment
Johnson & Johnson, 142–43
Johnson, Belle, 121
Journal of the American Medical Association, 144
journalist, 72
jump rope, 66, 132, *149*–51

Ka'iulani, Princess, 113, *115*–18
kachina, 179, *185*–88
Kalākaua, King, 116–17
Kansas, 70
Kaulapai, L. K., 12
Kē'ē Beach, *9*–10
Keller, Helen, 95, *101*–4
Keyes, Grandma, 70
Kickstarter, 201, 216–17
Kikuchi, Elizabeth, 153, *155*–58
King, Carole, 182–84
King, Edward, 85
kiva, 186–87
Klein, Carole. *See* King, Carole
knitting, 36, 50, 103, 129, 136, 199
Knox, Lucy, 52
Konigsburg, E. L., 190
Kotex, 143

La Ferle, Cynthia G., 178

labor, 62–64, 85–86, 135, 168; child, 113, 124–25, 147; domestic, 22, 36–37, 40, 63, 76, 78, 129, 134; factory, 124–26, 166; helper system, 125; manual, 44, 120
The Ladies Home Journal, 104
Lakota, 220
landmark, 44, 100, 118, 153, 170, 173, 196
Langley, Josephine, 120
Larose, Rose, 121
Latina, 201, 204, 216, 225. *See also* Hispanic
Latinx, 205
lawsuit, 168, 170, 184, 195, 222. *See also* court
Lazarus, Emma, 73, *91*–92, 94
Le Moyne, Jacques, *17*–19
Lee, Beverly, 182
legend, 10, 12, 15, 24–25, 55–56, 161–62, 226
leisure, 47, 50, 66–67, 99, 143, 157, 161
Lemhi Shoshone, 58
Lewis, Meriwether, 58–60
liberty bonds, 136
Lime Rock Lighthouse, *75*–76, 78
Lincoln, Abraham, 73, *87*–90
Lincoln, Mary Todd, 89
literature, 25, 37, 41, 92–94, 164, 172–73, 190
Little Miss Flint. *See* Copeny, Mari
Locke, John, 66
London, 23, 44, 82, 134
Longfellow, Henry Wadsworth, 55, 93
Los Angeles Board of Education, 170
Lost Colony. *See* Roanoke
Louisiana Purchase, 58
love, 11, 29–30, 85, 118, 139, 146, 179, *181*–84, 190, 200, 204, 213
Low, Juliette Gordon, 131, 134
Lucero, Flora, 121

Ludington, Henry, 54
Ludington, Sybil, 47, *53*–56
Lum, Martha, 168
Lyons, Sarah, 94

magazine, 66, 93, 125, 139–40, 144, 153, *159*–62, 176–77, 191–92, 201; fan, 139, 147; online, 212–14
Magnificent Seven, 209
Maine, 162
makeup, 131, 220
map, 37, 134
March for Our Lives, 196
marginalization, 12, 24, 47, 220
marriage, 11, 18, 29–30, 32, 36–37, 41, 45, 54, 60, 72, 82, 85, 90, 92, 98, 102, 108, 116, 126, 128–30, 138, 148, 177, 182–84, 190
Marsh, Julia, 99
Maryland, 28, 208
Massachusetts, 25, *31*–32, 44, 50–51, 54, 120
masturbation, 213
Mather, Cotton, 33
Matoaka, 25, *27*–30
matrilineal, 15, 19, 28
Mattaponi, 29–30
Mattel, 176
McCarthy, Joseph, 164; McCarthyism, 164
McKinley, William, 117
medal, 77, 136, 170, 208, 210. *See also* trophy
medicine, 14, 70, 81, 96, 106, 110–12, 129, *141*, 144
medieval, 36
Meglin, Ethel, 146
memoir, 30, 47, 82, 104, 148. *See also* autobiography
memorial, *43*–44, 170, *203*, 206
Mendez v. Westminster, 169

Mendez, Sylvia, 153, *167*–70
menstruation, 129, 131, 142–44. *See also* puberty; sanitary products
merchant, 37, 51, 80, 128
Mexican, 153, 168–70, 204–6
Michigan, 220
military, 41, 55, 77, 80, 120, 134, 153, 156–58, 165, 198; militia, 54–55
mill, 10, 88–89, 147; Lancaster Mill, 125; towns, 124–25
Miller, Shannon, 209
Mills, Clark, 88–89
missionary, 12, 85, 110, 120, 130
Mississippian culture, 14, 16
Missouri, 58, 63, 70, 88, 220
Mitchell, Sarah, 121
Moceanu, Dominique, 209
Model Indian School, 121
monarchy, 116
Monks Mound, 14–15
Montana, 120, 122
Montgomery bus boycott, 165, 173
monument, *21*–22, *57*, 59, *167*
Moon Cup, 143
Moore, Annie, 95–96, *105*–8
morality, 162
mortuary practices, 7–8 *See also* burial; grave
Motown Records, 184
Mount Washington Female College, 80
movie, 104, 131, 138–40, 146–48, 151, 172
Munn, Elizabeth Alice, 98
murder, 11, 14, 22, 24, 71, 80, 138
music, 36–37, 88, 92, 103, 118, 165, 179, 182–84, 201, 204–6, 209, 212; musician, 18, 183
myth: mythology, 10, 15, 60, 92. *See also* legend

NAACP. *See* National Association for the
 Advancement of Colored Persons
naïveté, 139, 183
Narragansett Bay, 76
National Alliance for the Protection of
 Stage Children, 147
National Association for the
 Advancement of Colored Persons,
 168–70
National Association of Colored
 Women, 112
National Child Labor Committee, 124
National Historic Landmark, 100
National Medical Association, 111
National Register of Historic Places, 104
Native America: Indian, 3, 7–8, 40–42,
 113, *119*–21, *185*; Native American, 3,
 7, 16, 18–20, 23, 25, 30, 32, 41–42, 47,
 59–60, 70, 113, 120–21, 179, 187–88
Nazi Party, 208
needlework, 36–37, 50
New Colossus, 94
New Jersey, 182, 190–91
New Woman, 131, 142
New World, 25
New York, *39*–41, *53*–55, 73, 92–94, 98,
 105–7, 138, 160, 164, 173, 176, 182,
 190–92, 216–17
The New York Times, 93, 107, 192
New York Toy Fair, 176, 216–17
New York University, 190
Newseum, *193*
newspaper, 44, 51, 55, *61*, 102, 107, 164
Nikomis, 28, 30
Nisei, 156, 158
North Carolina, *21*, 62, 125
North Dakota, 220–21
nuclear family, 161
nurse, 73, 110, 142, 161, 173, 176
nursing, 80, 85, 100, 196

Obama, Barack, 221–22
objectification, 2
ochre, 6–8
Oki, Peggy, 179, *197*–200
Olympic Games, 201, 208–10
Oneida, 67
oppression, 2, 15, 150, 187, 226
oral history, 10, 15–16, 47, 55
orgasm, 213
orphan, 33, 107
Osburn, Sarah, 32–33
Owens, Jesse, 208
Owens, Shirley, 182

Pacific Ocean, 6, 58, 60, 198
Pacific Western University, 204
Page Act, 128
Page, Jake, 1, 3
painting. *See* art
pants, 67, 176, 198; pantaloons, *65*–68,
 142; trousers, 66–68
Parker, Cynthia Ann, 42
Parks, Rosa, 154, 172–73
Parris, Betty, 32
Parris, Samuel, *31*–32
patriarchy, 8, 129, 179, 214
patriotism, 51, 134–36, 153, 160, 162
Pearl Harbor, 153, 156, 158
Pele, 10–11
Pennsylvania, 25–26, 40, 120
pension, 55
performance, 12, 15, 50, 82, 121–22, 147,
 176–78, 206, 209–10, 217
performer, 184, 206
periods. *See* menstruation
Perkins Institute for the Blind, 102
persecution, 32, 34, 93, 187, 195
personal hygiene, 142
Peters, John, 45
petition, 55, 162, 218, 221

Pfeifer, Sadie, 113, *123–26*, 147
Phelps, Jaycie, 209
Philippines, 117, 121
philosopher, 66, 93
physical activity. *See* exercise
pinup girl, 165
plantation, 62, 64, 84, 102
Playboy magazine, 191
playground, 150, 198
Plessy v. Ferguson, 169
Pocahontas. *See* Matoaka
Poems and Translations, 91–93
*Poems on Various Subjects, Religious and
 Moral*, 44
poetry, 11, 26, 44–45, 55, 73, 88, *91–94*,
 116, 121, 130, 152, 212; "The Jewish
 Cemetery at Newport," 93; "In the
 Jewish Synagogue at Newport," 93
police, 150, 173, 191, 205, 221
politics, 47, 51, 58, 94, 116, 135
Polynesian, 116
pop culture, 184, 191, 213
pornography, 146, 213
portrait, 44, *109*, 112
poverty, 94, 111, 113, 126, 131, 151
Powhatan, 23–24, 28–30
pregnancy, 22, 29, 58, 63, 82, 106, 142,
 173, 182
Presbyterian Mission House, 130
Pretty Young Things, 191
priestess, 28
princess, 3, 29, 113, *115–16*, 217
prison, 81–82, 153, 157
privacy, 165
propaganda, 117, 135
property, 62–64, 85, 98, 103, 130, 150
prostitution, 128–29, 138, 146
protest, 135, *193–94*, 202, 220–21
puberty, 29, 63, 187, 191–92. *See also*
 menstruation

publish, 44, 72, 82, 93, 152
Pulitzer prize, 152
punishment, 33, 195
Puritan, 33–34
Putnam, Ann, 32

Quaker, 194
quarantine, 106, 128
queen, 3, *17–20*, 23, 29, 116–17, 204–5
Quintanilla, Selena, 201, *203–4*

racism, 2, 45, 85, 112–13, 121, 124, 128,
 146, 150, 156, 158, 165–66, 168, 172,
 208–9, 216, 220
Radcliffe College, 103
raiding party, 40
railroads, 128
A Raisin in the Sun, 152
Raleigh, Sir Walter, 22
rape, 29
Ream, Vinnie, 73, *87–90*
Reed, Dolly, 84
Reed, Patty, 48, *69–72*
Reeves, Jeremiah, 172
refugee, 33, 85, 194, 198
relationships, 46, 63, 178, 183, 212–13
religion, 14, 16, 29, 33–34, 44, 92, 135,
 173, 186–88, 190–91
relocation centers. *See* internment
Reminiscences of My Life in Camp, *83–84*
rescue, 41, 71–73, 77, 130, 190
Revere, Paul, 54–55
Revolutionary War, 45
Rezpect Our Water, 220–21
Rhode Island, 36, 73, *75–76*, 93
Rhynhart, Jeanne, 108
Ribault, Jean, 19
Riot Grrrl, 212
ritual, 3, 11, 14–15, 29, 187. *See also*
 ceremonial

Roanoke, 3, *21*–24, 28
Roberts, Sarah, 168
The Rocky Horror Picture Show, 213
Rolfe, John, 29–30
Rollins, James, 88
Romania, 209
romantic love, 182
Rome, 89
Rookie magazine, 201, *211*–14
Roosevelt, Franklin D., 156
Roosevelt, Theodore, 147
Rosskam, Edwin, *149*, 151–52
Rudolph, Wilma, 208
Russia, 8

Sacajawea, 47, *57*–60
sacrifice, 14–16, 134–36; female, 15;
 human, 14
Saldivar, Yolanda, 205
Salem, 25; Village, 32–34
sampler, 25, *35*–38
sand paintings, 187
sanitary products, 131, 143, 192; belts,
 192; pads, 142; puff, *141*–42; tampon,
 142–44
Sansaver, Emma, 121
Santa Anita Assembly Center, 156
Santa Monica, 198
Santos, Lucia, 214
Satan, 32–34
savage, 59–60, 117
Scepter Records, 184
school, 11, 25, *35*–37, *49*–50, 52, 66, 68,
 70, 76, 80, 84–85, 89, 103, 110–11, 113,
 117, *119*–21, 125, 138, 143, 150, 153,
 156–57, 160, 165, 168–70, 172, 174

Tanner, Obour, 44
Tapestry, 184
Tate, Gertrude, 100

Taylor, Susie King, 73, *83*–86
teaching, 2, 11, 36, 84–85, 92, 103,
 151, 187
tear gas, 221
technology, 98, 140, 162, 202, 216–17, 226
Teena, 161–62
teenage, 14–16, 25, 55, 77, 80, 84–85, 90,
 95, 99, 106–7, 110, 112, 129, 138, 153,
 160–62, 172–73, *175*–76, 182–84, 190,
 212, 214, 221
Tejano, 201, 204–6
temperance, 135
Temple, Shirley, 132, *145*–48
Tennessee, 110
tennis, 99–100, *137*, 140
Terri Lee doll company, *163*, 165
Texas, 170, *203*–4, 206
textile, 113, 124, 126, 147
Thorfinnsson, Snorri, 24
Tiara Records, 182
Tilden, Freeman, 1
Time magazine, 192
Timucuan, 3
Tinker Tour USA, 196
*Tinker v. Des Moines Independent
 Community School District*, 195
Tinker, Mary Beth, 179, *193*–96
Tituba, 32
tomboy, 138–39
Touro Synagogue, 93
toy, 71, 140, 154, 165, 176, 187, 201,
 216–18
trade, 28, 51, 58, 60, 67, 84, 129
trafficking, human, 128
traitor, 81–82, 156
transgender, 213
transportation token, *171*
Treasury Department, 136
trial, 32–34, 130, 170
trophy, 122. *See also* medal

Turkish trousers, 67

Uchida, Yoshiko, 157
Uncle Sam, 164
underwear, 66–67, 140, 142
Union Army, 73, 80–82, 84–85, 92, 95
United Kingdom, 134, 218
university, 5, 37, 110–11, 190, 194, 199,
 204. *See also* college
upward mobility, 95
Upward Sun River, 3, 5–8
US Army Corps of Engineers, *219*, 221

vaccinated, 85
Valentine, Helen, 160, 162
victim, 126, 190
Victoria, Queen, 117
Vietnam War, 179, 194
Vinland colony, 24
violence, 86, 150, 178, 212
virgin, 144, 213
Virginia, *27–28*, 62, 73, 80; Company, 29
voyage, 18, 22, 45

wage, 107, 113, 124–26, 166
Walker Baptist Institute, 110
wangka, 10
Warren, Earl, 170
Warren, Mary, 33
water, 19, 45, 76–77, 99, *101*, 103, 106,
 172, 187, 220–22; pump, *101*, 103
West Virginia, *79*, 196
westward expansion, 47
Wheatley, John, 44–45
Wheatley, Phillis, 26, *43–46*
Wheatley, Susanna, 44–45
Whitaker, Alexander, 29

white captives, 41
White House, *87–88*, 116–17, 208–9
White, John, 22
widow, 32, 82
"Will You Still Love Me Tomorrow," 179,
 181–84
Williams, Abigail, 32
Williams, Eunice, 42
Wilson, Edith, 135
Wilson, Woodrow, 135
Wingina, 22
Winslow, Anna Green, 47, *49–52*
Winterthur Museum, 37
Wirth, Nettie, 121
Wisconsin, 88
witch: trials, 32; witchcraft, 32–34
Woodhouse, Mary, 84
World Gymnastics Championships, 208
World War I, 126, 131–32, *133–34*, 142
World War II, 153, 156, 158, 160–62,
 168, 182
Wright, Mary, 25, *35–38*
Wright, Richard, 151
A Wrinkle in Time, 190
Wyoming, 120

xenophobia, 158

Yale University Art Gallery, 37
yearbook, 201, *211*, 213–14
Yellowhammer, Anna Lee Rain, 202,
 219–20, 222–23
Young Women's Christian Association, 112

Zephyr Surf Shop, 198
zine, 201, 212–14

About the Authors

Ashley E. Remer is the founder and Head Girl of Girl Museum—the first and only museum in the world dedicated to celebrating girlhood. She holds a first-class MA in the History and Criticism of Art from the University of Auckland. For over two decades, Ashley has worked as an art historian, curator, writer, and editor internationally. She has collaborated with artists, NGOs, scholars, educators, and girls across the globe showcasing girl culture to raise awareness and promote social change. Her research focuses on girlhood in various local and global contexts. Ashley has written numerous articles and book chapters, including "Sites of Girlhood: A Global Memory Project" in *Feminist Pedagogies: Museums, Memory Sites and Practices of Remembrance* (October 2019), "Lesson Object as Object Lesson: The Embroidery Sampler" in the *Journal of the History of Childhood and Youth* (Fall 2019), and co-authored "Girl Museum: Using the Digital to Showcase Feminism in Cultural Heritage" in *Feminism and Museums: Intervention, Disruption and Change* (MuseumsEtc Ltd., 2017). She is currently working on her PhD at the Australian National University and is the co-chair of the *Girls' History and Culture Network* with the Society for the History of Children and Youth (SHCY).

Tiffany R. Isselhardt serves as Girl Museum's program developer, where she oversees exhibitions, podcasts, community outreach, and social media. She holds a Master's in Public History from Appalachian State University, and has worked with the Hickory Ridge Living History Museum, Blowing Rock Art and History Museum, Theodore Roosevelt Center, Museum Hack, and the Kentucky Museum at Western Kentucky University. Her research focuses on uncovering the hidden history of girls in order to advocate for gender equality, and how museums can better interpret and provide programming inclusive of girls' unique history and culture. Her publications include contributions to *Women in American History: A Social, Political, and Cultural Encyclopedia* (2017), *The Museum Blog Book* (2017), and co-authoring "Girl Museum: Using the Digital to Showcase Feminism in Cultural Heritage" in *Feminism and Museums: Intervention, Disruption and Change* (2017). She has presented on girlhood at several conferences, including the International Girl Studies Association and the National Council on Public History, and enjoys working at the intersections of history, material culture, and girl studies.